Louise Neri Lynne Cooke Thierry de Duve

Roni Horn

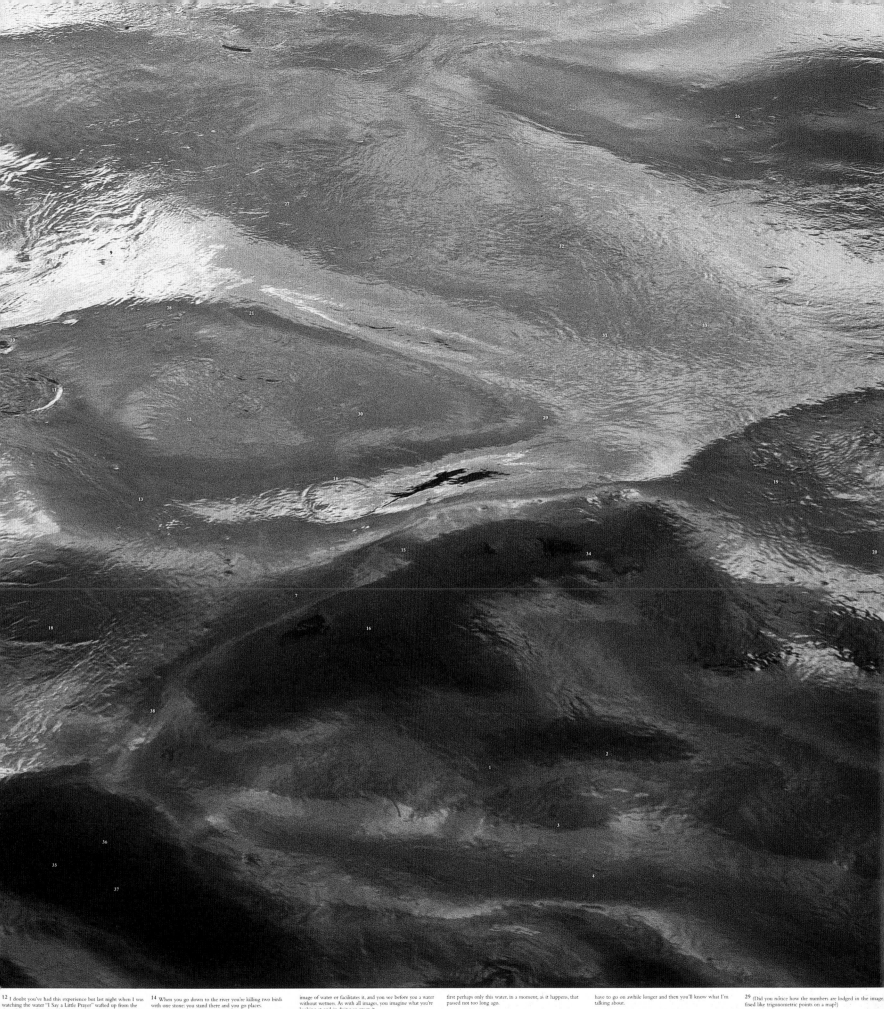

12 I doubt you've had this experience but last night when I was watching the water "I Say a Little Prayer" wafted up from the river. (It came along in a faster tempo than the version I remembered.) The moment I wake up . . . make up . . . wondering what dress to wear, I say a little prayer This is my prayer I say a little prayer This is my prayer Answer my prayer. . . ."[13] But it was so brief, a wisp really, almost nothing. (Maybe I didn't really hear it.)

13 From "I Say a Little Prayer," written by Burt Bacharach and Hal David in 1967. Version referred to was recorded by Aretha Franklin in 1968.

14 When you go down to the river you're killing two birds with one stone: you stand there and you go places.

15 (Is this a wave?)"

16 (Maybe a wave of sorts but also a soft place to lay myself down, tuck myself in.)

17 Are you wondering why I'm not talking about the Ganges? Or the Yangtze? Or even the Mississippi?

18 This is an image of water. When you look at it, as you are probably doing now, you are looking at paper, and there is no necessary relationship between the two. Yet the paper floats the image of water or facilitates it, and you see before you a water without wetness. As with all images, you imagine what you're looking at and in doing so grasp it.

19 When you look at this image (and the others) do you imagine jumping in?

20 When you look at this image do you see how smooth the paper is? How soft and sensual? (But you can't jump in.)

21 A sprinkle of little numbers over the water. They run in a possibly endless sequence connecting you, as you read this, to the river. They connect you to the various and particular points they locate in the water. And even though it is only an image, you are connected to this water and maybe even all water, but at first perhaps only this water, in a moment, as it happens, that passed not too long ago.

22 This footnote (and all the others) gives confluence to this spot on the paper (twenty-one inches down and seven inches over), to this undulation in the water, to this greenish color of the ink deployed to image the water, to the idea of water, all water, to the sensual surface of this paper, to the moment when you happened upon this number, and to you in that moment.

23 The Thames is me.

24 Here you are at footnote 24, and even though there's no real beginning to this installation you must have started somewhere. It's possible you started here, at footnote 24. That means you'll have to go on awhile longer and then you'll know what I'm talking about.

25 What about this footnote? Do you like it? I could have moved it over an inch or two but that might have changed its content.

26 Are you following the footnotes in their proper order, or are you just picking out the ones you like?

27 (Did you notice how the numbers are floating on the paper but they're not moving?)

28 (Did you notice how the numbers are floating in the water but they're still not moving?)

29 (Did you notice how the numbers are lodged in the image, fixed like trigonometric points on a map?)

30 This litter of numbers on the photograph is a constellation composing the view.

31 This litter of numbers on the photograph disrupts and annoys like rubbish floating on the water.

32 This litter of numbers on the photograph breaks up the view, punctuating the image of water with little digits. These digits, a small part of a larger corpus, enter by unseen logics into the flow of the river.

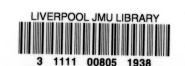

Publisher's Acknowledgements
We would like to thank the
following authors and publishers
for their kind permission to reprint
texts: **Franziska Baetcke**, Basel;
**Agencia Literaria Carmen
Balcells**, Barcelona; **Jan Howard**,
Baltimore; **Collier Schorr**, New
York; **University of Texas Press**,
Austin, Texas; and the following
for lending reproductions: **Andrea
Rosen Gallery**, New York; **Lisson
Gallery**, London; **Galerie
Sollertis**, Toulouse.
Photographers: **Eric Baum**;
Christian Baur; **Paula Court**;
F. Delpech; **Joe Garlington**; **Paula
Goldman**; **L. Barry Hetherington**;
Bill Jacobson; **Karl Krauss**;
Fredrik Nilsen; **Albrecht Ohly**;
Morgan Rockhill; **Douglas M.
Parker Studio**; **Philip Schorbërn**;
Oren Slor; **Nic Tenwiggenhorn**;
Kees Visser.

Artist's Acknowledgements
Thanks to Jerry Gorovoy, Matthew
Marks, Kathleen Merill and the
Lannan Foundation, and Jeffrey
Peabody. Thanks to North Tool
and Cindy and George Blake; Nic
Tenwiggenhorn; Jeff Williams;
Rudiger Hentschel and Armin
Reidel at Schott Glaswerke; Ginny
Williams; Helena Blaker and the
Public Art Development Trust,
London; David Adamson; Gerry
Vezzuso; Kevin Ott and Hennegan
Co; Gerhard Steidl; Walter Keller;
Geoff Verney and Monadnock
Paper Mills; Petur Arason, Frída
Björk Ingvarsdóttir, Margrét
Haraldsdóttir Blöndal, Hildur
Björnsson and Björn Björnsson,
all of whom have helped over the
years directly in the production,
or more broadly supported the
realization of my work. Thanks
also to Richard Schlagman, Gilda
Williams, Ian Farr, John Stack,
Stuart Smith and Veronica Price
at Phaidon Press for their support
and efforts in producing this book.

All works are in private collections
unless otherwise stated.

Phaidon Press Limited
Regent's Wharf
All Saints Street
London N1 9PA

First published 2000
© 2000 Phaidon Press Limited
All works of Roni Horn are
© Roni Horn

ISBN 0 7148 3865 9

A CIP catalogue record of this
book is available from the British
Library.

Printed in Hong Kong

Design: Stuart Smith

cover, Hot pot at Strútur, Iceland
1991
Previously unpublished
photograph from the artist's
archive

page 4, From **Still Water (The
River Thames, for Example)**
(detail)
1999
Offset lithograph printed
photograph and text
77.5 × 105.5 cm
From the series of 15 lithographs
Collections, Musée d'Art Moderne
de la Ville de Paris; Lannan
Foundation, Santa Fe

page 6, **Roni Horn**, Iceland
1991

page 30, **Ellipsis I** (detail)
1998
Photo installation, 64 Iris printed
black and white photographs tiled
together
244 × 244 cm

page 78, **You Are the Weather**
(detail)
1994–95
Photo installation, 100 colour
photographs and gelatin silver
prints installed on 4 walls
25.5 × 20.5 cm each
Collections, De Pont Foundation
for Contemporary Art, Tilburg, The
Netherlands; Kunstmuseum
Nürnberg, Germany

page 88, From **Untitled (You
Are the Weather)**
1995–97
Rubber floor
47 m²
Installation, Matthew Marks
Gallery, New York

page 92, Drawing for the text
The Cold Blood of Iceland, 1992

page 144, **Roni Horn**, with Nic
Tenwiggenhorn and Helena
Blaker, River Thames, London,
1999

Contents

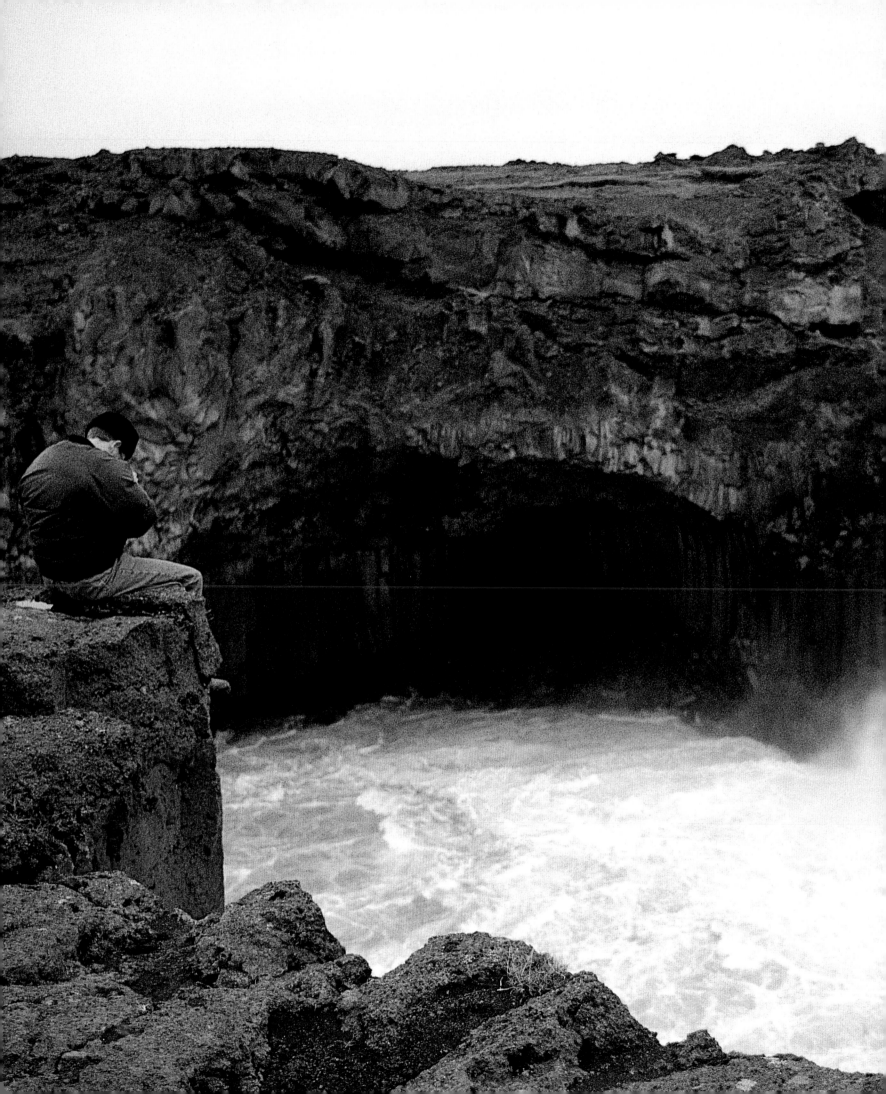

Contents

Interview

Lynne Cooke in conversation with Roni Horn

Lynne Cooke Your most recent piece, *Pi* (1998), establishes a new relationship in your work between the photographic image and architectural space.

Roni Horn It started as a book in the ongoing series of volumes, *To Place*. *Arctic Circles* (1998) was the title of the book, and in that context, it was overtly located in Iceland. When I pulled this other work, *Pi,* out of the *To Place* series, by implication it was pulled out of Iceland. When you're looking at this piece there's no necessary relation to Iceland although it derives from there. The title evolved into a broader relation to the circle: *Pi* being a reference to the mathematical constant π which is the ratio of the diameter to the circumference of a circle. The Arctic Circle doesn't exist except as a mapping device. It's a bit of civil infrastructure; it functions, in a sense, as a means to relate humanity to the scale of event that the planet exists in. *Pi* too presents a means of relation to something that exceeds us. In this installation it refers to a collection of circular and cyclical events, which, together, form an idea of constancy. The passage of time; life-death rounds; mundane daily existence; dramatized stylized life; the harvest … all form these cycles. The installation of *Pi* also involves an architectural aspect that extends the circular reference to the idea of a surround or a horizon. The work surrounds the viewer spatially. It is hung above eye-level so that you literally come in onto a horizon.

Pi
1998
Photo installation, 45 Iris printed colour and black and white photographs installed on 4 walls
Various dimensions, 51.5 × 69 cm; 51.5 × 51.5 cm; 51.5 × 46 cm
Collection, Staatsgalerie Moderner Kunst, Munich

below and following pages, Installation, Patrick Painter Gallery, Los Angeles

opposite, Installation, Matthew Marks Gallery, New York

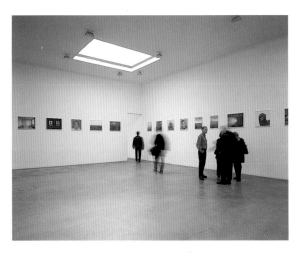

Cooke It's installed about six feet off the ground, so the horizon line is over the average viewer's head. Since you look up at an angle, you are forced to stand back; as you move towards the middle of the room to look at it, no-one is ever in your way. You can always see the work as a whole.

Horn **I wanted to prevent the viewer from focusing on each image singly, isolating and interacting with individual images out of the context of the whole. If that happened the work would not, in a crucial sense, be readable.**

Cooke In the presentation of *Pi* at Matthew Marks Gallery, New York, in particular, it was evident that there was no hierarchy: all four walls of the room were virtually the same length and there were three entrances. There seemed to be no starting point, no point of closure, and no focal point. Moreover, several images which were repeated, or reversed, were so situated from each other across the room that a dialogue developed or an echo formed. Consequently, the viewer was always looking across, round, and back: *Pi* is a non-directional, non-directive piece.

Horn **There is no prescribed beginning or end, and, among the images, no single motif dominates. The potential for narrative, which is implied in the nature of the imagery, never actually evolves. Thwarting the narrative is an important way to engage people's interest.**

Cooke Tidal and seasonal change are cyclical rather than linear. Such cycles suggest an eternal return. Then there are the cycles of the birds' lives and of course, the lives of the elderly couple Hildur and Björn, who are towards the end of their life cycle. One feels a conscious layering and overlapping of different histories, different temporalities and durations.

Horn **There's also the cycle of the harvest. And then there's a cycle, at least in my mind, which is the relationship of human nature to nature, this mirror-like relationship in which humanity is trying to remake nature in its own image. That's the role of the stuffed examples of indigenous animals, which have an extraordinarily human look to them. Mainly they're odd or goofy looking. Maybe the taxidermist just never got them right. They seem closer to human beings than to familiar animals ... I see the seal and Hildur, or the mink and Cassie – a fictional character from the American soap opera *Guiding Light* – as being like twins.**

Cooke The sea is uninflected. There are no rocky outcrops or boats interrupting it: it's a quintessential expanse of water, like a slate. It's both a place and placeless, both very particular and universal. Given that there's nothing to identify out there, the singular and the generic are conflated.

Horn **The television stars are generic types so they, too, operate in the realm of the collective. The daily drama of the soap opera, *Guiding Light*, is another cycle that is important to the work. Whatever kind of artificial, mundane drama it might contain is reflected in the mundane drama of the birds, dead, alive, on the cliffs, over the water: a local and universal expression of drama. *Guiding Light* was part of the daily routine for Hildur and Björn and most of rural Iceland.**

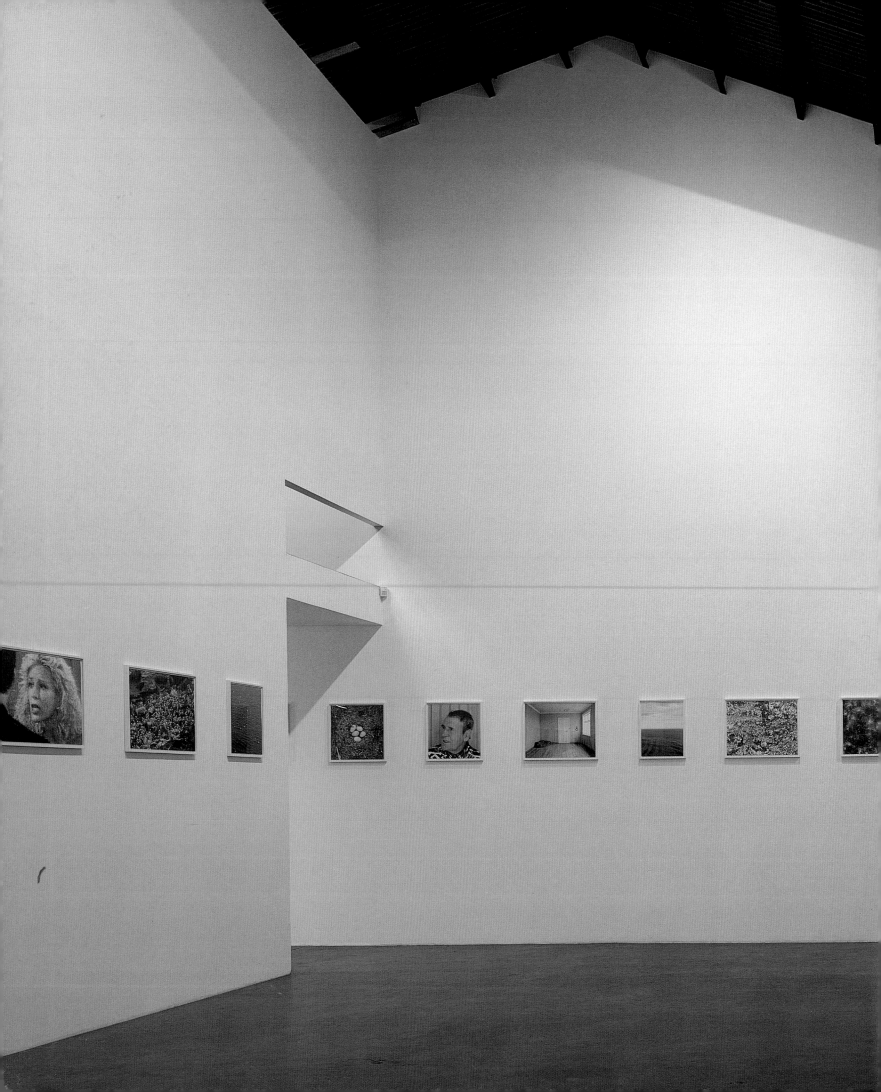

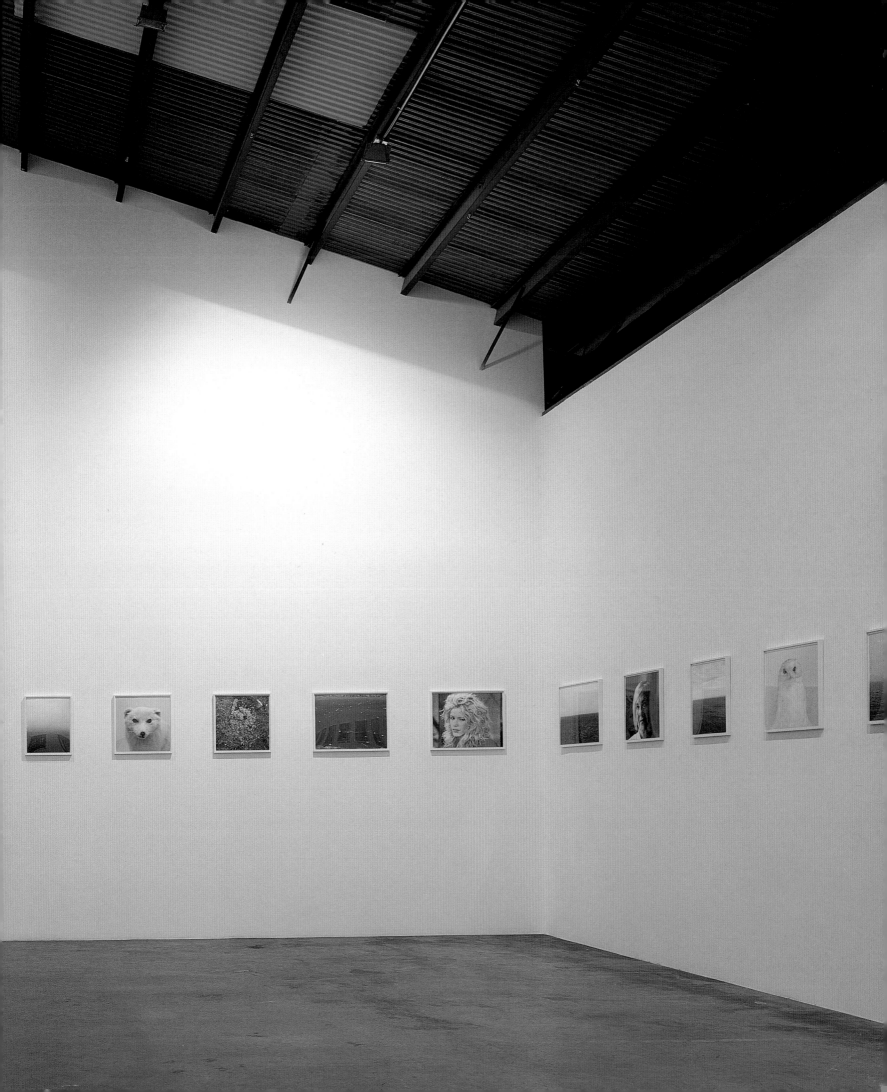

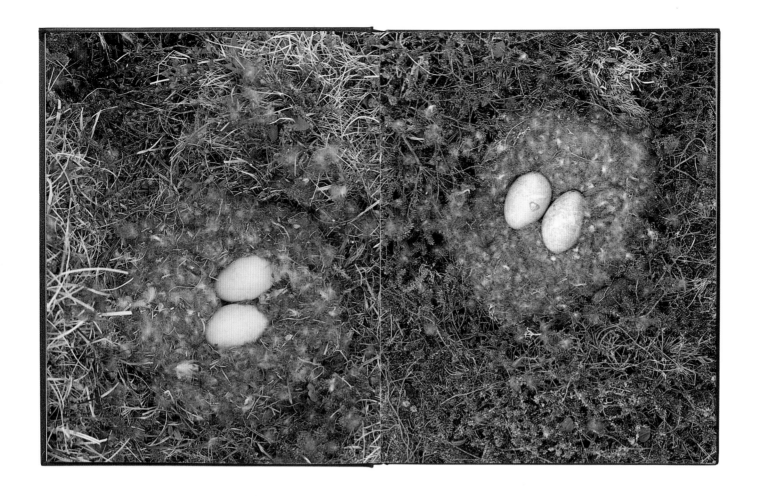

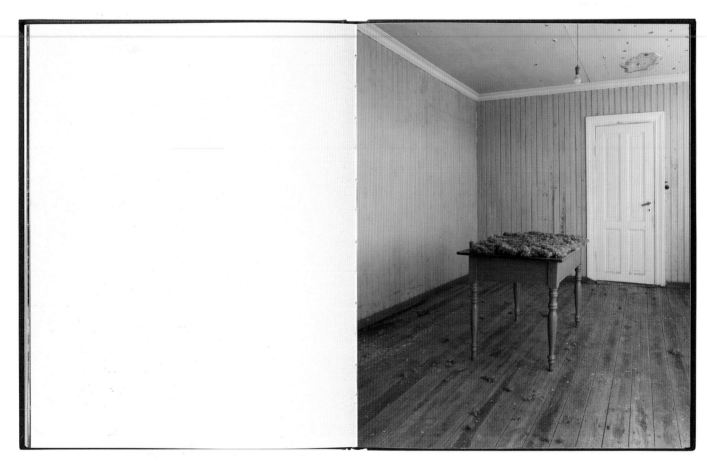

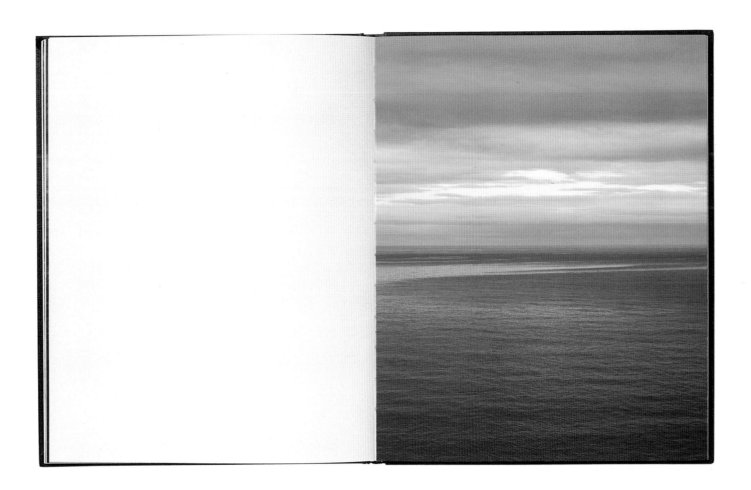

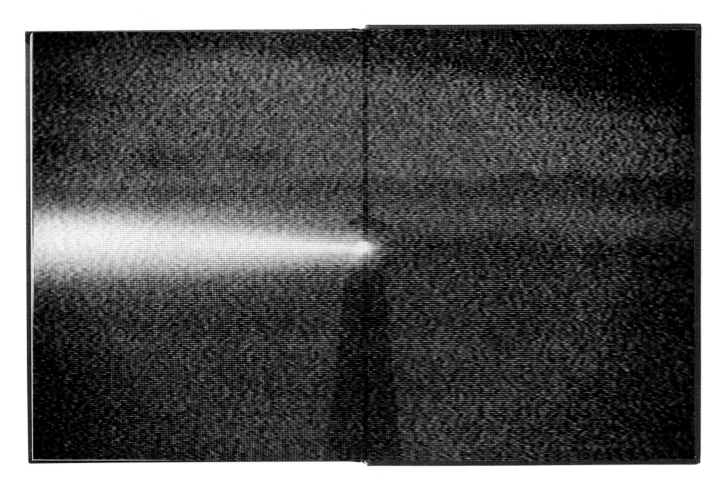

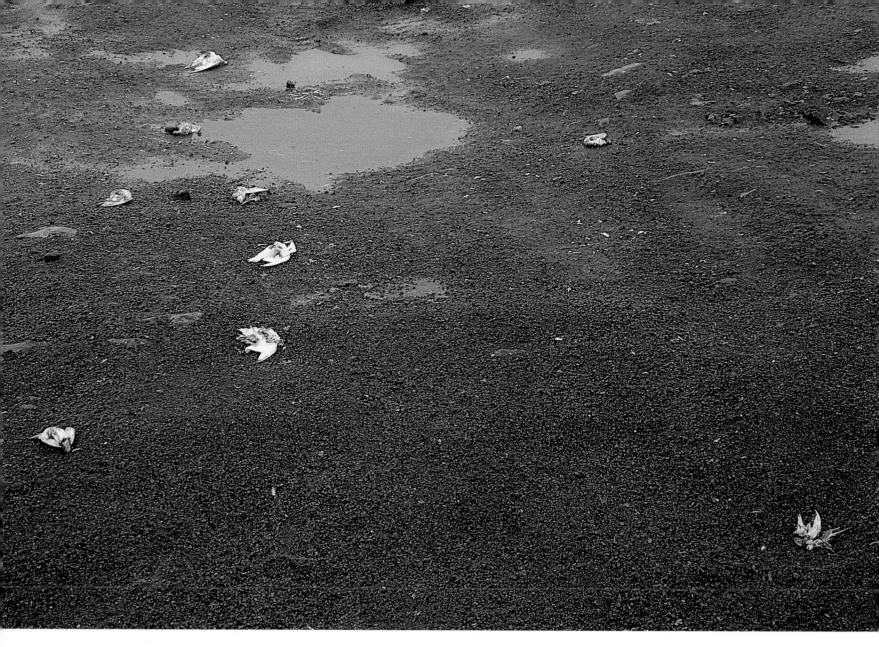

Cooke The eider down is collected and stored in a very spare, austere room. Beyond that, there is no further access to Hildur and Björn's home, to their living-quarters or anything that would domesticate or localize them. They reveal their individuality through the way that time has marked itself on their faces, rather than via objects or surroundings. These two people are recognized in their singularity but they're not explored in their anecdotal particularity. They're locked into very large cycles related to space and time.

Horn Were I to have gone too specifically into them I would have wound up with a narrative or a more descriptive relationship to the subject, which I didn't want. I wasn't so concerned with the fact that they were old, but with the intricate qualities of their physiognomies which you don't get with younger people, for the obvious reason that aging is a dimension which becomes more apparent in the face with time. It operates as a metaphor for landscape: when I look at those faces there's a level of complexity which doesn't come from their expression; it comes from their physical reality … I originally placed some of the dead animals and Hildur and Björn opposite from one another so that gaze met gaze. I liked this intersection in architectural space, this use of image to engage physical space. There are images which I cut in half and which occur in different parts of the room, and there

preceding pages, opposite and below, From **To Place – Book VII: Arctic Circles**
1998
136 pages, 65 colour, 7 duotone reproductions, clothbound
26.5 × 21.5 cm
Edition, Ginny Williams, Denver

Selected original photographs from the above work are also sequenced in the installation **Pi**

are images which were taken seconds apart from each other. One series of images was photographed at three in the morning, and then again at three in the afternoon. The light was oddly similar, yet you felt the difference when you were there; it was more a tactile or palpable experience than it was a visual one. So in *Pi* there's a delicate relation to the passage of time: minuscule differences in physical terms may prove great in visual terms. I also used these manipulations in the book *Arctic Circles*. *Pi* has half as many images as *Arctic Circles*: every motif had to occur at least twice, preferably three times, in order to create a circular experience for the viewer. That limited the way it was structured.

Cooke What are your feelings about the inversion or reversal of an image? To me, it operates like a flashback; it reminds you to look back, literally, or to look a second time, metaphorically. It also brings the photographic medium to the fore, making it self-reflexive. There's one motif which, exceptionally, is not repeated yet which also, in a very subtle way, ties things together. This is the image of the wallpaper, which is like a map or a net. It introduces a larger

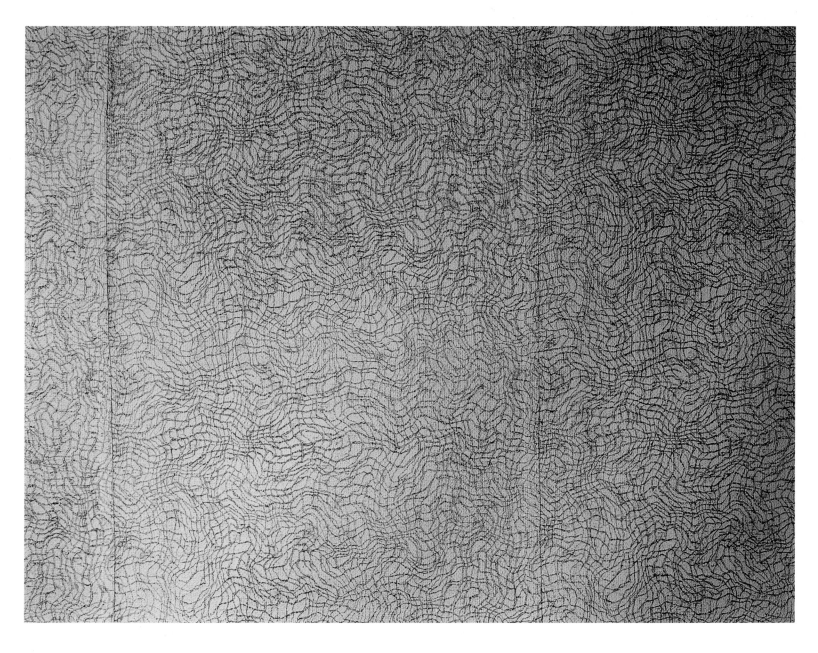

infrastructure into the piece, a skein of things overlaid, interwoven and entwined together.

Horn Yes, it is the only image that doesn't recur. I thought I could use that image alone because it communicated 'cycle' in itself. I thought about the way the formal structure might allow me to relate images together which are so disparate. All the shots of the Arctic Circle, the horizon shots of the ocean, are cut in half. Given the nature of the horizon a person looking at them will understand that they're only seeing half of something. Either they'll look for the other half or they'll carry it in their head. This was the element that really allowed me to draw together all this seemingly unrelated imagery. The half horizons sew the work together. The inner logic needs to be extremely intelligible to the viewer in order to have this wide range among the images and still keep the work cohesive. Each visual motif is woven in or drawn together, so that everything seems to have a certain quality. The wallpaper has the passage of time in it, in the way that it's faded. It also has a visual relationship to the feeling of oceanic expanse, to the static field of the television set, and from that to the down, the soft down material; that then goes into the nest. Or Cassie with her TV nest and the close-up shots of the down, and then the crowd shot of the birds on the rocks. One of the reasons I chose Cassie was because she has this big hair. I like the idea of moving from human to landscape via big hair, which became an extension of place. There's another woman I wanted to use, named Dinah, who was a Warholian type with close-cropped black hair and red lipstick. She was very photogenic. She would have been an interesting presence, but she was completely separate from the setting – too graphic, perhaps – whereas Cassie was half place and half object. So I worked with her.

Once you recognize and step into the logic of this piece, it becomes evident how everything matters. The more clear the thing becomes to you, the more defined the critical edge becomes. This work is complex, not just in terms of its content, but in terms of how the viewer relates to it and, ultimately, puts it together. A work always comes together twice: first, for the artist, and, second, for the viewer. For me that second coming together is really an essential part of the experience.

Cooke One is very conscious of one's movement in the space of the gallery which is quite different from the kind of experience one has with the book to which it is closely related.

Horn This is a subject that I come back to again and again. I'll go into a work thinking that it's going to be a book, and find that it then develops into another work which is parallel and separate, sometimes in very subtle ways and sometimes in really big ways. In the latter, they become completely different works. For example, in *You Are the Weather* (1994–95), a hundred images of the same woman stare at you from a hundred different points in space. This sets up a completely different experience from that which anyone could possibly have flipping through those images in the book *Haraldsdóttir*, to which it is related, where no more than two are visible at any time. The differences between these works are much bigger than the quantitative description of either one of those two forms allows.

From **To Place – Book VII: Arctic Circles**
1998
136 pages, 65 colour, 7 duotone reproductions, clothbound
26.5 × 21.5 cm
Edition, Ginny Williams, Denver

Selected original photographs from the above work are also sequenced in the installation **Pi**

Cooke One aspect of *Pi* that is quite different from *You Are the Weather* is that when experiencing *Pi* one is conscious of being in a social space. Being present with one or two people, which is normally the case in a gallery setting is, for me, the optimum experience: it reinforces the social identity of the two protagonists, Hildur and Björn. With *You Are the Weather* the movement is incremental, you go from one image to the next, just you and the woman in the image (Margrét Haraldsdóttir Blöndal), whereas with *Pi*, by contrast, there is a more fluid, unstructured movement across and around the room.

Horn ***Pi* is more fragmented and the fragments add up eventually, whereas in *You Are the Weather* there is a constancy and extension to the gaze, either because of the voyeuristic element or because of the fantasy element. I'm interested in that relationship to the image: in the way an image breaks down and becomes less an image.**

Cooke Given that Margrét's face is not expressionless but is very contained, one watches subtle, incremental shifts which one might think are physiognomic changes, or the product of changes in the light, rather than changes in her moods. That is, we're very conscious of reading the face as a physical surface. In the faces of Hildur and Björn there's a condensation of what we've been discussing – time and its imprint on the surface – whereas, because Margrét is so much younger, and because there are so many more images that are subtly different in the work, one finds oneself moving literally across textured surfaces - not internally and, therefore, not psychologically - but nonetheless in a one-on-one relationship, an individuated engagement.

Horn **When I was editing the images for *You Are the Weather* and now, again, with *Still Water* and the book in progress *Another Water*, the editing process became the principal aspect in the development of the form: images were either taken away or sometimes later added back in. It's a slow process of learning to see what you're looking at, paying attention, with something that is not exactly ignorance but a kind of intuitive intelligence. In *You Are the***

From **To Place – Book VI: Haraldsdóttir**
1996
96 pages, 30 colour, 31 duotone reproductions, clothbound
26.5 × 21.5 cm
Edition, Ginny Williams, Denver

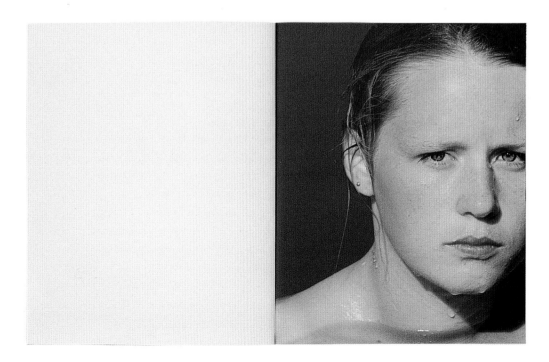

Interview

Weather, I edited out all the images where Margrét was smiling or really miserable, all the extremes, which I learned to do with *Pi*, too, because they broke the continuity and cohesiveness of the work. I also cut images that became too descriptive or seemed too novel, and so functioned differently from the others, taking away from what was going on around it. Although *Pi* is not an intimate experience in terms of physical proximity, it is in terms of where you go in your head. It's half you and half what's out there, because it keeps you in the space in such a way that the room becomes a landscape.

Cooke It becomes a place?

Horn **Exactly, it becomes a place. That doesn't happen in *You Are the Weather*. It's you and this woman, and where you go with that.**

Cooke In this, *Pi* recalls your pair objects, sculpture suites such as *Things That Happen Again* (1986–91), or *Pair Field* (1990–91), which engage circumstantial reality. When, for example, you are looking at one of two forms that are apparently identical, you realize that they cannot, by definition, be identical because you can't have the same experience twice. In addition, you inevitably see each one from a different angle, approach it differently, and thus always see one in relation to another. So though these works utilize space differently from *Pi*, it seems to me that the vividness, the sense of presence and immediacy they engender in the actual space, has been carried through into *Pi*.

Horn **I'm working on a pair object now that happens to take a photographic form. It's so integrated into that series that the photographic aspect is nominal. I suppose I haven't really used photography in any way but nominally. Usually the subject matter of the image is not the subject matter of the work. A thing can generate so many different appearances as an image. If only through its use in mass media, photography has become increasingly vital to our knowledge of ourselves. My work rides on that familiarity, and uses photographic images in order to get into architectural or psychological spaces that have very little to do with the image *per se*. In *Still Water (The River Thames, for Example)* (1999), photographs of the water in the River Thames that are then footnoted extensively, there is something interesting in the quality of the images because, photographically, they capture aspects of the water that are not visible to the naked eye, such as when the water is moving a touch too fast to be seen. When water is translated into a photographic image it has so many different personas. I was not expecting that. I know that most of what's out there in the world is occurring too quickly or too slowly for me to see. But somehow I didn't expect that when water was converted into this graphic form it would be so surprising. In these images you see how unfamiliar water really is. Perhaps because it's so complex, one of the qualities of water is to sustain this unfamiliarity.**

Cooke The photographs in *Still Water* are intended to be shown in different spaces, so that it won't be possible to see more than one at any time. One's ability to hold in memory an image that is intrinsically evasive is stretched to the fullest. The subject is highly elusive. To recall each image as one moves from one space to another brings into play a very different sense of time and vision from that found in either of the two projects we've been talking about.

opposite, **Piece for Two Rooms** from **Things That Happen Again** (Room 1) 1986–91 A suite of four sets of paired, solid copper forms, each forged and machined to duplicate mechanical identity l. 89 cm each ø 43-31 cm each Installation, Galerie Lelong, New York Collections, The Detroit Institute of Arts, Detroit; Donald Judd Foundation, Marfa, Texas; Städtisches Museum Abteiberg, Mönchengladbach

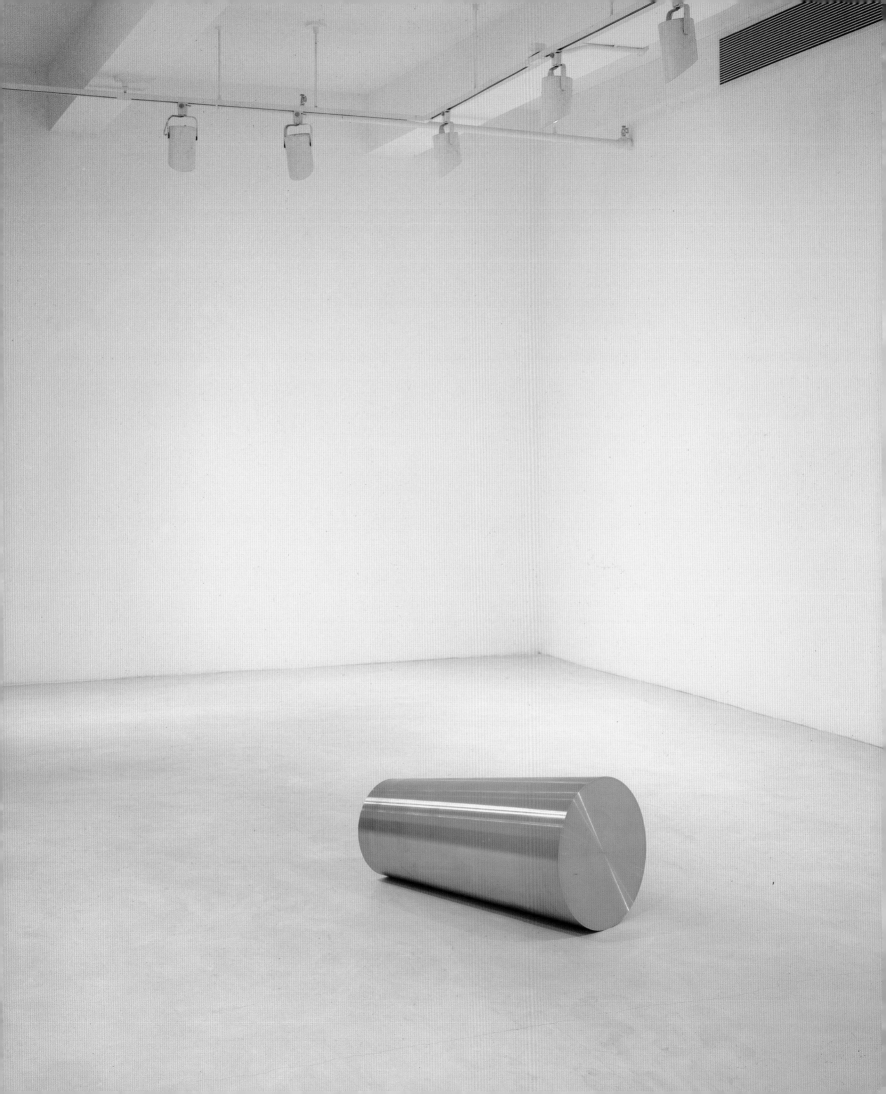

Horn **That depends not only on the evasiveness of the images and the way they seem to haunt your memory. The footnotes, which form a band at the bottom of each image, sustain a third element in the work. The image is one part of the form, the viewer is the second, and the voice in the footnotes is the third. This voice is mainly characterized by an endless flow of consciousness. In parts of the text it anticipates the viewer. It is also my voice. I am there with you as you look at these images. I'm talking to you. The idea of installing the images throughout a building – using the service and transition areas as well as the exhibition spaces – is a way of redirecting the flow through a space.**

I'm working on another piece called *This Is Me, This Is You* – something that my niece often says to me. For example, when looking at a photograph with two elements, she will say 'this is me', and 'Roni, this is you.' I've reached the point where I see this as a paired form. It's not comparative: it's an identification of relation, a simple relation. The form of this work is evolving into a collection of twenty or thirty images that are related to another collection of twenty or thirty images. The only difference between the two groups is that within each pair, each image was taken a few seconds apart. The thirty pairs of images are composed into two separate groups and hung in two different places. One of the things I'm interested in here is the way that this integrates photography. The photograph almost disappears because difference is being measured in seconds. You're recording or identifying difference as a measure of change. In a few seconds you can have extreme changes or imperceptible ones.

Cooke As viewers, we'll literally act out what conceptually we comprehend as the subject of the work …

Horn **Yes. Narrative has no interest for me except in terms of how an experience unfolds for the viewer. That is the narrative of the experience of the work itself. To take another example: in *Piece for Two Rooms* you go into a space and see a simple disk. It doesn't look like much: it isn't, until you walk in and see that it is a three-dimensional cone-shaped object which is familiar but has certain subtle formal qualities which make it different, which take away from it being familiar. It becomes memorable. Then you go into the next room and enact exactly the same experience, but of course it's unexpected and it's so many minutes later; it's a slightly younger experience in your life. Whereas when you walked into the first room, you had the experience of something unique, you can't have that a second time. That's it. It's a one-shot deal: it's not a reversible thing. When the viewer is going through this experience, that becomes the narrative: it's literally a piece of your life and it's the narrative of the work.**

Cooke Your exhibitions are made in the 'here and now'. Whatever allusions or recollections one might have from other pieces or previous shows don't seem particularly relevant. It's an unusual way of working. But you not only make exhibitions that are highly self contained; almost every work in your oeuvre seems hermetic vis-à-vis your practice as a whole.

Horn **That goes to the heart of it. I have this idea that each work should be unto itself. You walk in, you engage the experience, you leave: that's it. There shouldn't necessarily have to be a history of like works or future works,**

opposite, **Piece for Two Rooms** from **Things That Happen Again** (Room 2)
1986–91
A suite of four sets of paired, solid copper forms, each forged and machined to duplicate mechanical identity
l. 89 cm each
ø 43-31 cm each
Installation, Galerie Lelong, New York
Collections, The Detroit Institute of Arts, Detroit; Donald Judd Foundation, Marfa, Texas; Städtisches Museum Abteiberg, Mönchengladbach

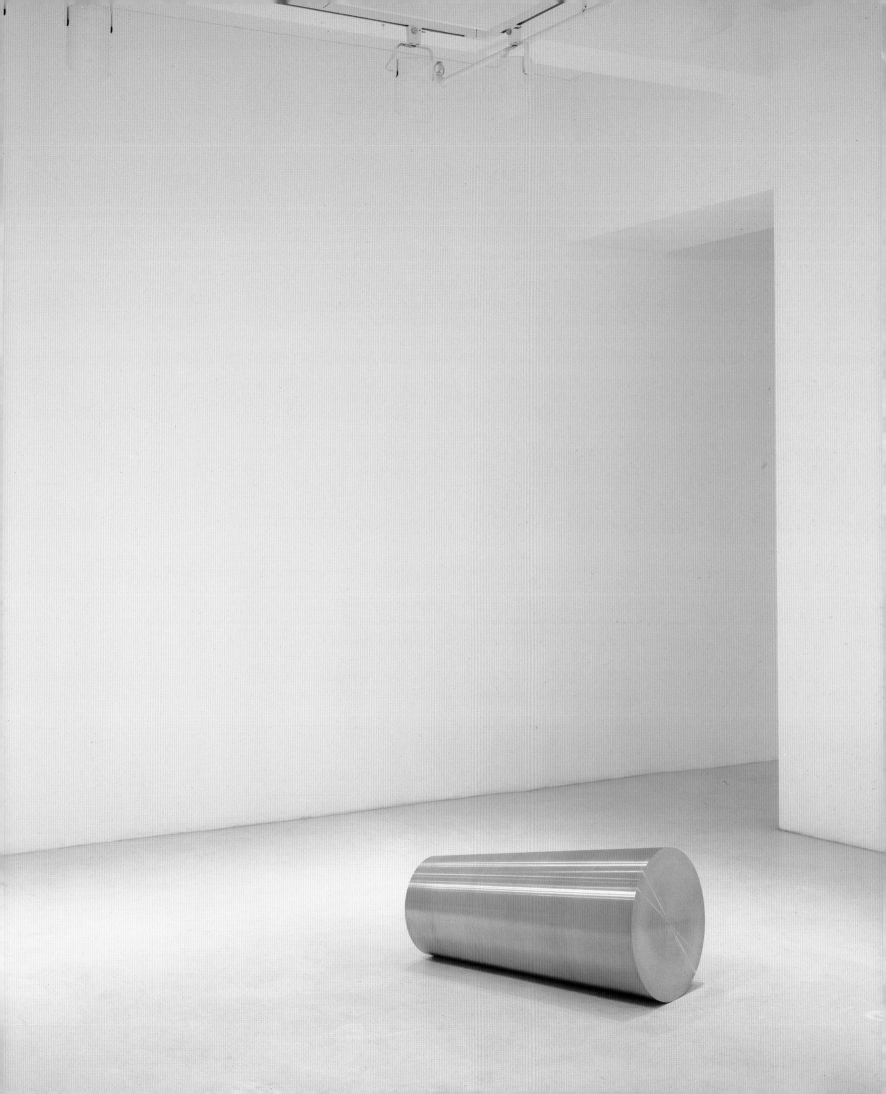

or variations on them. I've never felt tied to that way of working. If you say that the viewer's experience is a big part of the realization of the work, then you have to tune in on that individual possibility.

Cooke One of the consequences of the way that you've made shows up until now is that an informed viewer is not in a better position than a viewer who has no previous experience of your work. If each were actively prepared to engage, each could apprehend the art equally well. That's very unusual. It's generous to the viewer. It doesn't distinguish between different types of audience.

Horn **If you present someone with a credible physical reality they have to deal with it, and to do it whether they have a lot of information about what is in front of them or not. Preferably not. Knowledge is a funny thing: it often precludes experience. Usually no knowledge is better than some, or too much.**

Cooke Because with too much knowledge one reaches automatically to the previously experienced, to the known?

Horn **Yes, you don't really have an experience. There's a discovery process involved in every experience, and I want that discovery process, that starting from zero, again, and again, and again. I feel I'm always starting from zero. Obviously I have more experience than I did ten years ago, but somehow that experience has not dedicated my future towards a certain outcome, in terms of style, medium, or even idiom. I don't think I'm going to run off tomorrow and make a film, or write a book of poetry. But I do feel that within a limited range I can utilize a number of different forms with ease. I don't think of myself as a writer, but I conceive works, such as *Another Water*, which require a significant amount of writing. In these texts, it's not just what is being said that matters, but how it is being said.**
When developing three-dimensional work, I've always thought in terms

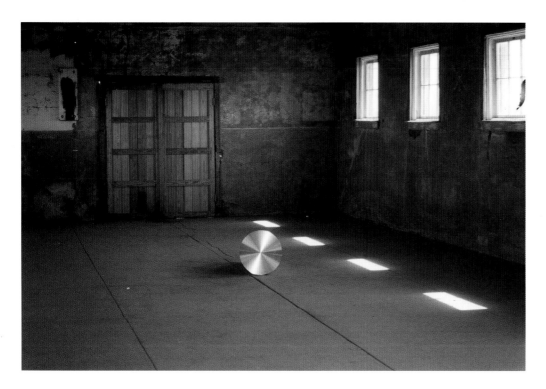

A Here and a There, from **Things That Happen Again**
1986–91
A suite of four sets of paired, solid copper forms, each forged and machined to duplicate mechanical identity
l. 89 cm each
ø 43-31 cm each
Installation, Chinati Foundation, Marfa, Texas, 1988
Collections, The Detroit Institute of Arts, Detroit; Donald Judd Foundation, Marfa, Texas; Städtisches Museum Abteiberg, Mönchengladbach

of language as opposed to thinking visually. So even in the case of the sculpture *Piece for Two Rooms*, the initial idea came when I was reading a book and started to think about how you could take an episode and repeat it a hundred pages later. I thought of this originally as a publishing defect; then it became the same thing in two different places; then it became two different things … I think in terms of syntax if not quite of grammar; of phrasing, leitmotif, chorus – the tools of language structures – which then take a visual form in the work.

Cooke You haven't yet embarked upon a film, but the way you speak brings structural film to mind.

Horn **Most popular films have a narrative. You step into an abstraction of time, which is not at all like the time one lives. But occasionally you have a film that does use time in a manner that is very similar to the way one lives time. In Robert Bresson's *A Man Escaped*, for instance (or, in a very different way, in Rainer Werner Fassbinder's *Why Does Herr R. Run Amok?*) the narrative goes on in real time. I would argue that my work, similarly, is not abstract: the acquiring of an actual experience is also the content of the work. That's all there is, and that's what it is, whether it's *Pi* or *Piece for Two Rooms*.**

Cooke Another parallel with film might be that during the encounter a sense of the actual place is obliterated, instantly; it's very rare to remember the form or character of the cinema as architectural space. There's been a lot of theorizing around the fact that the cinematic experience is quintessentially an experience of being in no place, and yet, at the same time, being in the absolutely here and now. Ultimately, it doesn't matter which auditorium one is in, or how the architecture is configured, the experience of the 'here and now' overrides all such considerations. Similarly, in the *Pair Objects*, it doesn't matter finally what the gallery is like physically, more important is the sense of an active relationship with the spatial envelope.

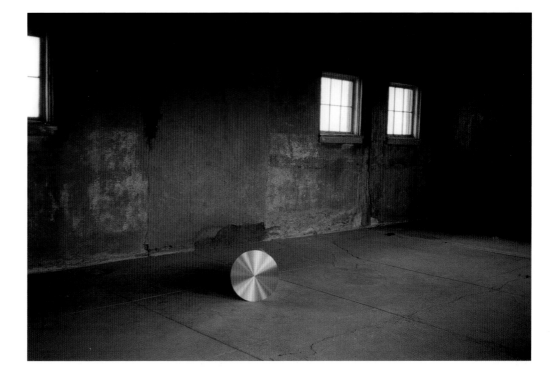

Horn **If you imagine a cinema, it necessitates the disembodiment of the world. Yet in some ways it's the exact opposite of what I'm doing. When a work is installed the experience of the setting becomes more prominent. The circumstantial aspects - that is, the specific architectural setting, the proportions of the space, the quality of the light, the location of the entrance and exit, the materials, all the things that make a space a particular place - become more prominent.**

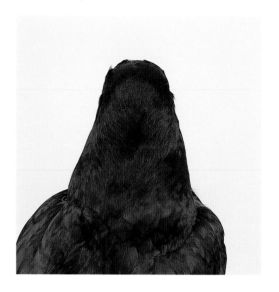

Cooke A viewer develops a heightened acuity to that context and yet, at the same time, the work wasn't made for that unique space or for any one particular gallery or museum. It's attentive to a sense of place, it's embodied in the space but not in the way that a truly site-specific work is, for such a work cannot by definition be transferred elsewhere. There seems to be a sliding scale between certain of your works which heighten one's awareness of the spatial context, like the *Pair Objects*, and others which draw more directly on it and are more governed by it, like *Pi*, and others which are commissioned for unique locations.

Horn **Site-specific remains an elusive term for me. There's a further distinction between these works and a commission. What happens when a work is commissioned is that the form of the piece evolves out of a dialogue with that site. It becomes indigenous to it. In site-specific works it's the entwining of the work with the circumstantial aspects of a place that makes it inextricable from it. The 'how' of that concept would be articulated very differently in a different building or site. But the 'what' of it would still be similar, if not the same, from one site to another. I don't think the concept itself is ever really site-specific.**

I'm working on a semi-public installation in Basel (*Yous in You*, 1997–2000) that involves a rubber-tiled walkway. The surface form is taken from a rock face in Iceland. The experience is primarily a tactile one, that is, one that will be felt via differences in density which, visually, will be imperceptible. On one level there is a purely conceptual element, which is the idea of taking the impression of a landscape from one place and shifting it to another place - a geological and a geographical shift. Sections of the walkway are cast in very soft rubber, others are in a harder rubber. Since there is no visible clue to those differences you become the reference for the experience. There is no visual confirmation of what you feel. It remains within the subjective realm: you're really on your own.

I think of the path as a reflection of the human condition: its scale is always that of an individual person. Crucial to the idea of the path is that it's an irreversible form with a very delicate and truly complex relationship to the place it's in – every path is a site specific event – in contradistinction to civic events like roads and highways, things that are built out of social need, out of massive collective effort. This path in Basel goes through an architectural setting which is fairly classic, a structure of platonic geometry. It introduces not simply an organic form – landscape – into an urban context, a public space, but also a psychological presence, a kind of mirror for the unseen. It introduces the idea of another place in order to form a complex with it and re-form the place you're standing in. Proximity is a very powerful basis for relation, for human and circumstantial relations. Proximity can compound meaning or, conversely, it can fragment it.

Untitled No. 1
1998
Paired Iris printed colour
photographs
56 × 56 cm each
Collection. Museum für
Gegenwartskunst, Basel

following page, **Dead Owl**
1997
Paired Iris printed colour
photographs
57 × 57 cm each
Collections, Museum für
Gegenwartskunst, Basel; Solomon
R. Guggenheim Museum, New
York; Musée d'Art Moderne de la
Ville de Paris

Cooke Over the years, certain of your abiding concerns have been differently
parsed; as, for example, when the *Pair Object* series took on the medium of
photography in one of its variants. What is the basis for a related process:
returning to a specific form, or revising a particular image?

Horn **Around 1980, I made *Pair Object I*, which was prescient, because I didn't
do anything like it for another five years. Then there were *Pair Object II* and *III*,
with the same theme. The idea of pairing then occurred in the drawings in
a very odd way, with this distant-double thing, where you have different but
very similar drawings in different rooms. I'm unsure which occurred to me
first, the *Double* and *Distant Double* drawings (1986–90) or *Piece for Two
Rooms* and related works, but they informed each other. There was no
question that they were parallel developments that helped me to grasp the
possibilities of proximity and distance and from that, difference and identity.
I guess we're really talking about what happens when I go from one form
to another, whether in a book, or a three-dimensional work, or a two-
dimensional work, or an installation. I can take the same material in these
different forms and arrive at different experiences. For me, that's the basis for
the re-use of certain images. An important instance of this is the owl image.
It occurred first as *Dead Owl* (1997) where it offered an experience of infinity
or at least the beginning of infinity. Then the same image, again paired, was
used as a spread towards the end of *Arctic Circles*. A form of punctuation, it
was a full stop. And then, in *Pi*, I used a cropped version of it, a head shot.
There it was one element among forty-four others.**

Cooke Closely related to this is the way that in certain of your titles the words
themselves mediate between your experience and the viewer's: they categorize
or classify one in relation to the other. Many of the terms you choose, like 'me'
and 'you', 'here' and 'there', 'this and that', are shifters, which makes for very
complex, fluctuating relationships. If I say 'you' and 'me', and you say 'you' and
'me', we mean the same thing but in reverse, from opposite sides, so to speak.
This plays crucially into the active role you consistently assign the viewer.

Horn **I love the way language compounds identity. I don't know who
'I' would be, or what the meaning of the relationship would be without
specific instances. But I'm attached to all the shifters, especially to 'you.'
It is ungendered and entirely dependent on point of view. It is all inclusive.
But a work can be especially meaningful and effective in how it questions
one's relationship to oneself. Through that it can be quite profound in
how it affects the world.**

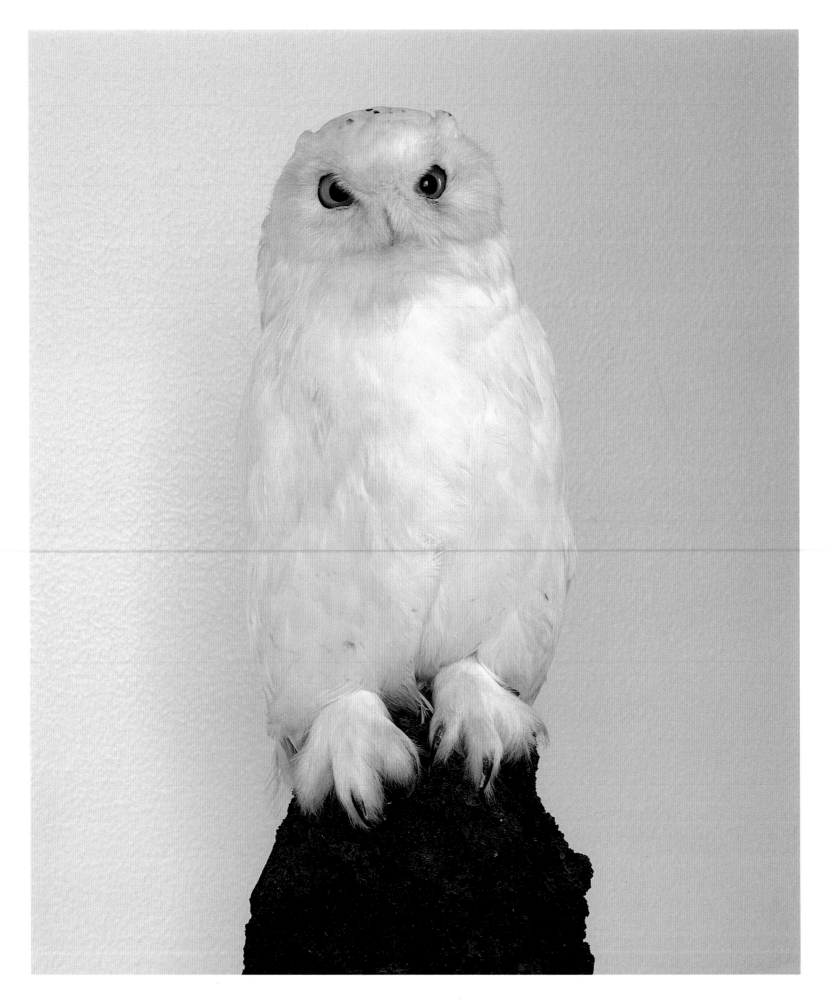

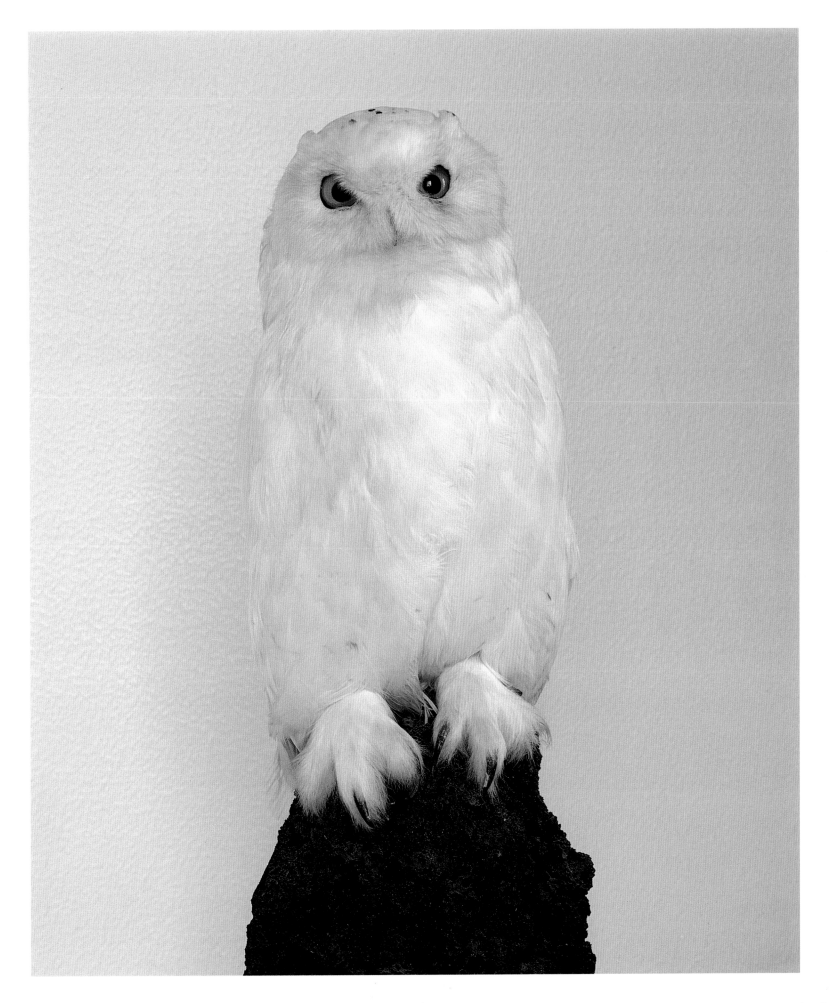

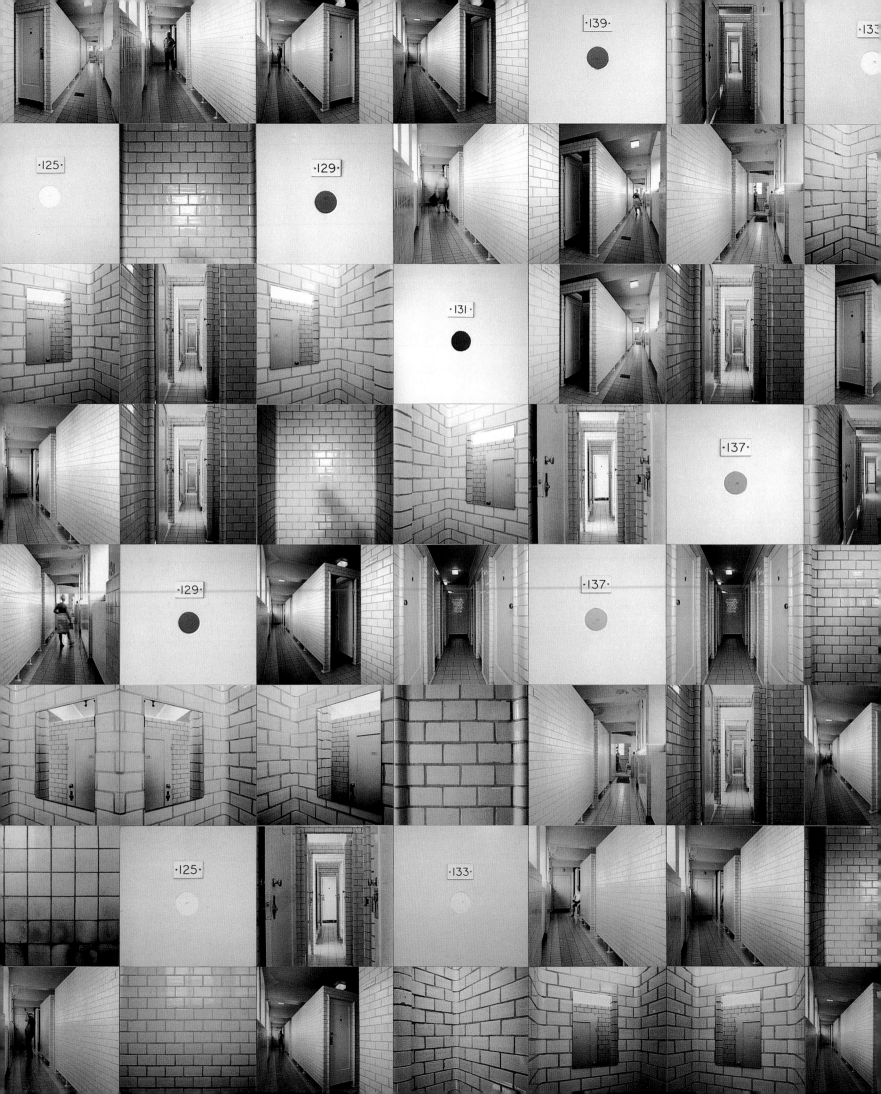

Contents

*'As long as you don't stop there's no getting lost
in the labyrinth, though there is the illusion.
The labyrinth razes all distinction. Disorientation
comes quickly. Your sense of place breaks down.
Your relation to the world beyond becomes tenuous.
The more protracted your journey, the greater the
chance of ambiguity forming about your identity.
Go on long enough and you may lose it altogether.
Go on long enough and you will be fortified,
clarified. It depends on your ability to endure, to
negotiate the tangled, endless web of direction.
As long as you don't stop – stop moving, stop being
present, stop paying attention – you won't get lost.'*
– Roni Horn, 'Island and Labyrinth', 1994

*'I felt my life with both my hands
To see if it was there –
I held my spirit to the Glass,
To prove it possibler – '*
– Emily Dickinson, *No. 351, c.* 1862

'I went looking for myself'
– Heraclitus, Fragment, *c.*500 BC

*'The Baroque refers not to an essence but rather
to an operative function, to a trait. It endlessly
produces folds.'*
– Gilles Deleuze, *The Fold: Leibniz and the
Baroque*, 1988

I

The discrete bodies of work that Roni Horn makes
bear no obvious visual relation to each other;
rather, they appear as monadic, or closed, units
of a common conceptual development.[1] Over the
years her oeuvre has ranged through many
different idioms and materials; it is visually very
broad, at times virtually camouflaged by its own
complexity. In the process of examining things and
events in their essence and mapping the myriad
connections between them, Horn draws out not
a prescribed order or unifying system but rather
a relational history in which 'events' or 'vibrations'
exist in an infinity of harmonics or submultiples,
perpetually moving, metamorphosing, or emigra-
ting from one condition to another. The logic
of her relational history tends to develop out of
a sensible, as opposed to primarily visual realm,
radiating everywhere in the geography of
experience and impugning all manner of fixed
or essentializing identification. Thus, in the
fragmentary totality of Horn's oeuvre, monadic
thinking is tied to the art of displacement and
transformation.[2]

Horn cites her first-hand experience of free
jazz as being particularly instructive to her
working methods and the ever-expanding scope
of her acts in rethinking the phenomenon of the
'point of view': she interprets improvisational
technique as 'the possibility of forming something
out of now and going to the next step with no
other deliberated knowledge, taking into account
of course that you bring your own history to every
now.'[3] In the algorithmic structure of Horn's
oeuvre, the history of which she speaks reveals
itself to be an ongoing search for a singular yet
supple identity in relation to what she perceives
to be a still predominantly androcentric world.
Interpolating the powerful 'masculine' modes of
artistic production – esoteric conceptualism, epic

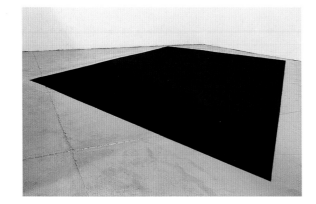

Untitled
1976
Graphite dispersal on floor
No longer extant
Approx. 366 × 488 cm
Installation, studio, Yale School
of Art, New Haven, Connecticut

quest, and literalism – Horn transforms them in a decentred dialectic between the empirical and the circumstantial, the world of atomic dynamics and the experience of events. This provides the framework for her own active pursuit of self-revelation and other subsidiary thematic notions concerning the individual's place in the modern world. 'Androgyny is about inventing an identity through my own life. It is a creative process. I never thought in terms of being an artist; I always thought about the idea of invention, of being connected with the unknown, because I did not respect the options available at the time. There is a relation between androgyny and options.'

II. Preliminary essences

Horn's earliest works already intimated the breadth and diversity of her reach. The first, a series of powdered graphite forms dispersed directly on the floor, were visually stunning and full of illusion, appearing to alter their shape with the viewer's shifting perspective. By making them, Horn quickly learned that to construct a purely visual appearance devoid of physical presence precluded a certain possibility of bodily comprehension and she subsequently abandoned this realm of investigation; the pieces no longer exist.

The untitled coloured glass wedges of 1974–75 are autonomous and non-allusive, each resting on a small shelf above head height, their apexes pointing upward. Horn describes them as 'exercises in self-evidence': their quality is integral. Fascinated by stained glass church windows – both the chemical process of their creation and how they imbue the purely visual phenomenon of

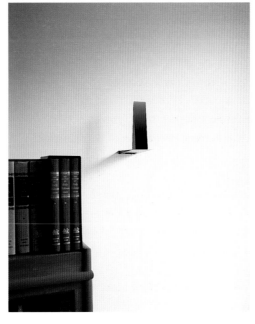
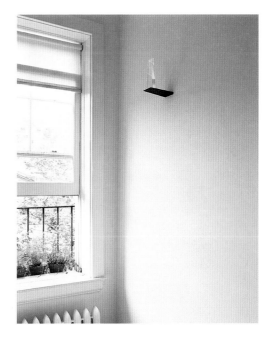
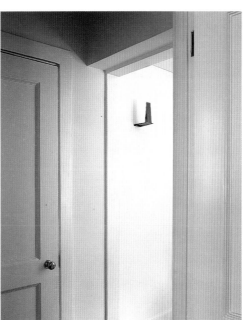

Untitled (details)
1974–75
6 coloured glass wedges, steel shelves; installation for up to 6 rooms
18 × 5 × 3.5 cm each

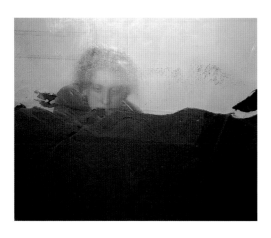

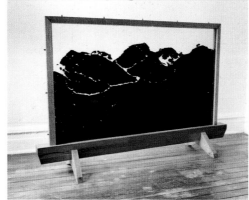

Untitled (Ant Farm)
1975
Wood, glass, earth habitat, living
ants
122 × 183 × 10 cm
Installation/performance, studio,
Providence, Rhode Island

illuminated colour with palpable presence – she
decided to study chemistry at university before
going to art school, learning, among other things,
literally how to make colour in glass. In the glass
wedges, the original connection she made to the
phenomenal presence of stained glass assumes
an integrated physical existence in six chromatic
variations from yellow through red to blue.

During the same period, she made *Untitled (Ant
Farm)*. A photograph shows the young artist
gazing intently through the 'window' provided by
its large glass – a bounded, cross-sectional habitat
analogous to a human community in which the
insect-inhabitants ceaselessly investigate and
reorganize space acccording to their social needs.
In the photograph, Horn is intently observing the
minute goings-on in this artificial, self-sufficient
island. It is our first glimpse of what is to become
her central dialectic concern of exploring the
relations between a viewer and a view. And in turn,
we, as her viewers, witness her first foray into 'the
event of a relation.'⁴

It was at this time, also, that she took her first

trip to Iceland, perhaps drawn by the same elusive
qualities that have impelled so many explorers
northwards before her. This marked the beginning
of what was to become for her a sustained relation
to the northern world's youngest and most volatile
land mass. It would take several years for the first
manifestations of this relation, *Bluff Life* (1982) –
a clutch of thirteen intimate impressions distilled
from over a hundred pencil drawings she made
while living alone in a lighthouse – to appear.
Horn attributes her reticence to express her
responses to this new environment in terms of the
gradual process of acculturation: 'Getting myself
to the point where I could just be some place took
weeks – weeks to arrive, and then to be present
and allow things to gather.'

The discreetly erotic untitled rubber pieces of
1977–78, large black mats placed directly on the
floor, were made of a polysulfide substance similar
to those utilized in aerospace technology. Soft
and heavy enough to assume the structure of what
they rested on so as to be half-object, half-place,
yet too delicate to be interacted with, the sensual
properties of these rubber works could only be
intimated.

In 1980, Horn introduced the notion of
doubling into her work with the *Pair Objects* – pairs
of simple elements placed in such a way as to
define themselves through their similarities and
through their various positions as drawings on
paper or as sculptures in space. Mutually compared
forms and their relation to a comparing viewer
consitute an elementary model situation in what is
now formally known as the field of comparative
studies in which indicated similarities between the

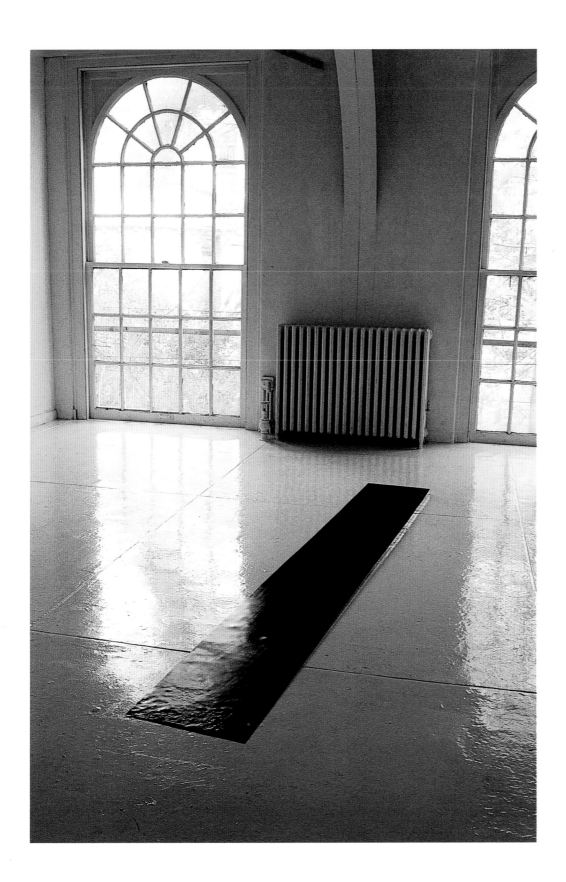

Untitled
1977
Soft rubber wedge
305 × 40.5 × 4 cm
Installation, studio, Yale School
of Art, New Haven, Connecticut

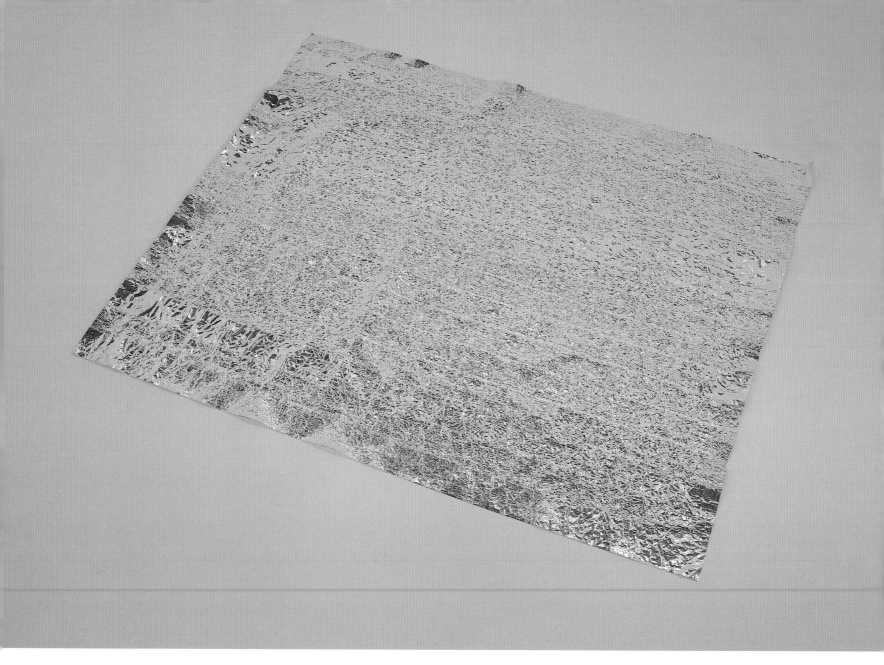

forms prompt the viewer to consider their differences. Likewise, Horn understands the development of the paired form in her work as a method of prompting the viewer to perceive the difference between things. It is in this perception that the experience of difference, and its deeper metaphorical implications with regard to sexuality and androgyny, resides.[5]

Gold Field (1980–82): Trying to reconcile a childhood fascination – the mythical fleece of Jason's quest – with the comparatively disappointing alloyed gold that frequently changed hands in her father's Harlem pawn shop, Horn set out to make a work using pure gold in all its spectacular quiddity. 'I wanted to put the gold out there, self-sufficient, purified to the fullness of what it is and laid out on the floor – not as an accompaniment to some other idea, but just in itself.' Pure gold is extremely malleable; she had it annealed – drawn out – into a single sheet of foil, like solid liquid in its ultimate softness. *Gold Field* is an object without an interior, devoid of image

Gold Field
1980–82
Pure gold (99.99%)
124.5 × 152.5 × 0.002 cm
Installation, The Museum of
Contemporary Art, Los Angeles

and mass. Its appearance is its substance. By considering how gold is located empirically in the world as an inert and finite element, rather than starting from its historical and metaphorical identity, Horn allows associations to gather rather than being imposed (although, I would argue, her conscious decision to render the element as a foil placed on the ground indicates a certain metaphorical realm).

Cobbled Leads (1983) was her first invitation to respond to a specific site – the imposing courtyard of the Glyptothek in Munich designed by Otto Klenze. Observing the architecture to be less about human presence than about the attendant polemical and ideological issues of the neoclassical paradigm, she decided to insert into the courtyard a triangular section of lead cobblestones cast from the original granite ones which she had had removed. The lead insert, weighing 22 tons, was virtually invisible yet perceptible in its greater density and softness which Horn describes so vividly as 'tearing quietly' at the perfect symmetry and scale of the courtyard. 'You walked from the granite and travertine and you hit the lead, and you were on a larger world and in a quieter place – and that's what the work was.'[6] The piece was later destroyed.

In these early works, Horn located the limits of empirical phenomena: 'In recognizing what is there, the experience itself does not reside in that realm. The distinction between the physical reality of looking at the object versus what it is when you walk away from it is a key part of that experience. It is not about attaching representational meaning to the object but rather allowing recognition,

meaning, identity, to gather. It is the idea of letting something be what it is, while at the same time exploring it through specific and subjective conditions of artifice.' Thus, in drawing out a concept of 'higher' realism based in empirical consciousness, exploring the difference between essence and experience and how they inform each other, Horn would proceed beyond the basic tenets of Minimal Art – clarity of idea, precision of means, standardization of elements, and impersonality of statement as exemplified by, say, Judd's 'Specific Objects' or Morris' gestalts or unitary forms – to place her simple, monadic forms in counterpoint with the charged circumstances of metaphor and language.

Years after *Gold Field*'s making, the piece resonated poignantly under the gaze of artist Felix Gonzalez-Torres when he saw it exhibited in Los Angeles in 1990: *'Some people dismiss Roni's work as pure formalism, as if such purity were possible after years of knowing that the act of looking at an object, any object, is transfigured by gender, race, socio-economic class, and sexual orientation. We cannot blame them for the emptiness in which they live, for they cannot see the almost perfect emotions and solutions her objects and writings give us. A place to dream, to regain energy, to dare. Ross [Gonzalez-Torres' partner who was to die of AIDS later that year] and I always talked about this work, how much it affected us. After that, any sunset became "the Gold Field". Roni had named something that had always been there. Now we saw it through her eyes, her imagination.'* (In the same text, Gonzalez-Torres wondered at not having been aware of Horn's work before. His chance encounter

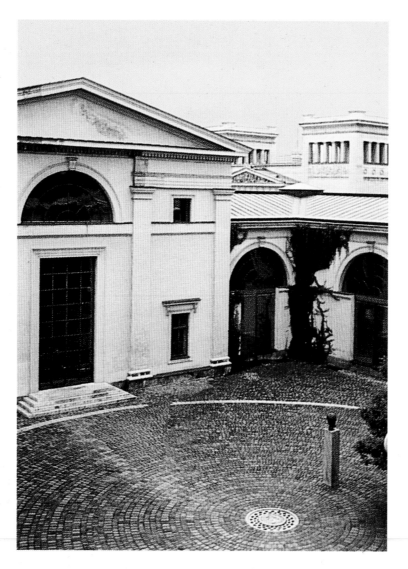

III. Drawing to think

Horn always has a drawing going on in the studio. From the outset, drawing has been a localized form of visual, physical, and mental continuity among her other wide-ranging activities – all of which involve applications of drawing both in terms of literal technique (describing, editing, composing, annealing, distorting, quoting, portraying, designing) and metaphorical extension (inducing, attracting, inferring) to explore the dialectical interaction with a view. Horn describes her daily practice of drawing as 'breathing', inferring an almost yogic dimension in the intense and complete concentration required to establish an identity of consciousness with the object of focus. Reflecting on the connection between air, breath, and life, the Ionian geographer and philosopher Anaximenes (*c.*500 BC) adopted Air as the primary principle.[8] Endowed with the power of movement, air as a vital principle could transform itself into the vast variety of things that make up our world.

In her book of writings on Iceland, *Pooling Waters*, Horn gives palpable form to this idea in the suspenseful text, 'Indoor Water' in which an event of respiration and vision unfolds:

'Water drips from the ceiling into the pool. Each drop echoes loud and resonant in the small concrete chamber. The water is hot and steam fills the air, condensing on the walls and the ceiling. Yellow-green mould grows copiously, encouraged by the vapors of the naturally hot water. The wet room amplifies the sound of my body as I float in the water. My breathing gets loud and louder. I hear it in every part of the room. My breath emanates from the corners, from the ceiling, from the windows.

with *Gold Field* was to mark the beginning of what would become a deep mutual relationship with Horn, both professional and personal, until his own death in 1995.) On seeing the subsequent paired version of *Gold Field*, Gonzalez-Torres responded, '*This time it is two sheets. Two, a number of companionship, of doubled pleasure, a pair, a couple, one on top of the other. Mirroring and emanating light. When Roni showed me this new work [I knew that] there was sweat in between.*'[7] In 1995, Horn dedicated *Gold Mats, Paired* to the memory of Ross and Felix.

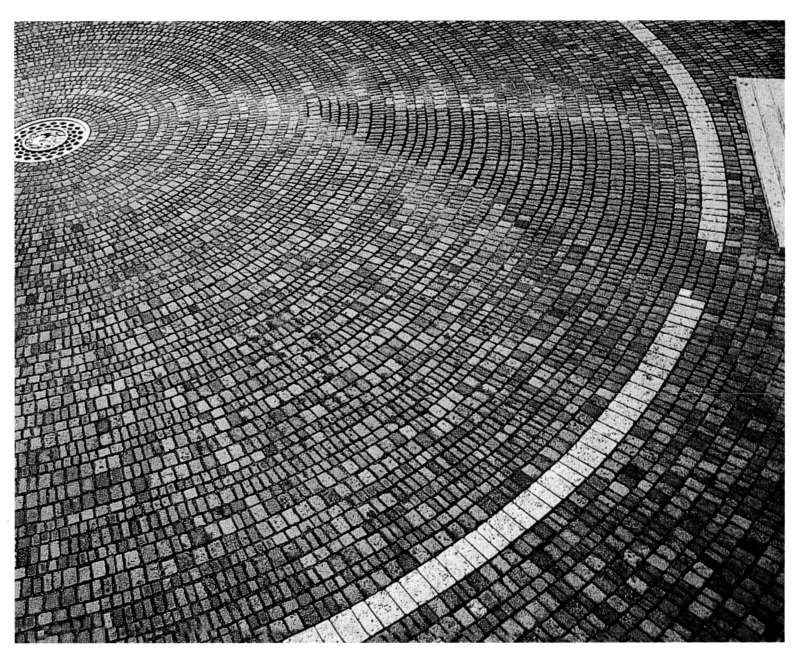

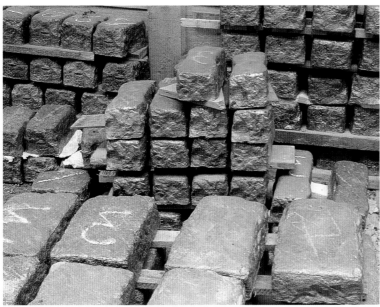

*'It is as though the building is breathing.
The concrete ceiling fills my view. The granules of
cement get large and larger as my vision magnifies,
in imitation of my respiration. The room fills with
loudness. The space is crowded out and the place
shrinks smaller and smaller. I am smothered by the
loudness and largeness of the room. A final kick fills
the air with the crisp smack of water as I pull myself
out and return this room to its essential vacancy.'*[9]

Horn begins a drawing by 'building' elements
of pure pigment on paper. These vary greatly from
solid, geological forms to delicate, linear poles,
open spirals, and ellipses – single, double, or
multiple – and are intensely coloured, almost
inferring temperature.[10] The drawing starts as
a collection of similar small drawings. She then
slices these forms into 'plates' or sections so what
appear to be lines are, in fact, edges indicating
physical and material reality. Horn's drawings are
constructions of space with a clear analogy to
architecture. Starting from a place and moment
bounded by a cardboard masque pinned to the

wall, she begins shifting the plates around in
a manner that at once suggests geological or
tectonic action and modern movement research;
she overlaps the plates then slides them apart,
shifting them, turning them; the composition
changes with every movement. Each physical shift
that occurs and is made visible by her is also
a shift in time, knowledge and experience –
'Each how takes you one step deeper, beyond
appearance, beyond the simple visibility of things.'

In this process, the coloured formations simul-
taneously seek their exact yet changing forms,
their place on the changing fields of paper and,
finally, within the composed field of possibilities.
Horn continues composing until the elements
finally come to rest. At some point, less critical
changes are being made, then virtually no critical
changes are being made; as this point passes, the
drawing nears completion. Horn stops working
on it when there seems to be 'nothing left to do.'
Throughout this process of observing, seeking, and
locating, all traces of her hands working the paper
remain as evidence of the drawing's becoming.
It is at the moment of detecting these traces that
the viewer begins to wonder about how the
drawings are created and a fourth dimension of
space and time opens up.

Interestingly, in recent years the drawings
are becoming more baroque, moving from monadic
forms with simple cuts and displacements
(*Untitled*, 1985) or juxtapositions of two or more
elements (*This 4*, 1986, *Untitled*, 1986, *Untitled*,
1989) into vast fields of complex and highly
articulated activity (*Just IX*, 1992, *That IX*
[*Twinning 2*] 1994). What may begin as a single

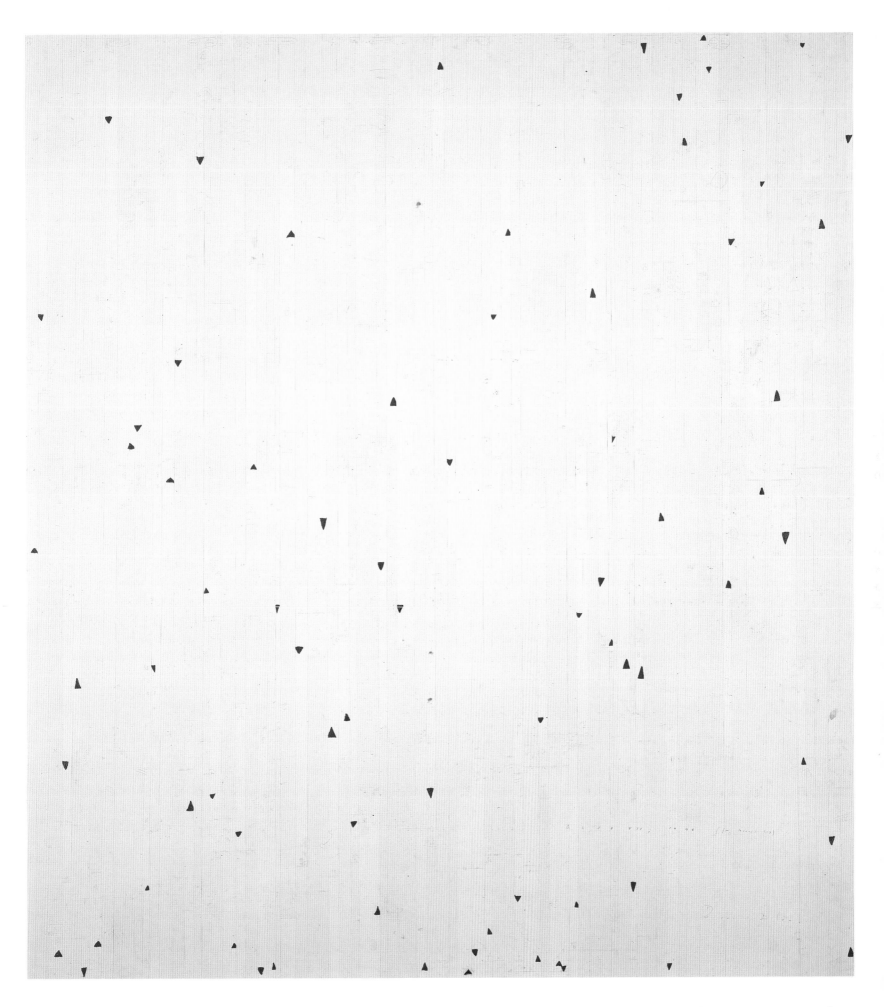

opposite, **The VIII**
1988
Powdered pigment, varnish on
paper
53.5 × 53.5 cm

above, **Also I**
1994
Powdered pigment, varnish on
paper
98.5 × 136.5 cm

From **To Place – Book V: Verne's Journey**
1995
56 pages, 8 duotone, 19 colour reproductions, clothbound
26.5 × 21.5 cm
Edition, Verlag der Buchhandlung Walther König, Cologne
Also **Untitled (Brink of Infinity)**
1995
Offset lithograph
107 × 147.5 cm
Also from **Pooling – You**
1996–97
7 sequenced offset lithographs installed as a surround
42 × 58 cm each

spiral ends up being cut into jarring discontinuity (*Must 7*, 1984–85); or two discrete amber forms are sliced in half and reassembled, each with the other's half cut into close perpendicular relation (*The VIII*, 1988); or strict graphic notations cut into narrow strips are reassembled on the diagonal, charging the composition with a new dynamism (*Just XII*, 1992). For Horn, drawing remains teleological, the most purely visual exercise that she engages in. Rather than drawing being the act of composing an image, it is the act of composure itself, implying a quality of gravity more akin to presence than image, more felt than seen. To gather composure is a deliberate act; it is a process by which one relates oneself to something, becomes present, as opposed to letting things accumulate entropically around oneself. Thus drawing as thinking is an open-ended activity that enables Horn to work as 'a viewer in dialogue with a potential view',[11] using multiple points of entry into the same source to produce different but related contents.

IV. Drawing to build

Intrinsic to Horn's concept and process of drawing is the notion of accruing meaning through gathering.[12] This might entail recording her many impressions of being in a place directly on paper to be later distilled into a succinct graphic essay (*Bluff Life*, 1982); or composing the raw, unedited material of her photographic researches into intense visual 'frequencies' (*You Are the Weather*, 1994–95; *Pi*, 1998); or editing together her own vivid writings and those of her inspirative sources (*Another Water*, 1999). In each case, she is careful to remain alert to the process, keeping her options open until the last moment.

Like the earlier phase of Horn's Icelandic project, *Verne's Journey* (1995), one might imagine that *Pi*, a photographic installation drawn in part from the book *Arctic Circles* (1998), also took its cue from Jules Verne's *Journey to the Centre of the Earth*. In his momentous novel of 1864, Verne trained his imagination to inhabit a place that he had never visited. Verne caught the world's imagination – and Horn's – by charging geography with his own literary imagination, by locating the entrance to the centre of the earth in Iceland. It is not hard to see why Horn might be drawn to the world-view Verne expresses in this novel, concerned as it is with the interaction between people and things, its sheer imaginativeness intensified by an empirical sensitivity to the physical world coupled with a constant interest in the dimensions of inner space. In his introduction to the book, linguist and mathematician William Butcher describes Verne's perspective in terms that are quite appropriate to Horn's own, although the writer and artist are separated by over a century: 'An anthropomorphization of the Earth and a mechanization of the human, with the biological often acting as a go-between; an attempt at sensual "totalization" of the world; a constant scepticism; the undermining by juxtaposition, humour, and irony of any dogmatic view of existence; a metaphorization of everyday objects and ideas, which are often re-metaphorized or even de-metaphorized; a distinctive rhythm, made up of repetitions, silences, minor and major keys, counterpoint, and slow movements leading up to

explosive crescendos; and an innovative narrative technique, whether in the use of tense, person, point of view, voice or structure.'[13]

In a brief passage in the book, Verne describes Iceland's eider harvest whereby the fine down that the female eiders pluck from their own stomachs to line their nests is straightaway 'hunted' by merchants. The nest stolen from under her, the eider is forced to begin again, this time continuing as long as she has any down left. When she is completely bare, it is the male's turn to contribute his. But as the hard, rough feathers of the male have no commercial value, the hunter does not bother to steal his future brood's bed. So the nest is completed; the female lays her eggs; the chicks hatch; and, the following year, the hunting of the eiderdown starts again.[14] What Verne is describing – besides providing an (unwitting) allusion to drawing in the birds' plucking of their own feathers – is nature's ability to respond, in this instance through the use of an ingenious camouflage, to the damaging effects of culture: to reinvent their ecology, to restore balance.

According to Horn, *Pi* started from the idea of trying to photograph something that was invisible. From this impulse grew a collection of circular and

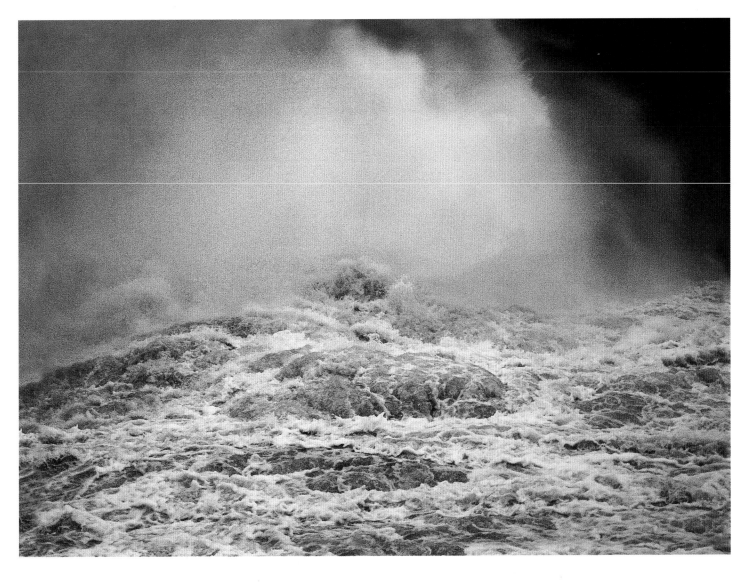

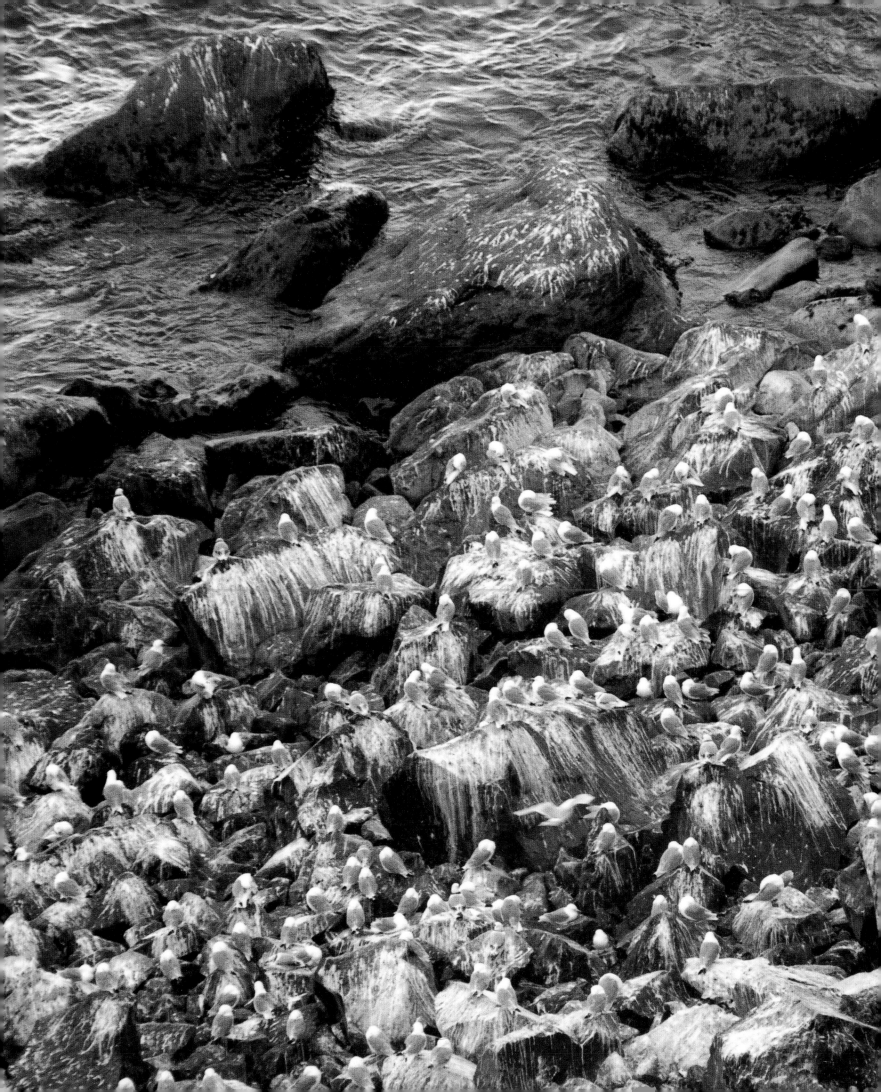

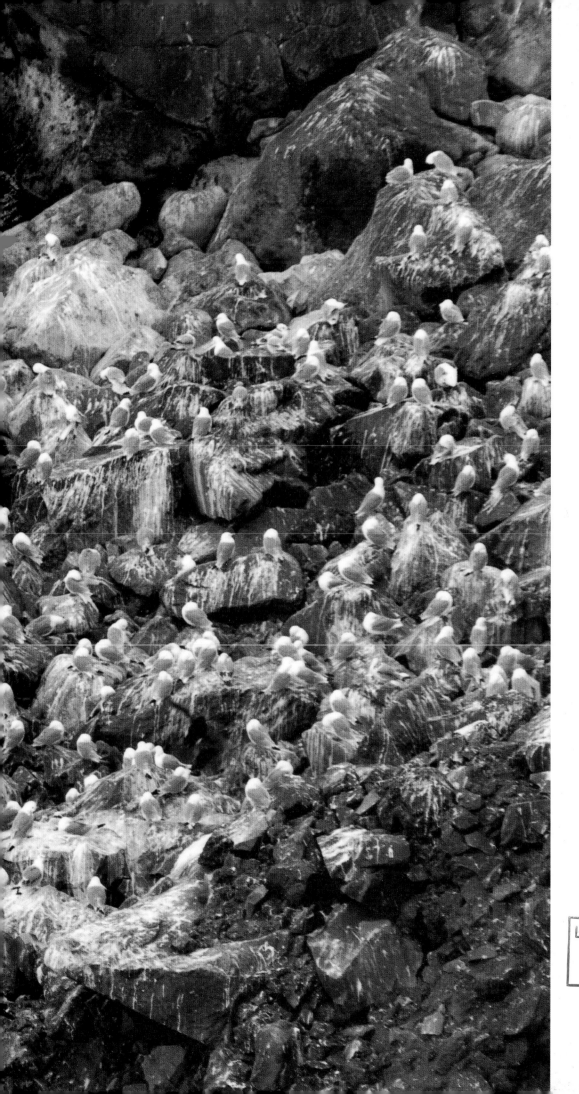

From **Pi** (detail)
1998
Photo installation, 45 Iris printed
colour and black and white
photographs installed on 4 walls
51.5 × 69 cm
Collection, Staatsgalerie
Moderner Kunst, Munich

Also included in **To Place – Book
VII: Arctic Circles**
1998

From **Pi** (details)
1998
Photo installation, 45 Iris printed
colour and black and white
photographs installed on 4 walls
51.5 × 69 cm each
Collection, Staatsgalerie
Moderner Kunst, Munich

cyclical events relating to the ineffable experience of the Arctic Circle. Going to the area of Melraakas- letta situated in the northernmost part of Iceland where the curve of the Arctic Circle is tangential to the island itself, Horn conducted her intensive photographic research of the area's vast and intimate geometries. Between the immense and implacable sweep of the Arctic Circle and the tenuous life-cycle of the eiders, Horn drew out subsidiary themes in the indigenous ecology – taxidermized examples of local fauna; an aged couple; the down harvest and its preparation – weaving them together like the loose, sinuous pattern of the wallpaper that appears as an enlarged detail in the cycle. But it is Horn's final addition of frames from the cheesy American soap opera *Guiding Light*, shot directly off the television screen on location in Iceland – as integral, apparently, to the old people's lives as the ocean which surrounds them or the creatures which sustain their livelihood – that gives *Pi* its edge. Suddenly the stuffed specimens are more to do with the artifice of the soap opera than with the

natural habitat, all foreign interlopers in the local environment; the life-cycle of the eiders becomes more ambiguous; and the images of the old man and woman take on a different, less idealizing quality. Every turn or event adds nuance and recalibrates what came before, thus increasing and charging the possible resonances and permutations of the original idea.

Horn contrasts the clarity and intensity of her direct impressions of daily life on the edge of the Arctic Circle with the static of the received local telecast of *Guiding Light*'s melodrama. As her characteristically incisive editing tells us, the main action of this soap opera turns around a lighthouse, a glamorous, frizzy blonde and a dark, square-jawed hunk. *Pi* brings into sharp relief Horn's wryly humorous apprehension of life in Iceland as a parable of contemporary life on earth, revealing how our depth of experience of nature, even in its most primordial state, is tempered by the mimetic complexities of modern life. Thus, Verne's earlier intimation of the pragmatic balance between nature and culture

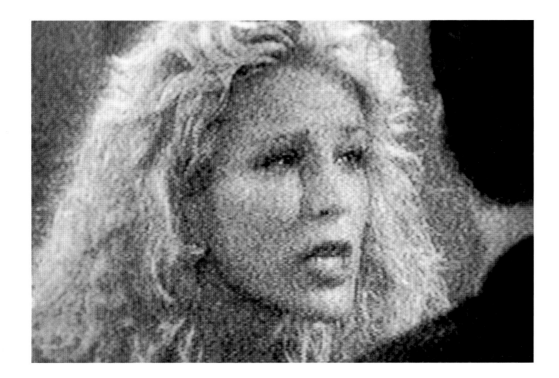

is played out to a fuller degree in the perversity of Horn's modern-day dramatization.

V. Drawing to dwell

Horn's intense, dialogic imagination (a term used by Mikhail Bakhtin in his theorizing of the novelistic form in literature to describe the active relation between a novelist and the history of writing)[15] draws precisely, deliberately from many literary sources, whether as inspiration – as in the case of Verne – or as direct, fragmentary quotation. Most of the Greek philosophical texts as we know them today survive only in 'fragments', the collective term given to quotations preserved in later writings. Although these texts may be only a small proportion of the originals, they gain in significance because they tend to illustrate the more striking or novel aspects of their author's thoughts.[16] In quoting directly from the writings of Dickinson, Kafka, Weil, and others, then transposing their words – their receptacles of experience – into durable industrial materials, and presenting these sculptural embodiments in the three- dimensional matrix of architectural space, Horn invites the viewer to actively inhabit a new archaeology of modern fragments.

'I don't make a clear distinction between the verbal and the visual; the verbal is analogous to the visual. The verbal is a complex source for me.' In secular Jewish culture, special emphasis is placed on language and pedagogy and its attendant forms of knowledge. Growing up in proximity to a tradition which disallowed the expressive potential of the visual forms might partly account for Horn's motivation to imbue linguistic form with the dimensions of physical experience. She interacts creatively with her sources, excerpting from them, alluding to them by way of dedication, emulating them – instrumentalizing or inhabiting them to serve the requirements of her vision and bring them into the space of her desire. Dickinson's illuminating flashes of consciousness; Wallace Stevens' invocations of presence through shared perception; Weil's ascetic fervours; Verne's metaphorical sagas in empirical existence: What are the common threads linking these subjects of

Gurgles, Sucks, Echoes
1993
Gouache on paper
25.5 × 20.5 cm

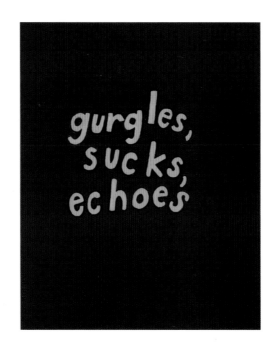

Horn's admiration? They are all startlingly modern in their use of self-awareness at all levels to create self-reflexive structures; they impress a definite and vivid sense of time and place – sometimes with the journey a central element – whether experienced or imagined; they intimate intense emotion but with a strong reserve; they acknowledge the necessity of inventing solitude in the active search for inner expressiveness; and, most importantly, they communicate what it is to pay attention to the world, to inhabit it imaginatively in a charged and meaningful way.

In the elemental vastness of Iceland, Horn began to explore the possibility of rendering language graphically as objects or views, like landscapes. Drawings inspired by her acute awareness of her environment such as *Elements of*

Solitude (1984) or *Gurgles, Sucks, Echoes* (1993) – in which lumpen, childishly rendered words assume almost onomatopoeic weight against dense black grounds – are thus windows onto another, interior, reality. '*When you collect these words together, you go somewhere where, in a sense, they don't exist; the physical reality of where you started falls away and you enter this space which is in you, completely so, much more so than with any overtly visual object. Because you have to be more active in the process of getting to that place.*' That place and the dynamics of getting to it were later materialized in *Kafka's Palindrome* (1991–94) – a milled aluminium slab around the edge of which are inserted lines of cast black plastic text reading IT WOULD BE ENOUGH TO CONSIDER THE SPOT WHERE I AM AS SOME OTHER SPOT. The viewer must walk around the slab in order to read the text, and in doing so, discovers this passage of circumscription to be the very meaning and constant of the work.

In the *Key and Cue* series (1994), notably the only series of sculptures Horn intended specifically for domestic settings 'to function with the pragmatic value of furniture', she used the first lines of poems in Dickinson's oeuvre – CRISIS IS A HAIR, THE BRAIN IS WIDER THAN THE SKY, FAME IS A BEE, selected for their synecdochal (and, it would seem, syncretic) force. Removing each line both from its position within the poem and from the discrete form and experience of the book containing the poems, she then cast them in black plastic and embedded them in slender aluminium rods to be propped against the wall. In doing so, Horn relocates these rather startling poetic facts in direct physical relationship with the

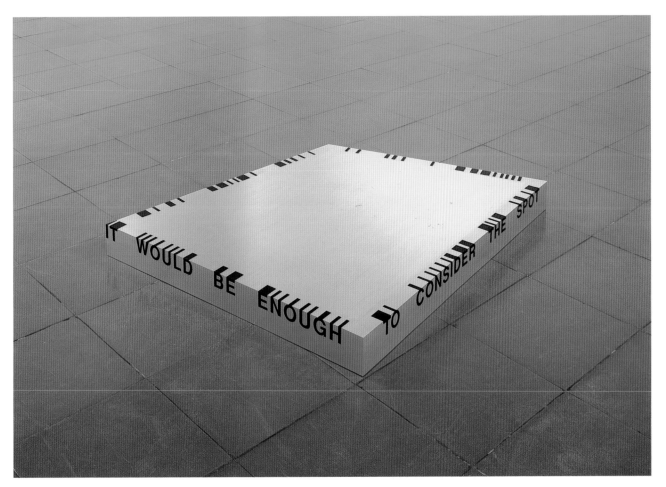

Kafka's Palindrome (also **Thicket No. 3**)
1991–94
Solid aluminium, plastic
11 × 124.5 × 102 × 91.5 cm
Installation, Mary Boone Gallery, New York
Collections, Baltimore Museum of Art, Baltimore; De Pont Foundation for Contemporary Art, Tilburg, The Netherlands

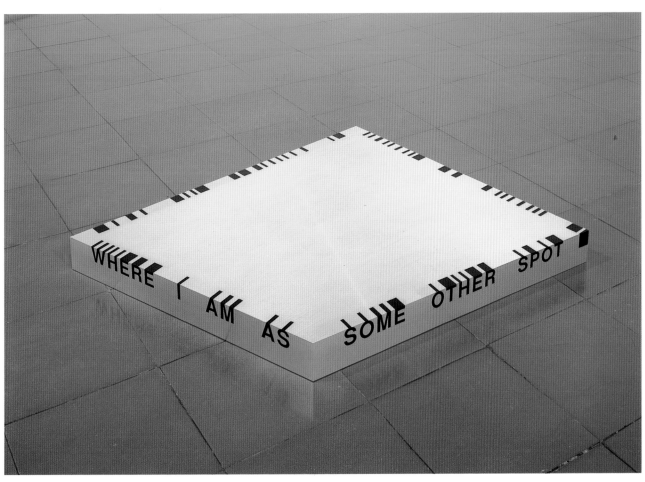

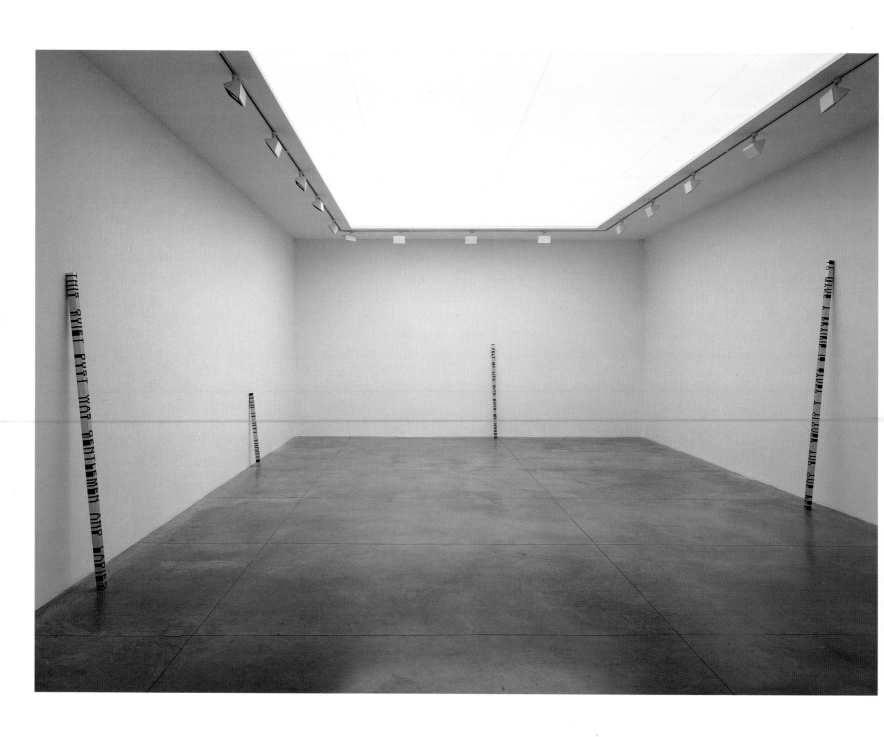

Key and Cues
1994
Solid aluminium, plastic
Series of works, each 5 × 5 cm by
variable length
Installation, Galerie Xavier
Hufkens, Brussels, 1998

mundane world and, as the title of the series suggests, in a performative relationship with the viewer. Dickinson's language is accorded the same materiality as the wall and floor that surround it but with a major distinction: during the viewing process the words act as a Möbius strip between physical reality and individual consciousness and in doing so access a completely different place in the world – the interior reality of the viewer.

In her assiduous study of Dickinson's work – both her poetry and her letters – Horn has found the closest precedent for her own sense of language as a material entity in itself, as an embodiment of a physical, as well as conceptual, relationship to the experience of things. Horn relates the way she uses language three-dimensionally to the way Emily Dickinson used nouns and verbs and adjectives in her singular modern style. In reading Dickinson's poetry, one sublimates it, senses it, connects with it before understanding it. Similarly, the *Key and Cue* series are conceptual works addressing a physical presence: As their name suggests, they are, literally, prompts for the viewer to recollect that bigger world beyond the personal, to recognize things that may lie outside the realm of one's current personal experience yet which seem familiar: they are windows which connect conscious thought with bodily knowledge.

VI. Drawing to pair

The poetry of Wallace Stevens, with its constant evocation of the shared dialogic process that exists within experience and produces meaning, has also left a deep impression on Horn's praxis. Horn once recited to me by heart the following lines from Stevens' veiled lovers' discourse, 'Bouquet of Roses in Sunlight' to convey precisely her understanding of the social relationship implicit in perceiving reality.

*'We are two that use these roses as we are,
In seeing them. This is what makes them seem
So far beyond the rhetorician's touch.'*[17]

But there is another poem by Stevens, 'Study of Two Pears', that is of even greater relevance to Horn's concept of 'pairing', as she commonly refers to her pervasive use of doubling in the graphic, photographic and sculptural work. In his precise reverie on the presence of two pears on a green cloth, Stevens discloses the paradox of perception – the very condition of impossibility, despite the perspicacity of empirical description, of representing the objects of one's perception in their full relational quiddity.

As with all areas of her artistic investigation, Horn's original concept of paired objects has continued to develop and proliferate in many different directions, charged with the expressive potential of each circumstance. In *Piece for Two Rooms* (1986), two truncated copper cones – their forged, machined curves and tapered ends inferring dynamic potential – are placed separately on the floor in two adjoining rooms. Entering the first room, the viewer immediately identifies the solitary, self-sufficient object, perhaps walking up to it and around it to take in its three-dimensional solidity and position in the space; proceeding to the next room, she or he encounters a second

object, identical to the first except for its positioning within the room. Intrigued, perhaps suspicious, that there is some sleight-of-hand at play, she or he might walk back and forth between the rooms, as if to verify the experience of déja-vu – or just leave, satisfied at having apprehended the repeat experience in a quick take.

In this case the viewer would be mistaken, for the experience of *Piece for Two Rooms* is not repetitive but cumulative. The viewer's experience of the first room is totally unprecedented, therefore the subsequent experience of the second room cannot have the same anticipatory edge. In the passage from room to room, one is surrounded by nothing but space itself and is therefore tied to the memory of what one has just seen and the anticipation of what one will see. In this interstitial space resides not redundancy but accumulation, a non-visual experience which serves to amplify the form of the relation itself and expand it in a very powerful way.) In the years immediately following the making of this work, Horn would continue her investigations into this phenomenon of relation, using the same machined copper objects to produce three successive works, *A Here and A There*, *A This and A That*, and *Things That Are Near*, which, upon completion, she collectively entitled *Things That Happen Again*.

This project reaches new heights of baroque complexity with the sculptural topography of *Pair*

The Odd Morphology of the Asphere
1988
Watercolour, graphite on paper
50 × 43 cm
Working drawing

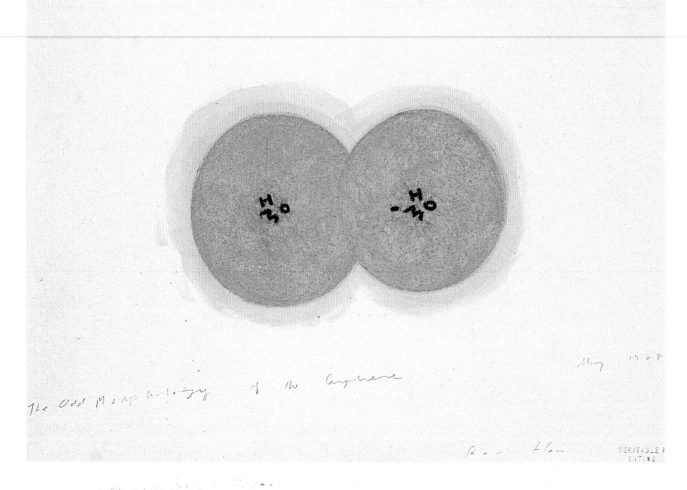

Field (1990–91), in which eighteen unique pairs of forged copper and stainless steel geometric forms – compressed spheres, truncated cones and swollen cylinders – are dispersed in two adjoining rooms of different dimensions. But in this instance, as the viewer moves from one room to the other, something more important is happening than a mere multiplication of his or her experience within the frame of repetition previously established by the *Pair Objects*. By complicating exponentially the formal elements between and across the fields of the viewer's perception, Horn is multiplying the dialectical paradigm to suggest the more open-ended notion of intersubjectivity that is the basis and meaning of her oeuvre – that her subjects and relations offer many different points of entry and therefore actively engage the viewer in a multiplicity of interpretations and meanings.

VII. Drawing to give material presence to

Throughout his oeuvre, Wallace Stevens insists on the primacy of actual experience, the 'sense which exceeds all metaphor.'[18] Like Stevens, like Dickinson, Horn repeatedly asserts in her work that attention is basic to human perception; it is evidence of an individual 'taking responsibility for being there, for being active'. Obviously, empiricism as a more general way of collecting experience or knowledge is of enormous appeal to Horn, in terms of how a viewer might enter a work. *'You walk into the room unquestioning. You take responsibility for being there. In the end I am not interested in what the viewer knows about my intentionality or identity. I am trying to make the work and one's experience of it the same.'*

All of Horn's work has a deceptive simplicity. But it is only when one starts enquiring about the 'how' that the deeper complexities of each piece begin to reveal themselves. Horn has stated that she is not interested in technical extremity for its own sake, but finds herself 'in that place' repeatedly. Whether a drawing, a book or a sculpture, each work is 'in itself': the surface is always confluent with its interior. Using complex industrial applications and precision-machine processes reflects a certain desire on Horn's part for detachment, although of course she does not exclude the possibility of working directly, as in drawing. How she chooses to work is to do with what she wants her precise relationship to that subject to be.

Lava (1992), the third volume in *To Place*, is a 'natural history' in book form of the igneous rock that covers most of Iceland. Along with the thermal waters, lava is the most visible evidence of the landscape's youth and volatility. In the course of her exploratory travelling throughout the island between 1979 and 1991, Horn gathered fragments of lava from the vast fields of the volcanic systems that denote the island's topography. In the book – which is printed in tritone for utmost graphic depth and clarity – the fragments are photographically reproduced to actual size and suspended in the otherwise completely empty pages, like meteorites falling. This treatment also foregrounds lava's astonishing anatomical consistency, which ranges from porous, sponge-like forms and crystalline shards to sections ressembling ancient, sinewy flesh and wrinkled hide. Leafing through the pages of *Lava*, one has the impression of being on a strange journey where the here and now is

Asphere
1986–93
Solid steel sphere, distorted
slightly and in varying degree in
each hemisphere
ø 30 cm by variable diameter
From the series of unique works
Installation, De Pont Foundation
for Contemporary Art, Tilburg, the
Netherlands
Collections, Boston Museum of
Fine Arts; Kunstmuseum
Winterthur, Switzerland

captured in a texture of timeless, (extra)terrestrial events.

For *Pair Object*, a piece designed to invoke the viewer's experience of engaged memory, machine technology is employed to create duplicate objects with a self-evident quality. Regarding *Piece for Two Rooms*, Horn suggests that 'any doubt about the solidity of the objects on the part of the viewer reveals an inability to be self-reliant in the face of the experience.' The large copper objects are forged; there is no way that they could be made hollow; also, forging purifies the mass of a substance. With the *Key and Cues*, the concern was more to make the presence of language palpable therefore aluminium, a soft, light metal, is a perfect vehicle for the cast plastic letters, possessing enough substance to provide structure without the dogmatic qualities of heavier metals.

Although Horn never actively works with images in her three-dimensional work, she was drawn to photography – partly inspired by the iconic power of Warhol's multiple silkscreened portraits of Mao Tse-Tung from the 1970s – to see whether she could evince from this graphic medium the condensed presence of a physical thing. But rather than relying on the sheer power of repetition with variation as a cosmetically applied after-effect, as in Warhol's numerous portrait series, Horn builds the physicality of her portraits through the seemingly inexhaustible circumstantial variations that emerge in her close and protracted scrutiny of her subjects. *Haraldsdóttir* (1996) is a book containing a series of lifesize head-shots of a young woman over ninety pages. Its title – the woman's own surname

– and the visible traces of the vaporous environment in which she is situated (which on first viewing might well be mistaken for vagaries of the development process) – identify it as being in Iceland. The woman's aura of self-sufficiency is as primordial and elemental in feel as the natural environment in which the shoot has taken place. This portrait also manifests as *You Are the Weather* (1994–95) – a photographic frieze installed so that the woman's eyes meet and hold those of the viewer – equally compelling in its vividness, gravity and candour. The directness and attentiveness of her gaze, in which is captured all expressive and environmental nuances of the moment, reflects Horn's own concentrated process of confronting and revealing what is present.

The *Asphere* (1986–93) like the mysterious entity in Jorge Luis Borges' story 'The Aleph', entails a knowledge which slowly unfolds in direct proportion to the time dedicated to its contemplation, as opposed to being revealed in the instant of looking. It is a key piece in Horn's oeuvre – not least because she refers to it as a private form of self-portrait – because of how one's knowledge of experience, of the relationship between the sensible and the palpable and actual, physical reality, evolves and accumulates solely through the act of perception. *Asphere*'s object-credibility depends both upon its material – steel, for its unobtrusive and enigmatic quality – and upon the mechanistic precision with which the material is worked to produce a sphere enlarged in one dimension to the point where it is just perceptible. Subtly distorting the most universally understood symbol of perfection and wholeness

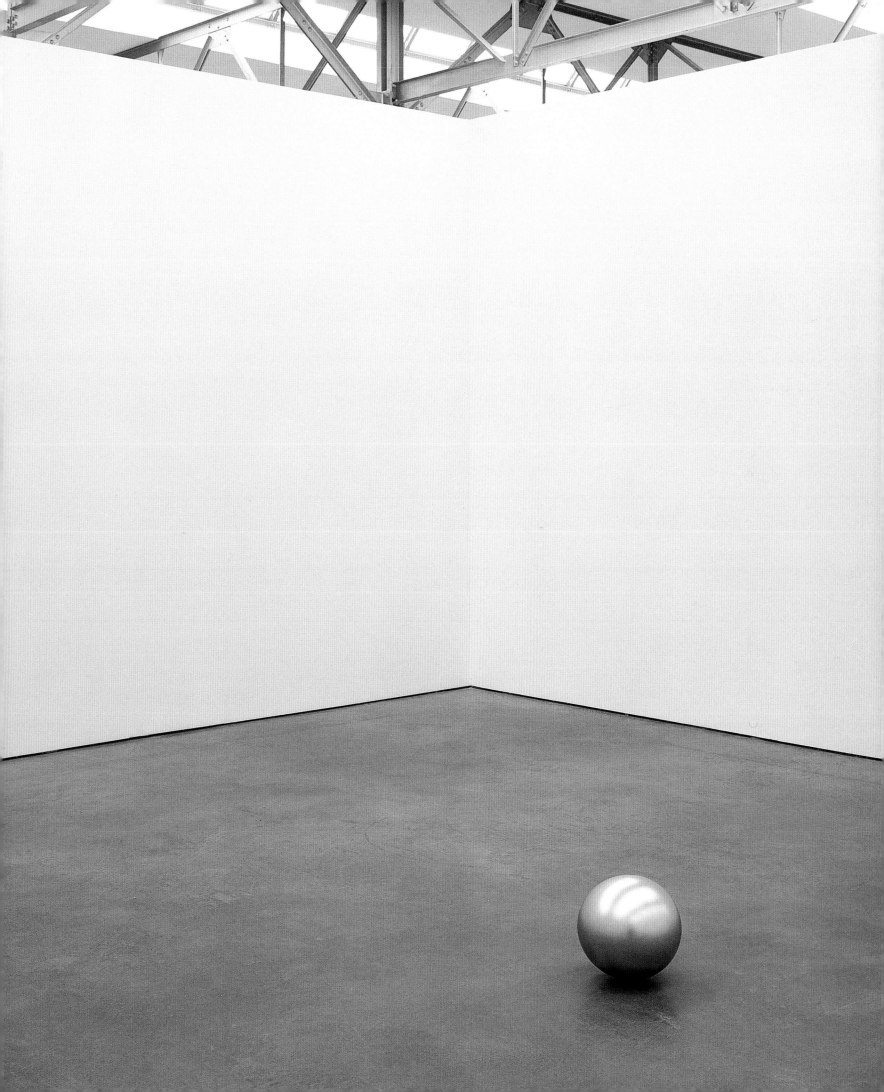

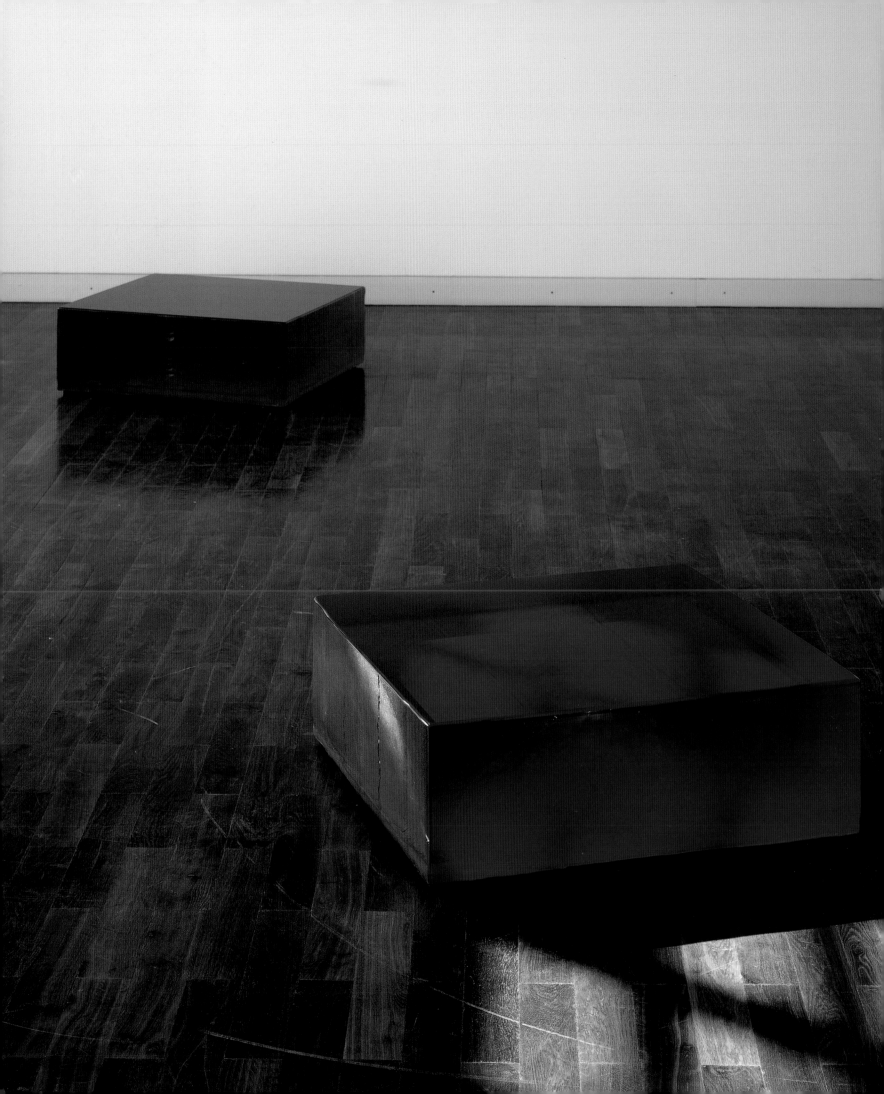

by introducing a subversive, decentring element into its essential geometry – and thereby challenging an entire mainstream history – *Asphere*'s difference is, therefore, the literal and metaphorical source of its identity.

Untitled (Flannery) (1997) a rare and gorgeous piece comprising two elements of solid, deep blue glass, also yields the conditions of its construction on careful scrutiny. Each block of glass is contained on five sides by a cast surface, which can be identified as such because the surface is uneven and its quality variable where the piece has picked up traces of contact with the mould. The upper surface, which was not in contact with the mould during casting, is fire-polished as the hot vitreous liquid cools, meaning that the transparency of the upper surface – its 'window' – is an organic condition of glass just as the translucency of the sides is the direct precipitate of the casting process. In other words, its spectacular yet subtle beauty is achieved totally within the integrity of the process itself.

VIII. Drawing to explore

The earliest known philosophers were the Ionian geographers. Anaximander (600 BC) invented terms such as *apeiron* to describe the boundless and unlimited stuff of the universe.[19] The processes by which explorers mapped the the unknown world aimed to give coordinates and edges to such boundless concepts. In drawing a map, the cartographer would actually move the calibrating measures to determine where he was on the paper, his place in the world and thus his identity. For Roni Horn, drawing is similarly a crucial act of

self-determination; she can only be in the place of its process as who she 'is'. But in her drawings she thwarts the cartographer's established certainty in the dynamic relationship enacted between edge and centre. What starts out at the centre may end up being displaced to the peripheries by slicing and shifting; in this self-evident process she thus plays out an exemplary metaphor of our time: the compounding of identity. It may have been the revelatory nature of these explorations on paper that impelled Horn to seek an analogous process in a real environment.

Just as sculptural materials present their integrity to Horn, so did Iceland suggest an obvious potential. Topographically Iceland is baroque, an entity that Horn describes as 'an act, not an object, a verb, never a noun.'[20] *'It is both an idiom and a material to manipulate. This is how you can imagine identity.'* Concurs pop iconoclast Björk on being Icelandic, 'It's about inventing your own roots.'[21] Thus the 'solid pleats'[22] of Iceland's natural geography have become another plastic element in Horn's syntax. It is a land mass in a state of perpetual and dramatic becoming, with little vegetation to obscure the extraordinary facts of its volcanic identity and, to date, insufficient inhabitants to have significantly compromised its natural state; its weather conditions are extreme, but its environment is otherwise benign; its inhabitants are a homogenic community of people who prize the qualities of independence and individuality.[23] It is this aggregate of inherent characteristics which provides Horn with 'a vivid feeling and connection to the place and what lies beyond it', and an ongoing desire to be a viewer

Untitled (Flannery)
1997
Solid glass
2 paired units, 28 × 84 × 84 cm each
Installation, Ludwig Forum für Internationale Kunst, Aachen
Collection, Solomon R. Guggenheim Museum, New York

To Place
Ongoing series of publications
Clothbound, 26.5 × 21.5 cm each
Book covers

Book I: Bluff Life
1990
36 pages, 14 colour reproductions
Edition, Peter Blum, New York

Book II: Folds
1991
72 pages, 34 colour
reproductions, letterpress text
Edition, Mary Boone Gallery, New
York

Book III: Lava
1992
96 pages, 16 colour, 29 tritone
reproductions, letterpress text
Edition, the artist, New York

Book IV: Pooling Waters (Two
volume set)
1994
Volume I
96 pages, 27 colour, 25 duotone
reproductions
Volume II
176 pages, 36 texts, 1 colour, 3
duotone reproductions
Edition, Verlag der Buchhandlung
Walther König, Cologne

Book V: Verne's Journey
1995
56 pages, 8 duotone, 19 colour
reproductions
Edition, Verlag der Buchhandlung
Walther König, Cologne

Book VI: Haraldsdóttir
1996
96 pages, 30 colour, 31 duotone
reproductions
Edition, Ginny Williams, Denver

(not reproduced) **Book VII: Arctic
Circles**
1998
136 pages, 65 colour, 7 duotone
reproductions
Edition, Ginny Williams, Denver

in the presence of a constantly changing and deeply compelling view.

Returning regularly to Iceland for protracted periods, Horn has evolved her own artistic process of 'eversion' – the complex topological process of turning a body inside out.[24] In order to record and distil what is essential to her experience of Iceland's uniqueness – the impassiveness of an island bluff; the vernacular ingenuity of sheep folds; the strange, lunar quality of volcanic lava fragments; the exuberant thermal waters; the highly suggestive natural topography of Snaefells, Verne's entrance to the centre of the earth; the monadic local people; the ecological equilibrium – she relies on intimate graphic methods: direct and impressionistic sketches, writing, and photography. In searching for the means by which to express the potential magnitude of her investigations, she has evolved her own form of saga.[25] The result is an ongoing collection of magnificent, self-published books entitled *To Place* – which to date numbers seven volumes, *Bluff Life* (1990); *Folds* (1991); *Lava* (1992); *Pooling Waters I* and *II* (1994); *Verne's Journey* (1995); *Haraldsdóttir* (1996); *Arctic Circles* (1998) – and some related photographic cycles – *Pooling – You* (1996–97), *You Are the Weather* (1994–95) and *Pi* (1998).

'I don't want to read. I don't want to write. I don't want to do anything but be here. Doing something will take me away from being here. I want to make being here enough. Maybe it's already enough. I won't have to invent enough. I'll be here and I won't do anything and this place will be here, but I won't do anything to it. I'll just let it be here. And maybe because I am here and because the me in what's here makes what's here different, maybe that will be enough, maybe that will be what I am after. But I'm not sure. I'm not sure that I'll be able to perceive the difference. How will I perceive it? I need to find a way to make myself absolutely not here but still able to be here to know the difference. I need to experience the difference between being here and not changing here, and being here and changing here.*

'I set up camp early for the night. It's a beautiful, unlikely evening after a long, rainy day. I put my tent down in an El Greco landscape: the velvet greens, the mottled purples, the rocky stubble.*

'But El Greco changes here, he makes being here not enough. I am here and I can't be here without El Greco. I just can't leave here alone'.[26]

In 'Making Being Here Enough', one of the

many entries in Horn's ongoing journal of island experience, she evokes the crux of her investigation into the paradox of modern existence: whether, with our cultural conditioning, it is indeed possible for us to experience the nature of things in themselves.

If we accept the claim of the metaphorical empiricist Georges Perec, that the earth itself is 'a form or writing, a geography of which we had forgotten that we ourselves are the authors ... ',[27] then *To Place* takes the form of an extended open journal. This journal is not an objective slice through geographical reality but rather a critical equivalent of Horn's spatial experience. When Horn describes Iceland, she is not just describing the country or her own state of mind, but the process of exploring itself. She does not simply transcribe her notes made in the field. She writes them up, overlaying the bare data with descriptive detail, with rhetorical asides and philosophical interludes. She transforms her disconnected notes into the connected narrative of the path:

'A path. Drive it, walk it, take it to be somewhere. When you're on a path, you're in the place you're in. There's no distinction between the path and the place itself ... Sometimes a path

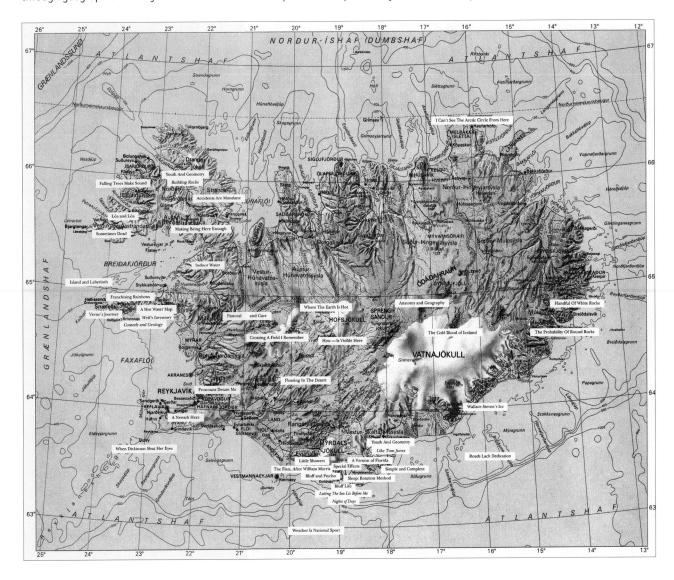

From **To Place – Book IV: Pooling Waters** (detail)
1994
Volume II
176 pages, 36 texts, 1 colour, 3 duotone reproductions, clothbound
26.5 × 21.5 cm
Edition, Verlag der Buchhandlung Walther König, Cologne

is nothing but an indication on a map, the reality having been blown or washed away ... The path can only be where it is and nowhere else: the path is dedicated.'[28]

This process of drawing a sense of unity and purpose out of the bare succession of events depends on Horn's ability to express her experiences metaphorically rather than literally, to amplify them in order to preserve their original spatial occasion – as can be seen in the drawing that appears in the second volume of *Pooling Waters* (see this volume, page 59) a palimpsest in which the titles of her entries are inscribed on the original map of Iceland. The landscape that is presented here is not a physical object as much as it is an object of Horn's desire; the basis of her interest in the landscape is not objectively empirical, but rather grounded in the recognition that she observes the world not through a window (or, in this case, the camera's lens) but by inhabiting it. It is almost as if her personality emerges in the difference between the country as it is and the country as she reports it to be. Like Verne, like Dickinson, Horn consciously evolves her identity through travelling a terrain – through telling it and representing it to herself – as a metaphor of the self.

By situating herself exploratorily in Iceland, Horn situates Iceland in her experience. This is why *To Place* must be a long and open-ended, perhaps endless, project; a form of existential psychoanalysis in which she recounts her activities and feelings to an unyielding constant, where she is thrown back on her own resources of cause and effect. 'The desert interior of Iceland is so

dogmatic and separate and self-contained that you really get an idea of your own limitations very quickly. And that is a very interesting experience. It is enlightening because it is so threatening.' This perpetual process of self-realization is Horn's ultimate meaning of 'to place.'

To be an explorer is to inhabit a world of potential objects with which one carries on an imaginary dialogue.[29] The explorer's space and time is of an active nature in which the process of exploration, rather than the fruits of travel, becomes history. In the explorer's journal what matters, then, is less the discoveries it contains than the quality of the travelling it reveals. For Horn, travelling itself is knowledge; it lays stress on her active engagement with her environment, recognizing phenomena as the results of her intention to explore. In the process of exploring, Horn finds blank spaces, gaps in her outline, which are as informative as the line itself. What Horn's drawing – and here I infer her oeuvre as a whole – reveals is that the quality of the travelling, her *geo-graphy* or spatial writing, is inseparable from the conditions of the enquiry itself. It does not seek to describe the appearance of natural objects as much as to preserve the trace of encountering them. It is designed to record particular information as a palimpsest of her experience, a crisscross of routes gradually thickening and congealing into a relation of fixed forms and grounds.

Horn's relational history of places recognizes that life, as it discloses itself spatially, is dynamic. Like the infinite possible worlds of Leibniz' early Enlightenment philosophy, it designates horizons and objects in order to imagine others beyond

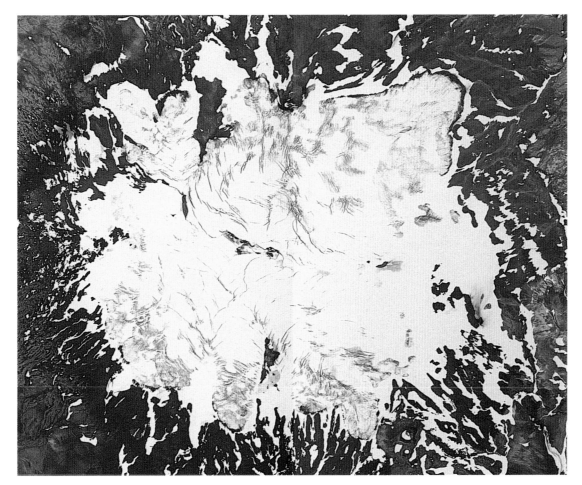

From **To Place – Book V: Verne's Journey**
1995
56 pages, 8 duotone, 19 colour
reproductions, clothbound
26.5 × 21.5 cm
Edition, Verlag der Buchhandlung
Walther König, Cologne

top, Also **Universal Rorschach**
1997
Photogravure
68.5 × 55.5 cm

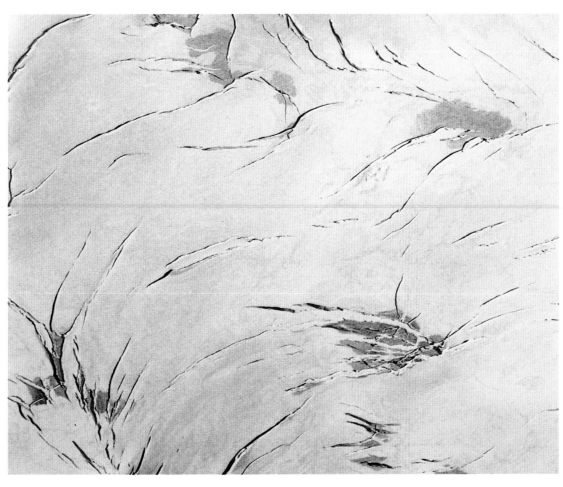

From **To Place – Book V: Verne's Journey**
1995
56 pages, 8 duotone, 19 colour
reproductions, clothbound
26.5 × 21.5 cm
Edition, Verlag der Buchhandlung
Walther König, Cologne

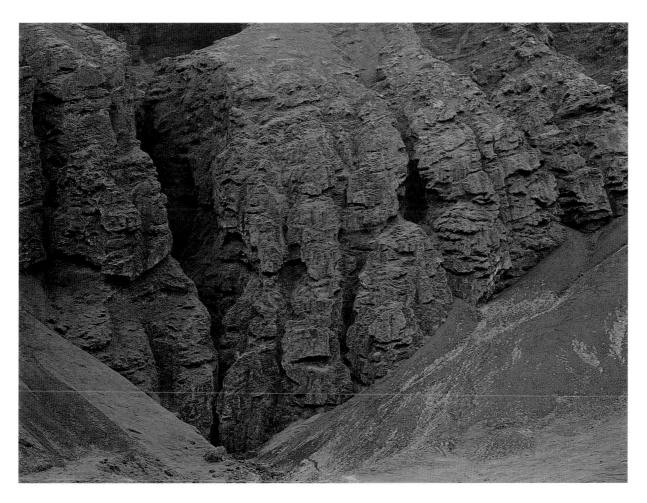

You Are the Weather – Munich
(details)
1995–97
Rubber floor, 37 handrail inserts,
solid cast urethane plastic
Floor, 60 m²
Depth 3 cm
Permanent installation, German
Meteorological Bureau, Munich

them. Thus Horn defines place not as a fixed location but as a 'condensation of acts.'[30] Moving in a world of language, proceeding within a cultural network of names, allusions, puns and coincidence, gives her conceptual space in which to act, both literally and metaphorically. In naming *Untitled (Flannery)*, she pairs the general with the specific, intimating the coexistence in her work of impersonal detachment and a more felt contemporary subjectivity, in this case her admiration of the Southern writer, Flannery O'Connor.[31] Like the work of O'Connor, the mesmerizing blue depths of Horn's *Untitled (Flannery)* suggest an elemental condensation of metaphysical, psychological, and corporeal meaning.[32] This, together with the fact of the piece's paired forms, creates a passage of space and time through which the engaged viewer accesses another, unspecified place.

With the photographic installation *Pi*, the experiential dimensions proliferate first on the linguistic front. Phonetically, the title conjures the idea of a pie, a circle divided into sections – a ready analogy to the place of this work within a larger opus; or the Greek letter π indicating 'twoness', a central preoccupation in Horn's dialectical project; or in geometry, the symbol representing the constant of the ratio of the circumference of a circle to its diameter. In the installation itself, a cycle of lush, photographic prints on uncoated paper is installed above head height on the four walls to force a certain perspective, enabling a clear view of the whole work from any vantage point. Here, Horn's previous references to Dickinson's notion of

circumference as a sculptural embodiment – MY BUSINESS IS CIRCUMFERENCE, the text for the sculptural installation *How Dickinson Stayed Home*, (1992–93), and an inspiration for her own writings ('When Dickinson Shut Her Eyes – I go to Iceland' in *Pooling Waters II*) – is released into the space of geometry itself. Horn, as it were, plays diameter to Dickinson's circumference, thus materializing for the viewer, in this moment of spatial experience, the constant of her artistic relationship to the poet's work. This, in turn, infers *Pi*'s identity (as the book *Arctic Circles*) as the active vector of Horn's ongoing Icelandic chronicle *To Place*, itself a gradually building series of concentric circles. And finally, the idea of diameter intimated in *Pi* is activated by the viewer who, on entering the room, enters into the space of its relation. Moving from one side of the room to the other in order to connect one image with its spatial opposite, the viewer becomes Horn's navigational instrument, at each move and turn establishing a recomposed horizon, a new point of view.

Horn is pursuing this active relationship between viewer and work further by moving out into the 'real world circumstances' of integrated, fully tactile architectural situations charged with vernacular metaphor. *You Are the Weather – Munich* (1995–97) is a project for a meteorological bureau in Munich, Germany, in which she has infused a space with literary innuendo. Taking adjectives commonly used to describe the weather, and which might apply equally to human moods – 'sultry', 'frigid', 'cool', 'good', and so on – casting the letters in acid yellow resin and rubber and embedding them in soft black rubber mats both

You Are the Weather – Munich
(details)
1995–97
Rubber floor, 37 handrail inserts,
solid cast urethane plastic
60 m²
Permanent installation, German
Meteorological Bureau, Munich

You Are the Weather – Munich
(details)
1995–97
Rubber floor, 37 handrail inserts,
solid cast urethane plastic
Floor, 60 m²
Depth 3 cm
Permanent installation, German
Meteorological Bureau, Munich

outside and inside the building, and in black resin for the handrails running throughout the interior, Horn has rendered the physical space as a nuance of both texture and text. For the viewer, the act of moving through, of reading, the elicited conditions of climate gives rise to a reflection on the mercurial nature of the self.

For a current commission in a Swiss building complex, she chose to work with an extensive pedestrian thoroughfare, the architectural frame of which was designed − significantly for Horn − by the Minimal artist Donald Judd.[33] After studying the site at length, Horn developed a concept involving the possibility of 'placing one part of the world in another' and compounding the simple geometry of the architecture with another form. She took a latex mould of a section of the unique tesselated volcanic formation in Iceland known as the Kirkjugólf − a miraculous stone terrace which looks almost as if it is constructed from manmade tiles − which was then used to cast large hexagonal tiles of durable terracotta-coloured rubber. The tiles are laid in varying sections of hard and yielding rubber, to a total length of five hundred feet. As commuters continue along the path they will feel it become more or less resistant while being offered no visual confirmation of the change; in passing over it, they will be absorbed momentarily into another landscape. Thus *Yous in You*, a quiet, monochromatic otherness, makes its presence felt rather than seen.

The ambition to actualize the relation between things, to bring distant things close, is quite literally the scope of Horn's activities; and it defines equally well her oeuvre as a whole.

The logic she uses originates in the logic of travelling itself, in the continuity of the working process which, carried out day after day, leaves no spaces unrelated and brings even the most remote objects into the contiguous world of her view. For her, travelling is not only a physical activity; it is an epistemological strategy, a mode of knowing. Horn's compulsive attraction to Iceland has doubtlessly added to her geographical knowledge of the place, however this empirical form of knowledge belies another, rather more ideational feeling, more far-reaching in its consequences, that she describes as follows: *'My sense is that as we go forward into the so-called "information age", paradoxically we recognize less and less because we value actual experience less and less. You need a strategy to survive in a culture of excess. Possibility can be oppressive, even meaningless, unless you enter into a relation with it, take hold of it, work with it. By the time I was in my teens, I was aware that there was less silence in the world, less empty space. I developed a nostalgic yearning for those empty silent spaces I had never actually experienced but which I knew existed.'* Glenn Gould, the renowned pianist, composer and music critic who withdrew peremptorily from his public career to the controlled solitude of the recording studio, intimated what this feeling might be in his assertion that *'something really does happen to people who go into the north − they become at least aware of the creative opportunity which the physical fact of the country represents and ... come to measure their own work and life against that rather staggering creative possibility: they become, in effect, philosophers.'*[34]

IX

So how might such a seemingly diverse oeuvre –
which continues to structure itself in a dual zone
of direct contact with developing reality on one
hand and pure metaphysics on the other – be
defined in terms of its contribution to the life
of forms in art?[35] The pulse of Horn's oeuvre issues
forth as a polyphonic composition in which the
various short subjects and themes emerge in
harmonic counterpoint to her central proposition
– that one's place in the world is a series of
constantly shifting coordinates. This gives rise to
a labyrinth of forms and 'events' not available to
more dogmatic or predetermined formal
structures. The fugue – a paradigm more common
to music than to art – has been described as 'one
of the most durable creative devices in the history
of formal thought'[36] revealing identical traits
existing as constants within the most diverse
environments and periods of time, corresponding
to the Baroque state with which it most commonly
associated. Like the corresponding literary genre
of the novel, fugue is not a canonical form as such
but rather an invitation to invent a form relevant
to the idiosyncratic demands of the composition;[37]
it is ever questing, ever examining itself and
subjecting its established forms to review; it is
'plasticity itself.'[38] By invoking a structure innate
to human consciousness, which expresses itself in
the most persistent forms of music and language,
Horn has invented a body of work which is more
than an oeuvre; it is a genre in itself.

The art of fugue reaches its fullest implement-
ation in the flow of her latest book project,
Another Water, and its related photographic instal-
ation *Still Water (The River Thames, for Example)*.
Inspired by the opaque waters of the Thames,
Another Water combines full-frame photographs
of turbid water with intricate footnotes (a medley
of Horn's own writings about water and excerpts
from other sources, including forensic archives
and newspaper reports, which evoke the relation
between human consciousness and water) to which
the viewer proceeds as if reading a split computer
screen. In reality, the water's slow flux transpires a
little too fast for the naked eye to see; Horn makes
the viewer aware of what is happening through the
subtle variations in temperament that are fixed in
the photographic exposures. Compounding the
view, her footnotes – a chorus of voices fused into
one – create a literal subtext for the images and an
interior monologue for water as a figment of the
darker reaches of human experience and imagin-
ation. In the related, fugitive work, *Still Water*, the
viewer is drawn through a building on an eccentric
path of successive images. The photographs are
scaled so that they can be visually 'entered', then,
as the footnotes come into focus, the viewer is
drawn right up into the picture surface, thus
creating a dual field of vision in which the form is
constantly merging and splitting. Only when the
viewer leaves the site do the two systems come
together and the experience coalesce.

Another Water began with a story told to Horn
in Iceland, about children's fear of opaque water.
A fortuitous trip to London further prompted
Horn's imagination, drawing her focus to the
specific quality of the Thames, from which she
developed a more critical inquiry into what
happens when water loses its relationship to light.

And so on. The eddies of her empirical approach to this invented subject became bigger and bigger until finally she began to draw the work itself into being. Joseph Conrad's *Heart of Darkness* – the famous allegory about an exploratory journey up the Congo in which the geographical heart of darkness is transformed into the darkness of the human heart – was a story recounted by Conrad's invented protagonist Marlow on a boat on the River Thames. It began with the recognition that the Thames 'also has been one of the dark places of the earth' – a historical observation that suggests not only reversibility but also the progress of the boundaries of civilization.[39] Horn's investigation into the mesmerizing effects of opaque water reveals itself equally to be a project of her imagination.

Horn's fugue offers future travellers an exacting chart which preserves every trace of her passage through the infinite folds of her oeuvre. It is open-ended; its very accuracy invites further exploration. It opens a new cultural space in which other places might eventually be found. Oriented towards the solution of problems, attentive to the changes in environment, Horn's travelling and its material emanations embodies an open-ended, imaginative vision of spatial history. It is this dynamic concept that makes fugal structure the perfect vehicle with which to navigate the elaborate baroque territories of her 'description without place.'[40]

Thus the theory of description matters most.
It is the theory of the word for those

For whom the making of the world,
The buzzing world and lisping firmament

It is a world of words to the end of it,
In which nothing solid is its solid self.

… It matters, because everything we say
Of the past is description without place, a cast

Of the imagination, made in sound;
And because what we say of the future must portend,

Be alive with its own seeming, seeming to be.
Like rubies reddened by rubies reddening.

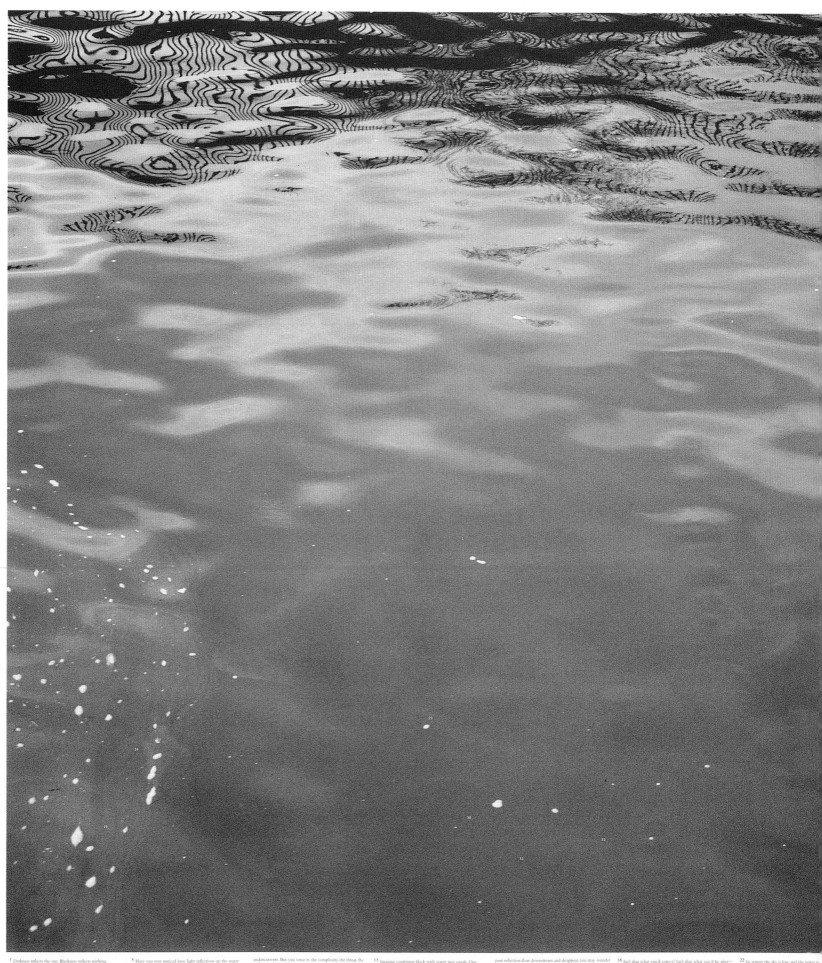

1 Darkness reflects the sun. Blackness reflects nothing.

2 Darkness reflects the sun. Blackness reflects nothing. ("Between grief and nothing, I will take grief.")¹

3 From the novel *The Wild Palms*, by William Faulkner, 1939.

4 From out here near the quieter currents you can see fibers of light stretching out on the river's surface.² Moving still and swiftly among the dark water, amorphous white energy elongating describe only the surface of this blackness—the beginning of something that cannot be seen.

5 Have you ever noticed how light reflections on the water sometimes look like camouflage?

6 Attracted by the lights upon this liquid blackness, you wade in among them, flowing with them briefly and submerging; from underneath maybe they will appear as constellations in the darkness. Other constellations than the ones you've grown accustomed to. Constellations from some other place, unseen until now.

7 You can't tell from looking at it how treacherous the water actually is. I mean you can't see what's going on with the currents, the river runs fast and tidal reversals work up strong undercurrents. But you sense it: the complexity, the threat, the difference. It's part of the river's attraction, part of its darkness.

8 Sometimes, in a quiet area, the water is tremulous and tender: an easier entrance beguiling you.

9 Crumbs of whitish froth float on the water. They cluster in formations that are not affected by the river's movement, in formations that linger too long.

10 The water is black, but it isn't really visible. You feel it, but you can't see it. It takes the breath out of you not being able to see it, point to it, touch it or just say it. But that's black.

11 Imagine combining black with water: two equals. One unchangeable, the other wholly corruptible.

12 Going into water is going into yourself. Water is a mirror. But even in black water there's a reflection, though a degraded one. You don't have to witness yourself in black water.

13 And what about juvenile water—immature water, young water? Water that's never seen the light of day. Juvenile water emerging from within the earth, arriving at the surface. All I can think to say is, "Hello."

14 Your reflection uncouples in this water. It drifts away from you. As you stand there on the bank or bridge, helpless, watching your reflection float downstream and disappear, you may wonder what forces black water gathers. But instinctively you already know they must be closer to witchcraft than geometry.³

15 "Best witchcraft is geometry."⁴

16 See poem No. 1158 by Emily Dickinson, 1870.

17 There was an article in the newspaper some time ago about a young man jumping off a bridge. He strapped his bicycle, a black Phantom, to his chest and jumped in. (It took six months to identify the body.)⁵

18 Isn't that what you'd expect? Isn't that what you'd be after—to lose your identity? The Thames looks like a solvent for identity, doesn't it?

19 The river is a drain.

20 In winter the darkness in the water deepens, and the river's flow seems to accelerate.

21 In winter the Thames is so drab, the darkness of the water is palpable. Close your eyes and you feel the darkness waiting up from the river: dark, clammy, close.

22 In winter the sky is low and the water is high. The atmosphere becomes an extension of the water, saturates your view. In water silently permeates the homes of London, and you live in the river.

23 Boatmen talk about seeing jumpers often, people jump—from London Bridge, Hungerford, Blackfriars, Waterloo, Westminster, Vauxhall. remember. They're common, jumpers—and

24 A boatman described the tendency of jumpers the parapet of the bridge and stare down at it while and then let go—face down into the

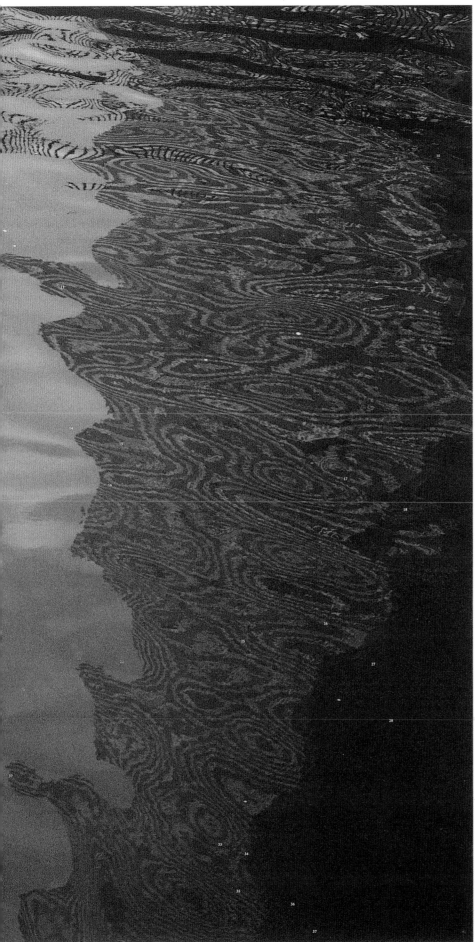

From **Still Water (The River Thames, for Example)**
1999
Offset lithograph printed
photograph and text
77.5 × 105.5 cm
From the series of 15 lithographs
Collections, Musée d'Art Moderne
de la Ville de Paris; Lannan
Foundation, Santa Fe

be cold, stunning. Cramp you up and make you stop
—make your heart attack. And then you enter a place
—a visible. But that's an act of faith—you just have to
h there.

be cold, stunning. When you enter the water it's
and you breathe fast, so fast euphoria comes, only
st lightening everything up as you pass down and on.

be cold, stunning. When you enter the water it's
and you breathe deep (you can't stop yourself) and
r the water in and you let go.

28 It will be cold. Even in the summer the water is cold; it
lingers on—the cold of unabiding darkness.

29 In some places when I look out across the river I see crumbs
of something or other floating on the surface. The water's reflec-
tions are speckled with them. (Mine ate, too.)

30 The English have a penchant for dismembering their murder
victims. I doubt there's a period of London history free from the
heads, limbs, and vital organs found in the Thames or washed up
on its banks. Last week police found intestines and a leg (they
didn't say if it was right or left). Over near Silvertown—intes-
tines and one leg.

31 Yesterday I read in the evening paper: "On the night of July
8th a man walking on the foreshore at Lower Pool stumbled on
a human head." The body it belonged to was found in pieces
over the following weeks, a leg here, a hand there. It took one
month but police found all the parts including the torso (More
river traffic.)

32 Body parts (victims of murder), corpses (suicides—mostly
jumpers), sewage (human waste), heavy metals (lead, mercury,
cadmium, for example). Herons and cormorants lighten up the
look, but not much—and only briefly.

33 (The Thames it in.)

34 What is the darkness in the Thames?³⁰

35 . . . it had become a place of darkness. But there was in it
one river, especially, . . . that you could see on the map, resem-
bling an immense snake uncoiled, with its head in the sea, in
body at rest . . . and its tail lost in the depths of the land." ³⁶ ³⁷

36 See *Heart of Darkness*, written in 1898–99 by Joseph
Conrad. Viking Press edition, *The Portable Conrad*, New York,
1947: 497.

37 (Are you wondering if I'm talking about the Ganges? Or the
Yangtze? Or even the Congo?³⁷)

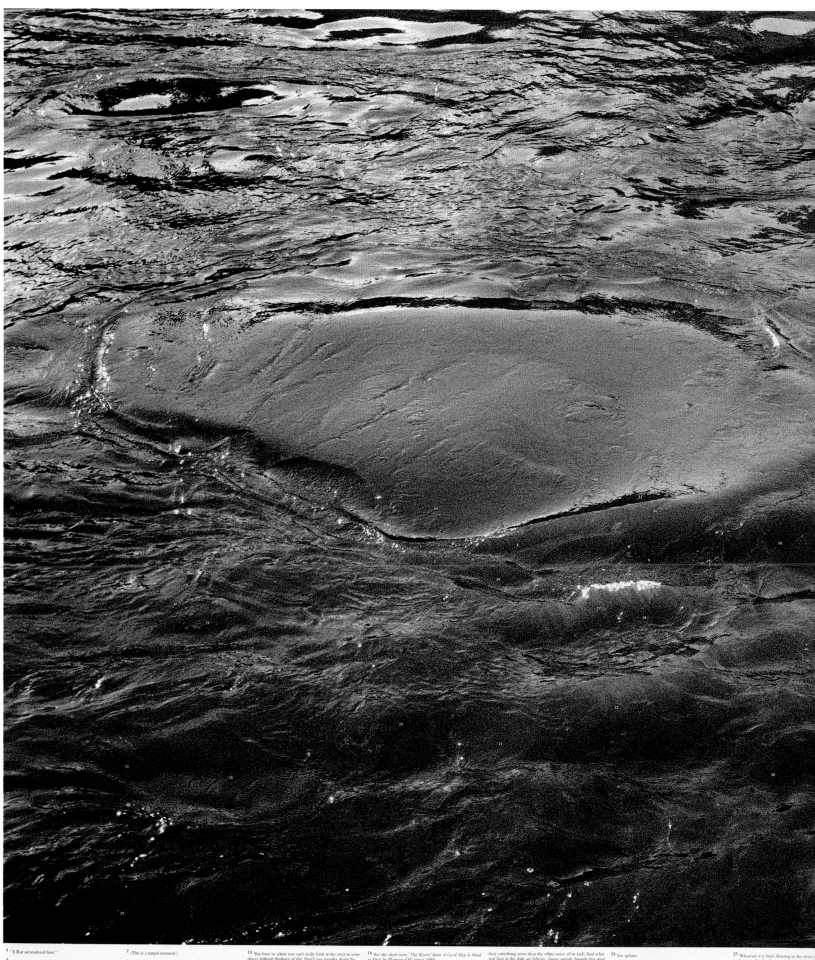

1 "A Rat surrendered here."¹

2 See poem No. 1340 by Emily Dickinson, 1876.

3 Roiled? Or real?

4 The Thames is turbid.

5 Turbid, not turgid. But then sometimes I have the sense that the Thames is turgid, too—bloated with another water.

6 Turbid, not turgid! (But then it appears that there are occasional turgid moments, too.)

7 (This is a turgid moment.)

8 A corpse, especially one found in a river, is likely to be turgid. But the water itself, at least in this river, is definitely turbid.

9 Putrid? (Putrid is good because there's the idea of life in it. Vile is good—but no life.)

10 What about lurid? Lurid as in gruesome!—or repugnant? This water's definitely got a lurid quality.

11 What about lurid! Lurid enhances the river's appeal.

12 Rancid? (Personally, I doubt it.)

13 You have to admit you can't really look at the river in some places without thinking of shit. Don't you wonder about the beautification and restoration programs going on around a more or less natural formations that reminds a person of shit? I think of it as nostalgia for an older, simpler meaning of water. This kind of development along the river strikes an ironic note; I can't be the only one who's terrified of falling in—of being submerged even for one second in this water.

14 Is the Thames a case of mistaken identity?

15 A boy is baptized in a filthy river (under a false name). The next day he goes back and drowns himself in it."

16 See the short story "The River," from A Good Man Is Hard to Find, by Flannery O'Connor, 1955.

17 Two little girls—sisters—tied themselves together and jumped in the river."

18 See the novel Our Mutual Friend, Charles Dickens, 1865.

19 Probably the Thames was never clear, but its lack of transparency means something different today than it did two hundred or five hundred years ago.

20 The sound of the river at night is a landscape of possibilities. You have to get fairly close before you can really hear it. I mean hear something more than the white noise of its rush. And what you hear in the dark are delicate, elusive sounds. Sounds that must be there in the day as well, but are unheard, muted by the light.

21 Water sighs. Water sucks. Water licks. Water laps. Water splashes. Water splashes. Water splashes. Water washes. Water washes. Water sloshes. Water murmurs. Water hushes. Water rushes. Water gushes. Water burbles. Water gurgles. Water sucks. (It's hard to associate these sounds with this image.)

22 This image is more like slops, flops, and plops. (But mainly I get the idea that something of this consistency would be silent.)

23 What does water look like?"

24 See gelatin.

25 A young man was found floating in the river, the fingers of each hand were bound with red and white insulation tape, "claw" fashion, with thumbs free.

26 We've all decided, in a kind of inarticulate a priori mechanism of survival, to behave around it as though it's water. But anyone can see that it isn't water that flows in the River Thames. But we haven't another name for it. And partly because we have so name for this substance that has been subsumed by, dull I use the euphemism, "impurities"—that we do not know what we are looking at when we look into the River Thames.

27 Whatever it is that's flowing in the river, it (or at least not by the dictionary). None of the def define water can be applied to the Thames. (I pure; it's not colorless, it's not odorless or taste still call it a water (mostly you still do) but you'c would have to be another water, but another w

28 Another water is not water. (Water is one no other.)

29 The river casts a shadow into itself, becomi shadows and dirt thicken the water with a dar that slices through everything: identity, place, t

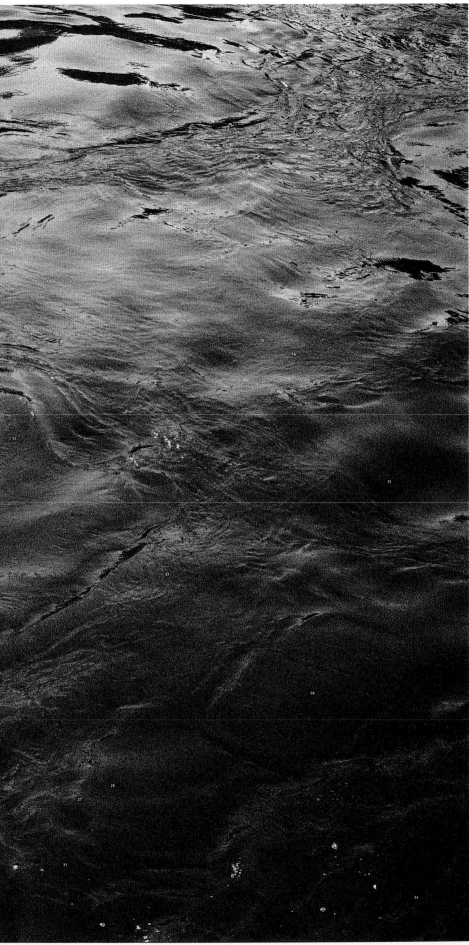

From **Still Water (The River Thames, for Example)**
1999
Offset lithograph printed
photograph and text
77.5 × 105.5 cm
From the series of 15 lithographs
Collections, Musée d'Art Moderne
de la Ville de Paris; Lannan
Foundation, Santa Fe

Ellipsis II (details)
1998
Photo installation, 64 Iris printed
black and white photographs tiled
together
244 × 244 cm

1 In his *Monadology*, a prescient treatise on possible worlds, the seventeenth century philosopher Gottfried Leibniz ascribes the name 'monad' to the soul or the subject as a metaphysical point, borrowing from the Neoplatonists who used it to designate a state of One, a unity that envelops a multiplicity which, in turn develops the One in the manner of an algorithmic series.

2 Gilles Deleuze's reading of Leibniz' oeuvre as constituting the grounding elements of a Baroque philosophy and of theories for analyzing contemporary arts and sciences, provided crucial links with which to galvanize my thoughts on structure in Horn's oeuvre. See *The Fold: Leibniz and the Baroque*, University of Minnesota, 1993

3 Unless cited otherwise, all quotations from Roni Horn are from discussions with the author, December 1998 to June 1999

4 Martin Buber, *I and Thou*, Simon & Schuster, New York, 1996, p. 23 It became evident in conversations with Horn that Buber's dialogical or 'I-Thou' philosophy – which Walter Kaufmann sums up in his prologue to the 1970 edition as the sacred being here and now in the actuality of human relationships – has been a prime influence in the articulation of her artistic praxis.

5 For an incisive discussion of Horn's thoughts on sexual identity, see 'Weather Girls: Roni Horn interviewed by Collier Schorr', *frieze*, No. 32, London, January/February, 1997, pp. 43-47

6 Roni Horn, Lecture for the Chinati Foundation, Marfa, Texas, 1998, (unpublished)

7 Felix Gonzales-Torres, '1990: L.A. "The Gold Field"', in *Earths Grow Thick*, Wexner Center for the Arts, Ohio, 1996, p. 69

8 Anaximenes, Fragment: 'Just as our soul, being air, holds our bodies together, breath-air encompasses the whole world', in J.V. Luce, *An Introduction to Greek Philosophy*, Thames and Hudson, London, 1992, p. 29. The originality of Anaximenes lay in taking up the widespread primitive idea of a breath-soul and giving it a cosmic application.

9 Roni Horn, 'How – Is Visible Here' in *Pooling Waters*, Verlag der Buchhandlung Walther König, Cologne, 1994, p. 11. It is interesting to note that the nineteenth century poet Emily Dickinson – a precocious modernist and one of Horn's principal mentors – once voiced her concern to a prospective publisher about whether her verses 'breathed'. Letter to Thomas Wentworth Higginson, 1862, in Thomas Johnson's introduction to *The Complete Poems of Emily Dickinson*, Little, Brown & Co., Boston, 1960, p. v. In his detailed exegesis on Horn's drawings, Dieter Koepplin observes that drawings' organic character requires that enough depth be specified in the frame for them to 'breathe', to accommodate the inevitable expanding and contracting of the paper's surface due to fluctuations in environmental humidity. In 'Six "Drawings" or Pigment Sculptures on and with Paper', *Roni Horn: Zeichnungen/Drawings*, Edition Cantz, Stuttgart/Museum für Gegenwartskunst, Basel, 1995, p. 23

10 Ibid., p. 25

11 Horn interviewed by Hannelore Kersting in *Roni Horn: Things Which Happen Again*, Städtisches Museum Abteiberg, Mönchengladbach/ Westfälischer Kunstverein, Münster, 1991

12 The idea of gathering came as a direct consequence of discussing Horn's work with her over time. Horn later referred me to Martin Heidegger's essay 'Building Dwelling Thinking', in which he elaborates the concept of dwelling as the way 'we humans are on earth', and the essence of building as 'letting dwell'. Heidegger locates the idea of inhabiting space in order for meaning to gather in the ingenious self-sufficiency of vernacular architecture. 'Building Dwelling Thinking' has been instructive to Horn in her ongoing Icelandic chronicle *To Place*, however I do not wish to represent this text as having determined my own thinking on the subject. In Martin Heidegger, *Basic Writings*, Harper Collins, San Francisco, 1993, pp. 344-362

13 William Butcher, Introduction to Jules Verne, *The Extraordinary Journeys: Journey to the Centre of the Earth,* Oxford University Press, Oxford, 1998, p. xiii

14 Jules Verne, ibid., P. 56

15 Mikhail Bakhtin, *The Dialogic Imagination: Four Essays*, University of Texas, Texas 1981

16 J.V. Luce, *An Introduction to Greek Philosophy*, op cit., p. 13

17 Wallace Stevens, *The Collected Poems of Wallace Stevens*, Vintage

Books, New York, 1990, p. 430

18 Wallace Stevens, ibid.

19 J.V. Luce, *An Introduction to Greek Philosophy*, Thames and Hudson, London, 1992

20 Jan Howard, 'Inner Geography: A Written Interview with Roni Horn', *Inner Geography*, Baltimore Museum of Art, Baltimore, 1994, p. 24

21 TV documentary on Björk, Bravo! channel, UK, 1998

22 Gilles Deleuze, *The Fold: Leibniz and the Baroque*, op. cit., p. 6

23 In his novel, *Independent People* (1946), Icelandic writer Halldor Laxness depicts the interrelationship of Iceland's landscape, its weather, and its people as being almost anthropormorphic in nature.

24 William Butcher, op. cit., p. xxix

25 The term 'saga' is used in its specific Icelandic meaning. The Danes in their early colonization of Iceland forbade the indigenous people to make music. In response to this injunction, the Icelanders invented the saga – a form of chant half-spoken, half-sung, usually by women – as a form of political and mystical subterfuge in order that the stories of their ordeals could be passionately preserved. In present-day Iceland, the pop iconoclast, Björk, is commonly held to be 'a woman of the sagas'. TV documentary, op. cit.

26 Roni Horn, 'Making Being Here Enough', in *Pooling Waters*, op.cit.

27 Georges Perec, 'The World', in *Species of Spaces and Other Pieces*, Penguin Books, London, 1997, p. 79

28 Roni Horn, 'Roads Lack Dedication', in *Pooling Waters*, op. cit.

29 Paul Carter, *The Road to Botany Bay: An Exploration of Landscape and History*, University of Chicago Press, Chicago, 1987, p. 25

30 Nancy Spector, 'Untitled (Flannery): A Condensation of Acts', Parkett, No. 54, Zurich, December/January 1998/99, pp. 65-66

31 The subjects of Horn's only two dedications – O'Connor and the aforementioned Gonzales-Torres, two artists of declared importance to her – shared certain character-istics of acute political conscious-ness, subtle subversiveness and biting candour. The American poet Elizabeth Bishop once eulogized O'Connor's work as being 'narrow, possibly, but clear, hard, vivid, and full of bits of description, phrases and the odd insight that contains more real poetry than a dozen

books of poems', a description that could well be applied to Horn's own oeuvre. In Robert Giroux, *Introduction to Flannery O'Connor: The Complete Stories*, Farrar, Straus and Giroux, New York, 1971, p. xvi

32 For more detailed discussion of this work, see Nancy Spector, op. cit.

33 On accepting the commission, it occurred to Horn to make the work as a homage to the late Donald Judd, who was a close friend.

34 'The Idea of North: An Introduction', in *The Glenn Gould Reader*, Vintage Books, New York, 1990, p. 392. Gould continues on to say that the idea of north 'is itself an excuse – an opportunity to examine that condition of solitude which is neither exclusive to the north nor the prerogative of those who go north but which does perhaps appear, with all its ramifications, a bit more clearly to those who have made, if only in their imagination, the journey north'. Thus does the idea of north assume a largely metaphorical dimension.

35 This expression is borrowed from Henri Focillon's 1934 meditation on the problem of stylistic change in art which posits the history of art and its meanings as an inherently dynamic system rather than one of fixed dualities of form/content, structure/history and idea/technique. *The Life of Forms in Art*, Zone Books, New York, 1989. In his foreword to the English translation of Deleuze's *The Fold: Leibniz and the Baroque*, Tom Conley suggests that the provenance of Deleuze's theoretical development resides in Focillon's radical rethinking of the evolution of aesthetic form.

36 Glenn Gould, 'So You Want to Write a Fugue?' *The Glenn Gould Reader*, Vintage Books, New York, 1990, p. 237. Gould's insightful writings on the central paradigm of Baroque music and its deeper metaphorical implications provide a useful analogy for the complex dynamic of Horn's oeuvre in particular, and intersubjective creativity in general.

37 Glenn Gould, 'Art of the Fugue', op. cit., p. 16

38 Mikhail Bakhtin, op.cit., p. 39

39 Jas Elsner, Joan-Pau Rubies (eds.), *Voyages and Visions: Towards a Cultural History of Travel*, Reaktion Books, London, 1999, p. 55

40 From Wallace Stevens, 'Description without Place', op.cit., pp. 339-346

With thanks to Geoff Lowe.

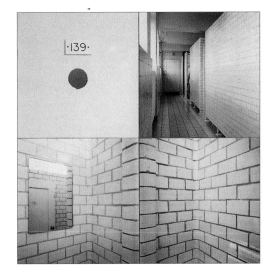

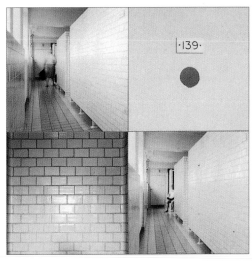

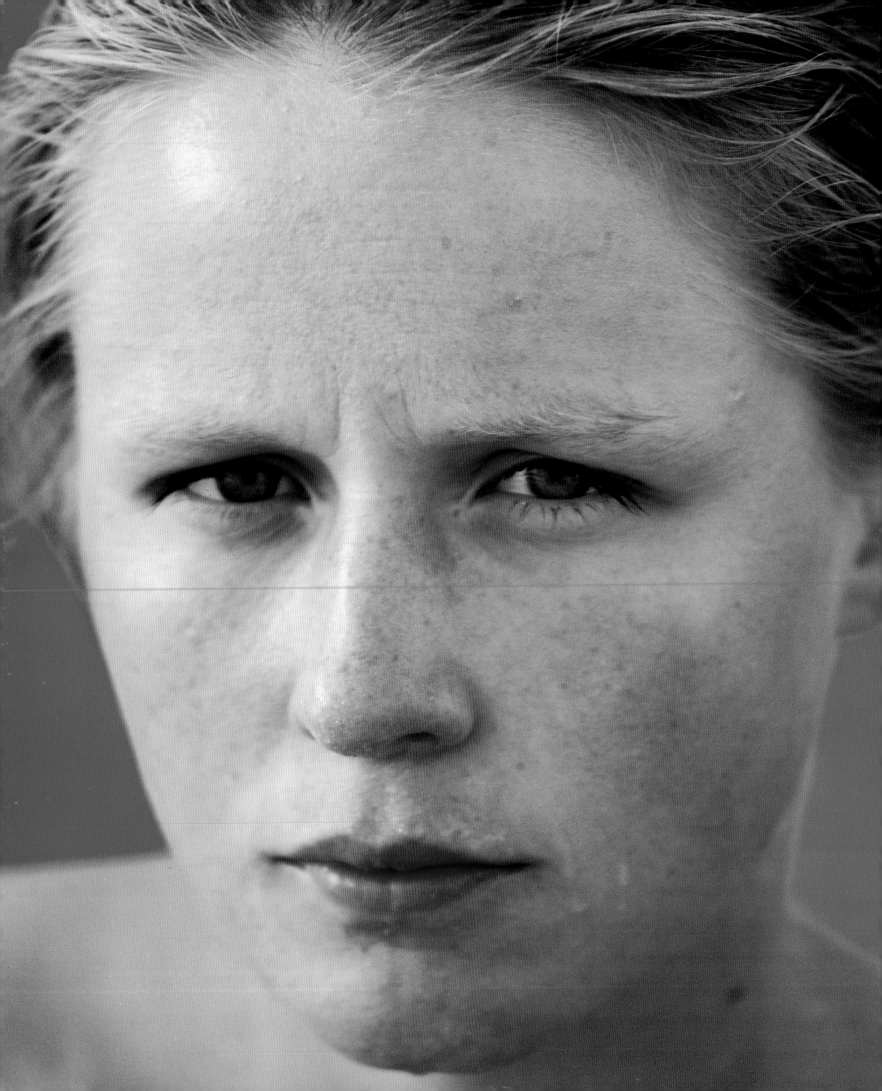

Contents

When I first came upon the installation *You Are the Weather*, I instantly fell in love with the piece. The thing is, being in love seemed to me very much at issue as a matter of content, but that's already an after-the-fact rationalization. I knew the artist was Roni Horn and Roni was a 'she' and I was familiar with some of her more minimalist-looking work as well as with her large-scale, abstract, 'cut-and-paste' drawings, which I loved for their intimacy. Now this. I had not suspected, until then, that she was also working in photography. Anyway, the piece just won me over, instantly. Could I possibly have fallen in love with the woman in the pictures – one hundred times the same woman, her various likenesses spread all around the room, at eye level, arranged in sequences of six or seven or eight, some in colour, some in black and white? I wasn't going to admit as much. Critics are no more supposed to fall in love with the figure in an image than artists with their model, though both have been known to happen. Yet it's what had gripped me in her that I felt I had to attend to. I say 'her' – the woman in the pictures – instead of 'them' – the pictures – but that, now, may be an after-the-fact romanticization. Before I saw her at all, I saw the frieze, the repetition, the series, the intervals between the series, I saw a form. Or did I? Did I really take in the rhythm, the syncopated alternation of colour and black and white, the differences in background colour from one series to the next, the oh-so-subtle variations in the way the face was cropped, before I saw her, her unbelievably changing and moving visage, one hundred times over? Who am I to decide that, now, almost two years later? All I remember is that I knew on the spot that the elation I felt had to do with the certainty that the work's form was its content. This doesn't happen that often, though it is – to my eyes, at least – the indisputable sign of a true work of art.

The trouble with photography is that, being inescapably figurative, its content is all too easily confused with its subject matter. When the subject matter is a living subject and is repeated one hundred times, the intimation is strong that obsessive infatuation with it is the content of the piece. Perhaps, after all, I had seen the woman in the pictures before I had registered the pictures as pictures. And perhaps her effect on me was sheerly quantitative at first. As Matisse said, a square metre of blue is bluer than a square centimetre. Thus multiplied, she was so touching that I simply couldn't resist her. Nor forget her. I guess I was infatuated. A year later, I bought the book. The hundred photographs were all there, cover to cover, actual size (that is, with her slightly larger than life-size in most images). Not only

Roland Fischer
From Los Angeles Portraits
1990
C-type print
141 × 162 cm

had the artist allowed me to see through the photographs and to engage with the model herself, she was willing to let me live with her, in book form. How many times did I find myself leafing through its pages? The book form doesn't mimic the form of the gallery installation. The object resting on my lap as I slowly turn or quickly flip through the pages induces a relationship to the images that is quite different both from the frontality of pictures hung on a wall and from the surrounding frieze beckoning me from all sides at once. Yet my feeling is that nothing is lost or added in the translation of installation into book, and that both forms are essentially one. I mean, one with their content.

There is very little text in the book. On the last page, we learn that 'Margrét Haraldsdóttir Blöndal made this work possible'. And on the first page, we read: *'These photographs were taken in July and August of 1994. For a six-week period I travelled with Margrét throughout Iceland. Using the naturally heated waters that are commonplace there, we went from pool to pool. We worked daily, mostly outside, and regardless of the changeable, often unpredictable climate that frequents the island.'* Signed, Roni Horn. There is not much I'd want to add to this succinct description of the piece's subject matter; perhaps just

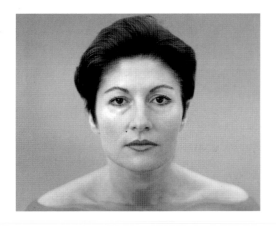

a fleeting comparison with a series of photo-portraits of women by Roland Fischer set in swimming pools, and then only to underline the difference. In Fischer's work, the half-transparent half-reflective (and yet strangely opaque) surface of the water serves to revive a particular genre of sculpted portrait, that of the bust, thereby conferring a distanced and commemorative (perhaps ironic) heroicism to the art of photo-portraiture. Immersing Margrét in waters of variable temperature from which, most of the time, she emerges wet, has the exact opposite effect. She appears de-heroicized, subject to the contingency of climatic changes, commemorating nothing, and her pictures do not belong to the genre of portraiture. Even setting aside the beautiful poetic connotations that the naturally heated and sulphuric springs of Iceland bring to mind, it seems to me that the water, in these pictures, rules out the genre of portraiture as a frame of interpretation. We're not dealing with identity here. Nor with difference, or differences. If we were, we would have to conclude that the artist felt she needed one hundred photographs to capture her model's personality in all its facets, where the traditional portraitist needs only one, and *You Are the Weather* would simply testify to the

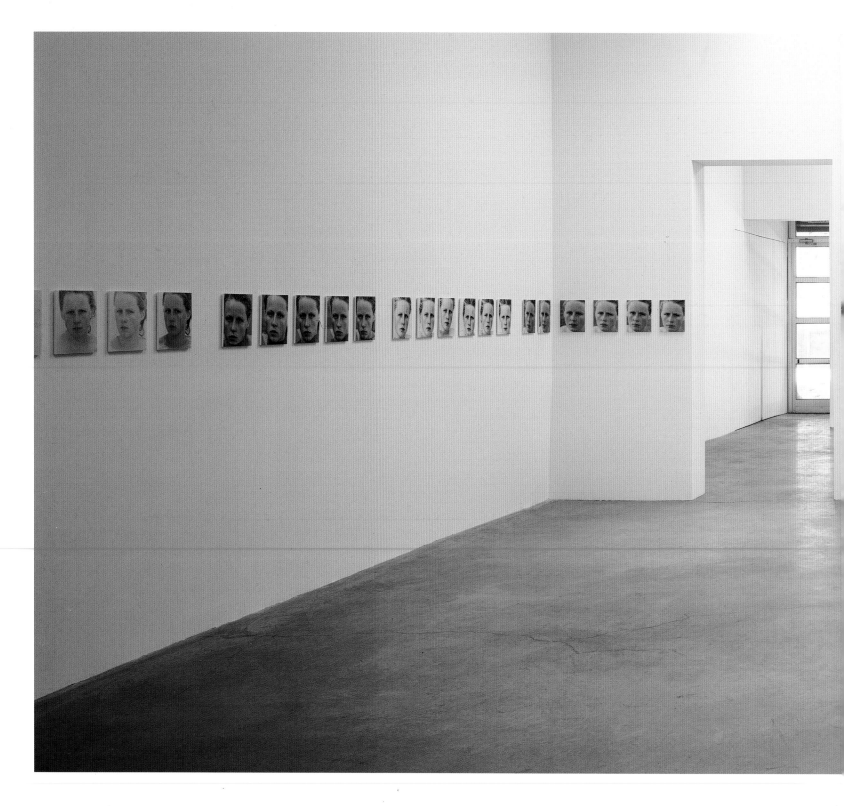

failure of the art of portrait-making. Yet I see nothing but success in this work. Poignant success, for sure, but of a kind that owes nothing to the ironic deconstruction of an established genre.

Working from the title is as good an entry into the content – as distinguished from the subject matter – of the piece as any. Whom does the 'you' in *You Are the Weather* address? Margrét, is the obvious answer: her features are indeed as changing and unpredictable as

You Are the Weather (detail)
1994–95
Photo installation, 100 colour
photographs and gelatin silver
prints installed on 4 walls
25.5 × 20.5 cm each
Installation, Matthew Marks
Gallery, New York
Collections, De Pont Foundation
for Contemporary Art, Tilburg,
The Netherlands; Kunstmuseum
Nürnberg, Germany

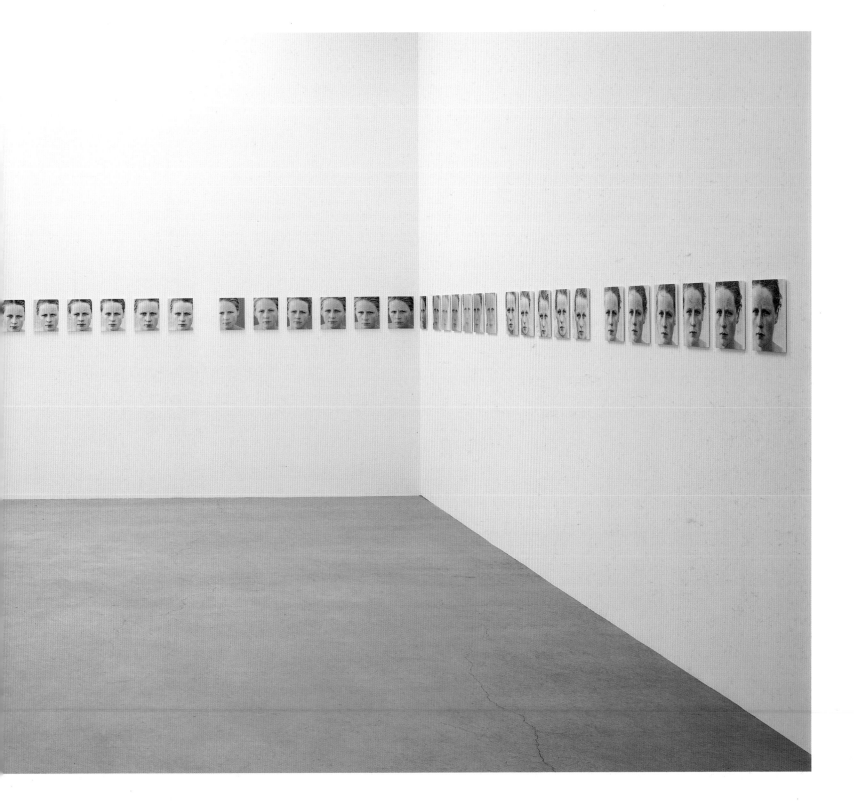

the weather might be. But a short and unsigned text on the back cover of the book complicates the issue: '*A luminous face rises again and again from the hot waters of Iceland. An unknown face becoming, page by page and photo by photo, a multitude. Her face is a collection of expressions telling the weather. But here in this book with her – you become the weather.*' This last 'you' clearly refers to the viewer. 'You' is a pronoun, and pronouns are shifters (as linguists would say). That is, they are mobile designators. 'I' designates whoever

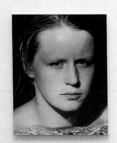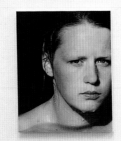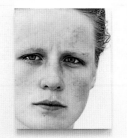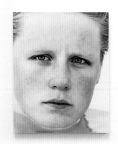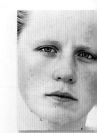

is speaking, 'he' or 'she' designates whoever is spoken about, and 'you' designates whoever is spoken to. 'You', the second person, is the pronoun of the addressee, and as such it shifts with each change of address. Hence the constitutive ambiguity of Roni Horn's title. Could it be that the content of *You Are the Weather* is nothing but the shifting of the 'you' from model to spectator? So formulated, the hypothesis is a bit dry. It does away with the pathos of the work, not because its movingness has suddenly become irrelevant (quite to the contrary: I remain convinced that falling in love with the work is essential to its content of 'being in love'), but because the kind of content that accounts for the work's quality as art, and that can be talked about without lapsing into indiscretion or fantasy, is of a piece with the work's form.

I am leafing through the book again. Although I am looking at Margrét, she is not looking at me. Is she looking at Roni Horn's camera? Certainly. The parallax in her eyes shows her focusing on a point midway between my eyes, the point where the monocular lens of the camera was when the photo was taken. There is nothing exceptional in this. She is still looking at the camera while I'm looking at her because all photographs imply the kind of time warp Roland Barthes described as 'an illogical conjunction between the here and the then.' As to her gaze escaping mine, every interlocking of gazes (whether with a person or with a depicted pair of eyes) involves a fascinating uncertainty, due to the fact that you cannot look someone straight into the eyes but only into one eye at a time. So far, Margrét's gaze is no more and no less troubling than that of any portrait. Yet, though her eyes are in focus and her gaze is not out of focus (what would that mean, anyway?), she seems to be

You Are the Weather (detail)
1994–95
Photo installation, 100 colour
photographs and gelatin silver
prints installed on 4 walls
25.5 × 20.5 cm each
Installation, Matthew Marks
Gallery, New York
Collections, De Pont Foundation
for Contemporary Art, Tilburg,
The Netherlands; Kunstmuseum
Nürnberg, Germany

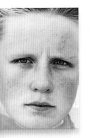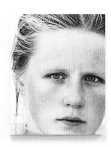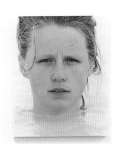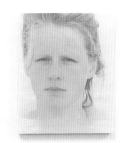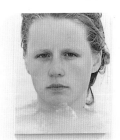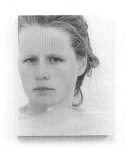

looking not at but rather through Roni Horn's camera. The fact is, she doesn't seem to address anyone except, perhaps, Roni Horn addressing her through the viewer of the camera. I'd say: she addresses the bare fact that she's being addressed. This, I believe, is the formal achievement and the unique novelty of this particular work.

Is Margrét the weather or the weather-sensitive recording device? Her face is so wonderfully expressive that it is hard not to yield to the temptation of reading the photos and the photo-sessions psychologically. There are the good and the bad days. If you spend some time with the book, you will soon learn to extract an overall mood from each daily photo-session; and if you give it more time, the sudden shifts in mood within each series will start jumping off the page. Now Margrét is resisting and defiant, now yielding and receptive, now responding and reciprocating, never miserable yet never 100 per cent happy either, rarely smiling and, if at all, faintly, with on occasion a twinkle of irony, or a tear, in the corner of her eye, often frowning and always, always, intensely interrogating. This last word is a key. Short of sainthood, there is no address that doesn't entail a demand – if only the demand that you pay attention, that you listen to me if I speak to you, or that you look back at me if I address my gaze to you. Margrét clearly complies with the scopic demand of Roni Horn's camera, she looks back indeed. Yet her gaze seems poised on the 'beyond' from where the demand is issued and refuses to respond with anything but a question pertaining to the demand itself. 'What do you want from me?' is the one constant message which this versatile barometer or thermometer is addressing the weather.

I said earlier that identity was not at issue in this piece. It all depends. I was talking with

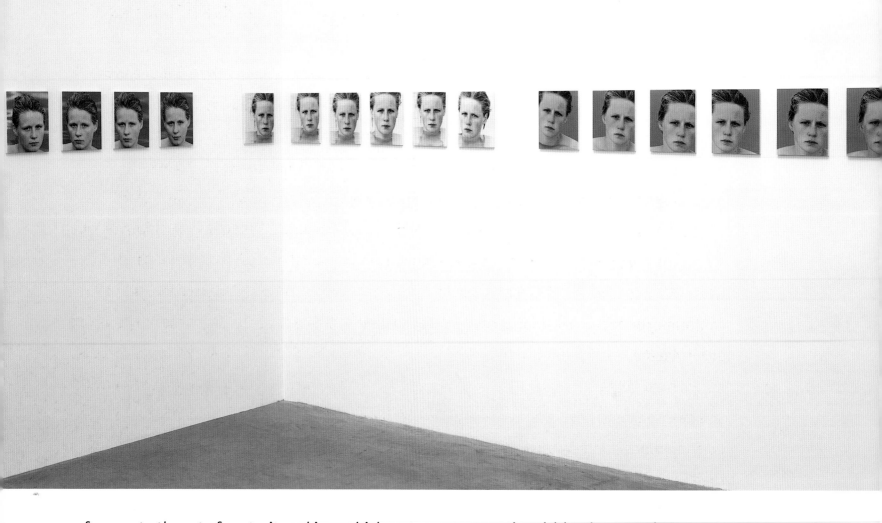

reference to the art of portrait-making, which rests on a conventional (that is, agreed upon) interplay of demand and response. The photographer begs the subject to supply an expression of what he or she thinks is his or her true self, and the subject complies with an expression which, translated in language, might read as: 'This is me, and I am this and that'. (Good portrait photographers might go beyond that, catch the subject unaware and reveal an even 'truer' self, but such breaching of the pact organizing demand and response still confirms the pact.) The portrait photographer addresses the subject in the second person, and the subject answers in the first. What happens in *You Are the Weather* doesn't rest on such a pact. The subject in the photos remains a 'you' and never quite fully assumes the position of the 'I'. It is as if, instead of responding, Margrét was content with acknowledging receipt of Roni Horn's demand to her. If identity is at stake in this piece, it is not in the usual sense that portraiture exemplifies. Neither is it in the equally usual sense of 'representation'. Whereas portraiture posits the model as a full-fledged subjectivity (someone 'talking' in the first person) the more general category of representation posits the figure it

You Are the Weather (details)
1994–95
Photo installation, 100 colour photographs and gelatin silver prints installed on 4 walls
25.5 × 20.5 cm each
Installation, Matthew Marks Gallery, New York
Collections, De Pont Foundation for Contemporary Art, Tilburg, The Netherlands; Kunstmuseum Nürnberg, Germany

represents as 'the referent' (the person who is 'spoken about' in the third person). Can identity present itself in the second person?

The pronoun 'you' is ungendered, which means either of two things. Either language in its wisdom has decided that it should ignore and neutralize the sex of the addressee (such is the traditional view); or it has made room for uncertainty and questioning in the matter – a far more interesting hypothesis. We wouldn't even need the now commonly accepted distinction between gender and sex if it weren't for this uncertainty, which therefore has ontological precedence over the gendered attributes attached to the pronoun of the addressee. (It may very well be that someone's sexual identity is fashioned in childhood at the hand of those attributes, as the child hears itself addressed with 'you are a boy' or 'you are a girl', in conformity or not with its biological sex.) I'm not saying that sexual identity is the only content of *You Are the Weather*, far from it. I merely surmise that it is one significant layer in its content. If I am right, what matters is that this content has found its form, and is one with it. It is quite an achievement to have broken with the conventions of both representation (in the third person) and portrait (in the first person), and to have invented figurative images addressing their viewers in such a way that the figure they contain presents itself – herself – neither as addresser nor as referent but as addressee. A 'you' addressing a 'you' indeed deserves to be called a new form. Well, isn't creating forms the worthy content of true works of art?

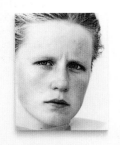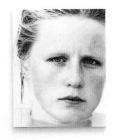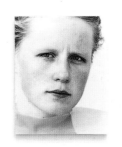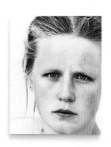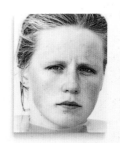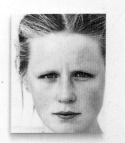

cool

quiet

cruel

Contents

That was the car that had uprooted itself with a hoarse sound in the middle of the night.

In the silence which was once more intact, the man now stared stupidly at the invisible ceiling, which in the darkness was as high as the sky. Stretched out on his back upon the bed, he tried with an effort of gratuitous pleasure to reconstruct the sound of the wheels, for he did not feel pain, but pleasure in a general way. He could not see the garden from his bed. A little mist was coming in through the open Venetian blinds, and the man could tell that it was there from the smell of damp cotton and from a certain physical yearning for happiness that fog induces. It had only been a dream, then. Skeptical, however, he got up.

In the darkness he could see nothing from the balcony, and he could not even guess the symmetry of the flower beds. A few splotches darker than the darkness itself showed the probable location of the trees. The garden remained as nothing but an effort of memory, and the man stared quietly, sleepily. Here and there a firefly made the darkness even vaster.

Having forgotten about the dream that had drawn him out onto the balcony, the man's body found that it was a pleasant feeling to sense itself in a healthy upright position. The air was in suspension, and the dark position of the leaves was little changed. He let himself stand there, then, docile, bewildered, with the succession of unoccupied rooms behind him. Those empty rooms multiplied themselves until they disappeared off to where the man could no longer see anything more. Martim sighed inside his long waking sleep. Without too much insistence he tried to grasp the notion of the rooms farthest away, as if he himself had grown too large and had spread out too much, and for some reason that he had already forgotten – for some obscure reason – it had become essential to retreat so that he could think or perhaps feel. But he could not get himself to do it, and it was very pleasant. So he stayed there, with the courteous air of a man who has been hit over the head. Until – just as when a clock stops ticking and only thus makes us aware that it had been ticking before – Martim perceived the silence and his own presence within the silence. Then by means of a very familiar lack of comprehension the man at last began to be himself in an indistinct sort of way.

Then things began to get reorganized, beginning with him: the darkness was beginning to be understood, branches were slowly taking shape under the balcony, shadows dividing up into flowers, undefined as yet. With their edges hidden by the quiet lushness of the plants, the flower beds were outlined, full and soft. The man grunted approvingly. With some difficulty he had just recognized the garden, which at intervals during those two weeks of sleep had constituted his irreducible vision.

It was at that moment that a faint moon passed out of a cloud in great silence, silently spread itself over the calm stones, and silently disappeared into the darkness. The moonlit face of the man turned then towards the drive where the Ford ought to be standing motionless.

But the car had disappeared.

The man's entire body suddenly woke up. With a sharp glance his eyes covered the whole darkness of the garden – and without a sign of warning he wheeled around towards his room with the soft leap of a monkey. Nothing was moving, however, in the cavity of the room, which had become enormous in the darkness. The man stood breathing heavily, alert and uselessly fierce, with his hands held in front of him against attack. But the silence of the hotel was the same as that of night. And without visible limits the room prolonged the darkness of the garden with the same exhalation. To wake himself up the man rubbed his eyes several times with the back of one hand while keeping the other one free for defense. His new sensibility was of no use. In the darkness his wide-open eyes could not even see the walls.

It was as if he had been set down alone in the middle of a field. And as if he had finally remembered a long dream in which a hotel, now broken up in pieces on the empty ground, had figured, a car imagined only through desire, and – above all – as if the reason for a man to be all expectant in a place was also a form of expectancy.

Untitled (You Are the Weather)
1995–97
Rubber floor
Area 47 m²
Depth 2.5 cm
Installation, Matthew Marks
Gallery, New York

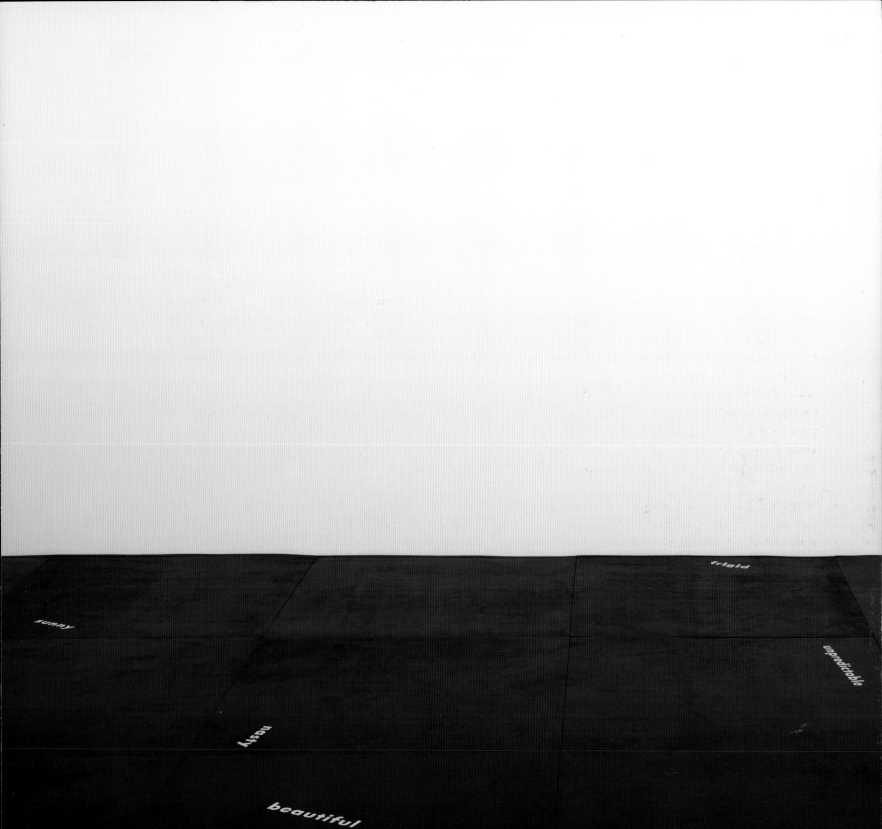

From **To Place – Book IV: Pooling Waters** (Two volume set)
1994
Volume I
96 pages, 27 colour, 25 duotone reproductions
Volume II
176 pages, 36 texts, 1 colour, 3 duotone reproductions,
clothbound, 26.5 × 21.5 cm each
Edition, Verlag der Buchhandlung Walther König, Cologne

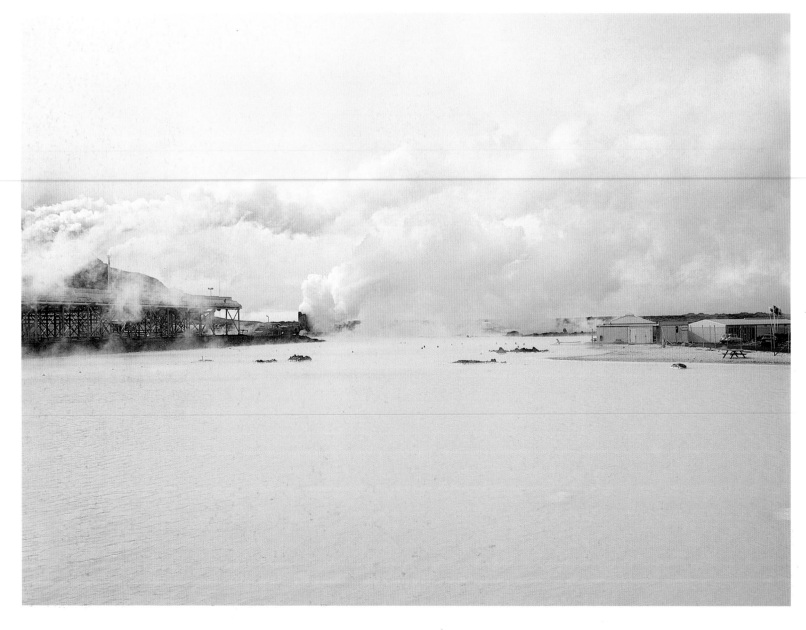

Artist's Choice

B A D

bad weather
bad weather
bad weather
bad weather

B A D

bad weather
bad weather
bad weather
bad weather

SNAKES
LIZARDS
TURTLES
CRIME
VIOLENT

B A D

bad weather
bad weather
bad weather
bad weather

VIOLENT
CRIME
SNAKES
LIZARDS
TURTLES

B A D

bad weather
bad weather
bad weather

NONE
TURTLES
LIZARDS
SNAKES
VIOLENT
CRIME

SNAKES
LIZARDS
TURTLES
VIOLENT
CRIME

B A D

bad weather
bad weather
bad weather
bad weather

The Cold Blood of Iceland

Contents

I Can't See the Arctic Circle from Here 1992

An Old Woman Who Has Passed
Her Life …
1984
Gouache on paper
35 × 36 cm

The Arctic Circle is geometry in the Arctic Ocean. It mimics the shape of the planet. I'm approaching the Circle now, a few miles more and it will be visible. Circles aren't usually hard to see and mostly they all look the same except some are larger than others. The Circle's out there in plain sight on the water. This far north nothing obstructs the view. The ocean opens an enormous, unbroken expanse of horizon up here, big enough that there won't be any problem seeing an arc of the world. And I want to see the arc. I want to see the shape of things from among the things themselves.

Since I first saw the Arctic Circle in geography class years ago, I was touched by how perfectly its entire existence coincided with that of the globe's. I knew the Circle was real, that it was no mere mapping device, since its synchronous relation to the earth was too unlikely. If the Arctic Circle were an ironic form it would simply be visible. Visible but imperceptible, camouflaged by its own perfect mimicry. The Circle would be there, like the ocean but never present to the eye.

It's the night side of morning, the sun sits on the horizon. The raking light gives each pebble in the road the large dense shadow of a rock. I'm dodging these rocks and rock shadows as I drive along, unable to distinguish their actual size. By seven I've arrived at the sea; the sun picks itself off the horizon and the indecipherable orange glow begins to dissipate.

This road goes right up to the Arctic Circle, almost the top of the globe. The road is tangent to the Circle. And I know if the Arctic Circle is tangent to something then it must be something. I pull over as I approach the northernmost point and settle down to look.

After staring out at the ocean for some time I notice that everything out there coincides precisely with the earth's surface, making it extremely difficult to distinguish the Arctic Circle. At the far right and left of the view the ocean gradually and symmetrically drops off and out of sight. It gets darker farther out, as any arc would. But the curvature is so subtle it appears flat. If I didn't already know the earth was curved, I never would have seen the arc at all.

A diffuse whiteness lifts off the surface, making it less a thing and more a part of other things: a part of the ocean and a part of the sky and even a part of the weather. Unaffected by the growing lateness of the day the sun remains high. Slowly a surround of distant specks, various other celestial bodies, become visible. The emerging multitude reveal their light without shedding it. But I continue staring out – believing it's only a matter of time before the subtleties of the view reveal themselves and the Circle becomes the discrete, perceptible thing that it is.

First published, *Pooling Waters*, Vol. 2, Verlag der Buchhandlung Walther König, Cologne, 1994. Revised 1995.

an old woman who
has passed her
life on a small

Scottish cliff island

is uncomfortable
on the mainland

because she can
not see the
edge

I Go To Iceland

Recently I was reading the letters of Emily Dickinson. I began wondering about travel and Iceland too, wondering about the insistence of my returns here, about their necessity and the migratory regularity of them.

I began to wonder about travel altogether, about the how and the what of it. Travel isn't so simple as a car or a train, or as nameable as a place. I thought about Emily Dickinson's travels. From the first letters she wrote, she told her correspondents she didn't go out, she didn't want to go out, and that she would not come to visit them. Dickinson stayed home, insistently. Locking herself into her upstairs room, she invented another form of travel and went places.

Dickinson's invention was multiplication, her self and empirical reach: everything that could be felt, heard, seen or smelt, everything perceptible, everything discernible from 280 Main Street, Amherst, Massachusetts. Perceptible includes the library; somehow Dickinson used the library as an empirical source, somehow she learned to consume its contents sensorially. Her library was not a source of acquired knowledge, not a tool of the intellect. Her library was simply another perceptible thing becoming another entrance, confirmation of all she sensed in the world. Even her poems about God and being dead are eyewitness.

Sequestered from the world, knowing that going out into it hampered her ability to invent it, Dickinson stayed home except for two summer trips to Cambridge as a child and one to Washington later in life. Dickinson stayed home when Ralph Waldo Emerson visited her brother next door. Her business was circumference.

In her verse Dickinson spoke of Vesuvius at home. In her letters she said she travelled when she closed her eyes, and that she went to sleep as though it were a country. In her room alone, she said, was freedom. Here she wrote one thousand, seven hundred and seventy-five poems. Dickinson shut her eyes and went places this world never was.

For the time being, Dickinson's here with me – in Iceland. For someone who stayed home she fits naturally into this distant and necessary place. Her writing is an equivalent of this unique island; Dickinson invented a syntax out of herself, and Iceland did too – volcanoes do. Dickinson stayed home to get at the world. But home is an island like this one. And I come to this island to get at the very centre of the world.

First published, *Pooling Waters*, Vol. 2, Verlag der Buchhandlung Walther König, Cologne, 1994. Revised 1995.

How Dickinson Stayed Home
1992–93
Solid aluminium, plastic
25 units, each 12.5 × 12.5 cm by variable length
Installation, Margo Leavin Gallery, Los Angeles
Collections, The Museum of Modern Art, New York; The Museum of Contemporary Art, Los Angeles

overleaf, **From the Windows of Emily Dickinson's Bedroom**
1994–95
C-type print
20.5 × 25.5 cm
From the series of 8 photographs

Island Frieze 1994

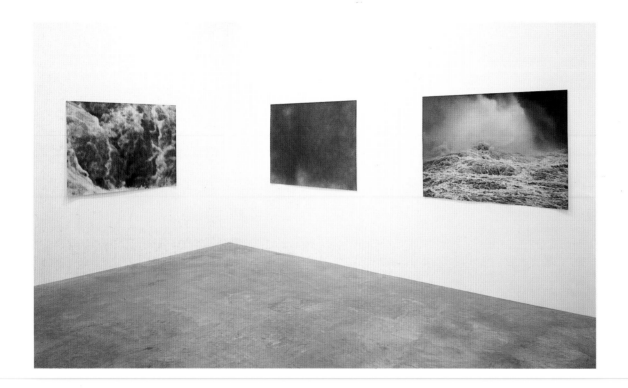

Pooling – You (details)
1996–97
7 sequenced offset lithographs
installed as a surround
106.5 × 147.5 cm each
Installation, Matthew Marks
Gallery, New York
Collection, De Pont Foundation for
Contemporary Art, Tilburg, The
Netherlands

From the sea the land is frieze and scroll. The rock island whose surface is obscured occasionally by greenery is chalky and light in colour. Round and well and generously spaced bushes grow ideal from its earth; they are a dense green, almost too dense for the green to be perceptible. Each bush is filled out by its black shadow to a perfect circular symmetry. These bushes and bush-shadows guide my gaze as I stare continuously at the changing view.

The island landscape is composed of washed-out ochre rubble broken up intermittently by large and weathered rock outcroppings – and the sense of dust compressed into mass – and the sense of a thing that has once been another thing – and the sense of a hardness impermeable and ungiving and cooked up a long time ago. The mostly cloudless blue sky assures a sunlight of relentless and unchanging intensity. No shadow except the small shade of each bush perforates the dense light. As I squint my eyes from the water, I imagine the reality of this island baking without end in the bright heat.

The island is still. This simple fact is the dominant presence and counterpoint to the turbulence of surrounding ocean and sky. The land mass appears to end or begin at the water. It is an ending or a beginning in the form of a line. On one side of it crowds a static mass and on the other the sea laps and merges.

In the foreground of my view the tumultuous manner of the ocean plays out. The surface heaves chaotically, undulating without repetition everywhere. White caps lick at its very-blue self. Troughs of rolling space submerge and mingle with crests. In the mid-ground of the view the water flattens improbably into a plane and line and

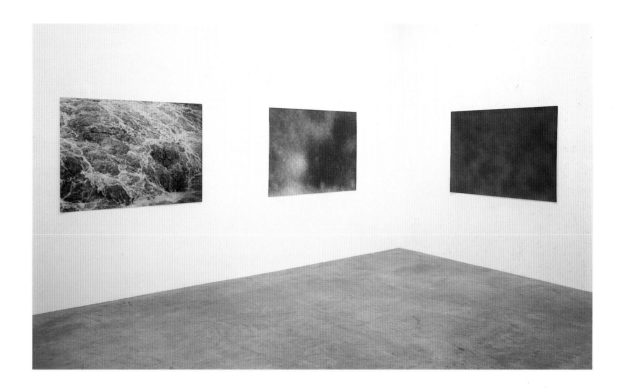

an idea of the bottom of the island. The line is level and flat and straight and perfect in the manner these adjectives suggest – perfect also in the way that perfect things can be.

As the taxi moves along in the water the island conveys its linear changing and repeating and constant form to me. As I watch the island slowly unfurl it is continuously changing in a radical and complete manner though the changes as they occur are imperceptible. I feel my anxiety at not being able to see them. It is the experience of losing control – of a sudden closing in. It is the experience of something escaping just as I am about to recognize it. I feel the anxiety of a thing disappearing slowly; of its change attenuating to a visibility one increment beyond my ability to see it.

As the taxi moves along in the water the island conveys its linear changing and repeating and constant form to me. The frieze of it is constant – an elongated shape further extended by these long afternoon hours taxiing beside the island elevation. The frieze of it is marked by a leitmotif of ochre outcroppings. The scroll of it is the island unfurling as I cruise along; the scroll of it is the repetition happening in different places, making each repetition different. The island unscrolling becomes a short narrative with various and unique incidents interrupted by unchanging recurrence. Each recurrence adds to the mass, making an island circumnavigable in one hour when taken at a reasonable, not swift, and not dawdling pace.

Returning to the beginning, the island-frieze ends, forming a repetition that is the final difference – a relapse in view from a different point of view, totalling the island into interval.

8 April, 1994, Hydra, Greece.

From **To Place – Book IV: Pooling Waters** (Two volume set)
1994
Volume I
96 pages, 27 colour, 25 duotone reproductions
Volume II
176 pages, 36 texts, 1 colour, 3 duotone reproductions, clothbound
26.5 × 21.5 cm
Edition, Verlag der Buchhandlung Walther König, Cologne

Jan Howard How did you choose Iceland, and how has it come to be so central to who you are?

Roni Horn **Iceland could have been anywhere. But as it turns out, Iceland suited my needs. In fact, it seemed to form a perfect complement to my native home, New York. Iceland is the place where I have the clearest view of myself and my relationship to the world. By clearest view, I mean a view that is less constricted by social conventions.**
 But it was my exposure to Emily Dickinson that crystallized this understanding. I spent a great deal of time reading her poems and letters. Her life and work settled about me in surprising proximity, and with surprising familiarity. Reading Dickinson I had the impression of remembering things I never experienced.

Howard A recurring theme in *Pooling Waters* (in particular in the text 'Island and Labyrinth') is the idea of Iceland as a place where you centre yourself in the world. As early as 1983 you published a note about Iceland: 'The island: a reflecting pool.' How do these ideas relate to your notion of inner geography?

Horn **The concept of the labyrinth is important to my idea of centring. Centring is a matter of belief and endurance. A labyrinth is designed as a puzzle, a path of confusion, a purposefully indirect course to the centre. I have always understood Iceland as being big enough to get lost but small enough to find myself.**
 My image of Iceland as a reflecting pool is the idea of using nature as mirror and measure. It's an understanding of oneself through a knowledge of what real, not imposed, limitations are. My experiences in the ice-and-ash desert interior of Iceland provided an especially accurate reflection. The desert is a mirror. It's a self-sufficient, self-contained environment. It gives nothing. What you take from the desert is who you are, more precisely. This is the subject of another text in *Pooling Waters*, 'Anatomy and Geography.' In it I refer to an inner geography. Inner geography is a plain knowledge of oneself. a kind of common sense gathered through repeated exposure to distilling experiences. Inner geography maps peace of mind in the world as it is and not as I imagine it.

Howard You once commented that since you were in Iceland you no longer understand place as a noun, that the word now only makes sense as a verb.

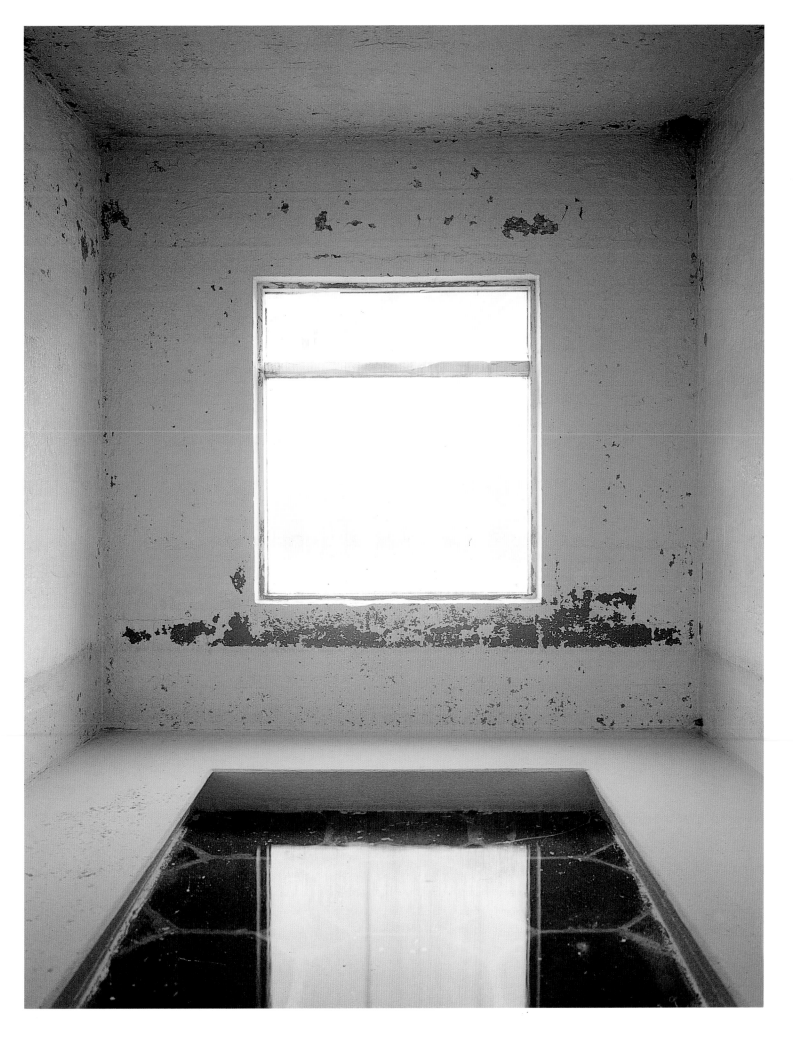

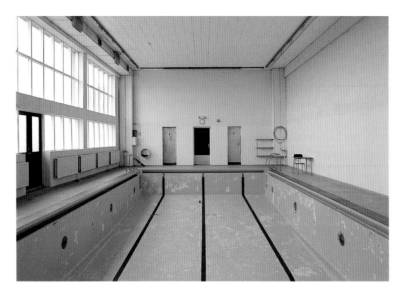

Swimming pool, children's school,
Skogar, Iceland
1997
Previously unpublished colour
photographs from the artist's
archive

Horn **Iceland is primarily young geology. Young geology is very unstable. In a literal sense, Iceland is not a very stable place. Iceland is always becoming what it will be, and what it will be is not a fixed thing either. So here is Iceland: an act, not an object, a verb, never a noun. Iceland taught me that each place is a unique location of change. No place is a fixed or concluded thing. So I have discarded the noun form of place as meaningless.**

The verb, to place, as an activity in itself is a condition of being present. In the context of *To Place*, the verb operates dialectically. The view is not separate from the viewer: Iceland viewed is something other than Iceland. Similarly, the identity of the viewer is not separate from the place viewed.

In *To Place*, the viewer is me and the view is Iceland. This reciprocity is key to this body of work. Each volume is a dialogue spun directly out of this interchange.

Howard What is your interest in the book form?

Horn **First, the book is a unique manner of address. Of great importance is the fact that the book is an intimate form; it mostly engages the individual individually. I can think of no other form so inherently private.**

Second, the individual must be active in the exchange, not simply encountering or locating a given book but consuming it. In this sense the book chooses its audience. It has a circumscribed appeal.

Third, reading or looking at a book offers a peculiar analogue both to lived experience and to the experience of landscape: sequential relations, mostly cumulative and irreversible, order them.

Fourth, and for me of special importance: a book is not a simple object: within its particular identity it harbours the path of its assimilation into society. The book is distributed. As a mass-produced portable object that is financially accessible, the book goes out into the world, ultimately locating itself where it is most desired.

Fifth – and very close to this idea of distribution – is the ubiquity and reach of a book. Its portable nature allows the book practical, physical transit to virtually any place in the world. So although the book may wind up where it is most desired, there are no limits to the location of that desire […]

Howard Your first book, *Bluff Life*, records drawings made in Dyrhólaey. Your trips to Iceland usually involve travelling around the country. Why did you decide to stay

in Dyrhólaey and live in its lighthouse for two months?

Horn At the time I decided to stay at Dyrhólaey I had travelled extensively around the country for years and I had visited this particular lighthouse on a number of occasions. The lighthouse was originally designed for a full-time keeper, though it was subsequently automated. So I knew there were basic living accommodations, that there was a room with a view overlooking the bluff, and, since it was in an isolated, sparsely inhabited area, I could be quite alone.

I wanted to go to a distant and solitary place and be there. I didn't set out to accomplish anything. I wanted to be in this place, with not much to do and not much going on. I knew that whatever came out of it would be about who I was and about what this place was. I thought of it as a bluff life because I was literally living on a bluff and because I was wagering that I could find intimacy in this isolated, pared-down way of life.

Howard How do the *Bluff Life* drawings relate specifically to Dyrhólaey?

Horn The *Bluff Life* drawings came out of Dyrhólaey but I am not sure how they relate to it. I am sure that they are a result of being at Dyrhólaey and nowhere else. Another place would have elicited a different body of work. Dyrhólaey's influence is very particular, like every place.

Clearly there's no attempt to depict the bluff. The drawings are a matter of the myriad and unaccountable influences of just being in a place. Perhaps it's a form of memory.

Howard So was drawing part of your routine while you were staying at the lighthouse?

Horn I did many small drawings. It was very casual. I got up usually late in the morning and went walking along the cliffs. I spent a lot of time watching birds since there were enormous populations of many species. I spent long hours lying along the grassier nooks or nestled into rock niches, watching the sky and water. It rained a lot and I read and drew in the lighthouse. At night and through most of the early morning until two or three I walked along the cliffs, keeping track of the incredible night life there. Another cycle of bird life plays itself out in the late night. It may be obvious already, but it was an extremely quiet time. In the book *Bluff Life* I use the phrase: 'Letting the sea lie before

From **Bluff Life**
1982
Watercolour, graphite on paper
32 × 30.5 cm each
5 from the series of 13 drawings
Collection, The Museum of Modern
Art, New York

Reproduced in **To Place – Book I:
Bluff Life**
1990
36 pages, 14 colour
reproductions, clothbound
26.5 × 21.5 cm
Edition, Peter Blum, New York

me.' I wanted to get to the point of no expectations, the point where I could be up there on the bluff in a kind of conscious passivity. This 'letting' is coming as close as possible to being present without influencing the course of a place or thing, without influencing the existence of something, while still being fully cognisant. I was keying my life to an awareness of the place. I really did get to the point where I could see birds intercepting other birds in flight and, although it may not have been grain by grain, I had a keen sense of the beach sands levelling.

Howard I know as early as 1984 you incorporated text in some of your drawings. But you first used text in your sculpture at the time you published *Bluff Life*. The sculpture *Thicket No. 1* (1989–90) incorporates the same Simone Weil quotation from her *Gravity and Grace* that you use on the back cover's endpaper in *Bluff Life*: 'To see a landscape as it is when I'm not there.' How does the text function in these works?

Horn In *Bluff Life* I use the quote to situate the work. Both the book and the drawings are introduced in terms of where *Bluff Life* came from and how it came about. It came out of my desire to be present and to be a part of a place without changing it, even as my mind knows that such a desire can only be thwarted. Perhaps *Bluff Life* tries to describe some of what this place is without the viewer's presence. But then, it's obvious that someone made these drawings. These drawings are the seeing of a place.

In *Thicket No. 1* the Weil text is part of the landscape, in this case a slab of unfinished, straight-from-the-mill aluminium, with an articulation partially visible on the far side, in another material. This articulation is situated so as to be present only as something different or enigmatic from the initial viewpoint. When the viewer walks around the piece the articulation reveals itself as text. It says in effect, 'what you saw before you walked around to this side was' – in this instance – 'a landscape as it is when you are not there.' The moment you become conscious of your separateness from a place, contradiction arises. *Thicket No. 1* gives the viewer an inkling of not being present. The contradiction lies in the instinctive weighing of that inkling against the reality, the certainty, of one's physical presence in that same moment.

Howard Did the *Bluff Life* drawings inform the development of the pigment drawings you began making in the early 1980s?

Horn I know that some viewers see visual relationships between the *Bluff Life*

Thicket No.1
1989–90
Solid aluminium, plastic
5 × 162.5 × 122 cm
Installation, Leo Castelli Gallery,
New York
Collections, Erzbischöfliches
Diözesanmuseum, Cologne; Tate
Gallery, London

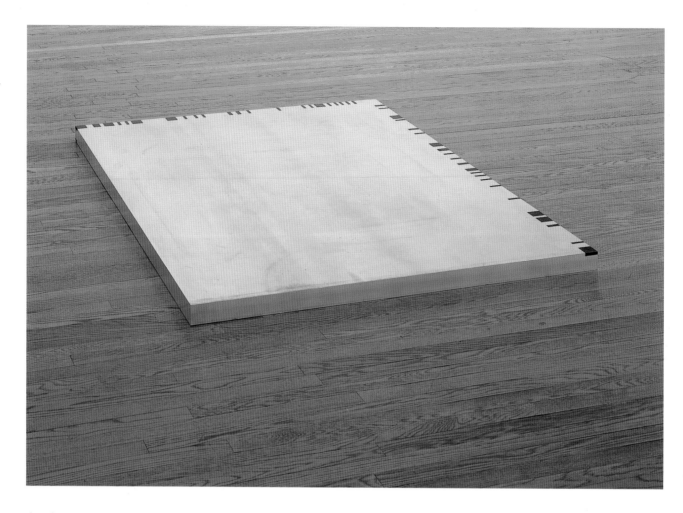

drawings and the pigment drawings. For me, the process and intention of these bodies of work are so utterly different that I consider them unrelated.

Howard *Bluff Life* is a selection from a larger group of drawings you made in Dyrhólaey. What is the importance of keeping this selection together as one work?

Horn **There were hundreds of little drawings. I selected thirteen. Seeing a group of related drawings gives a feeling for the language you're dealing with, its expanse and its limitations.**

Howard Did you always intend to reproduce the *Bluff Life* drawings as a volume of *To Place*?

Horn **I didn't make the drawings with the idea of a book in mind, and I haven't been going to Iceland with the idea of putting what I glean from this place into books. But when I first started going there, I was thinking about a work that would take the form *To Place* is presently taking, but without knowing what the subject would be.**

Howard Presence seems central to the subject of *Folds*. Did you photograph the sheepfolds to document a dialogue others have had with the landscape?

Horn **Ostensibly I was interested in the folds as structures. Most of the forms are unique to Iceland. But this subject allowed me a way of photographing the landscape itself. I could use the image of the fold to impart a sense of place.**

Howard There are photographs in all the *To Place* books, but you resisted photographing

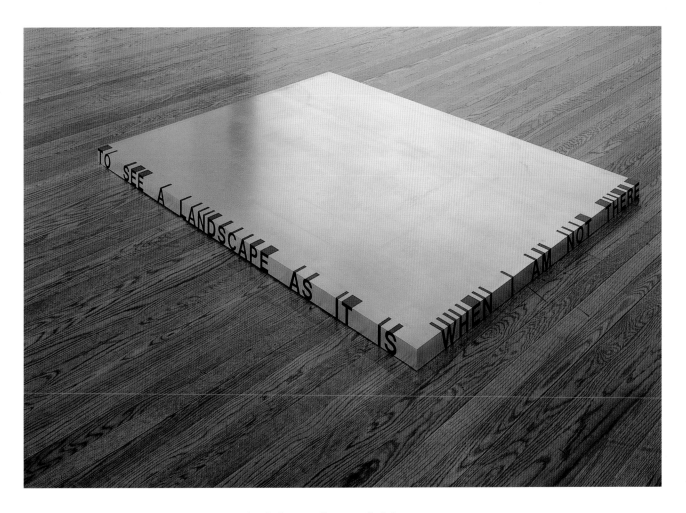

Iceland when you first travelled there.

At what point did you feel you could photograph Iceland?

Horn My first extended stay in Iceland was for four and a half months. I was twenty-three years old. My desire was just to be there. I didn't even bring books. I thought it would distract me too much from being there. But somehow I thought I could spend part of my time photographing the island. After a few days there I tried to take a photograph. But with my first attempt, the place disappeared on me. Photography – or really doing anything much more than just being in a place – requires the imposition of a whole other consciousness. I hadn't been in Iceland long enough to simply be there.

To be capable of simply being in Iceland and no more is an achievement. On that first visit Iceland was still a fantasy to me, still too unknown. All the dazzling features, of which there are many, isolated themselves. It took months just to get past this veneer of sensationalism and picture-postcard possibilities. I felt as though I were watching some long, drawn-out criminal act. But this was the kind of picture I was limited to because I didn't yet know the island. It was obvious that photography was going to interfere with my interests and I didn't have it in my power to take the pictures I wanted to take anyway. I put my equipment in a locker in the bus station in Reykjavík and took off for four months. This was 1979. It really wasn't until 1988 that I again ventured out in earnest with a camera in Iceland.

Howard Describe what it's like photographing the island – you're outside most of the time, aren't you?

Horn Framing a shot in the landscape is contingent on the direction of the wind and

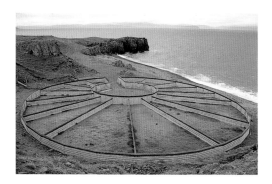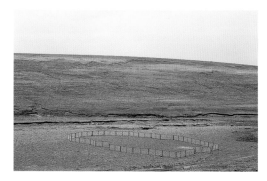

From **To Place – Book II: Folds**
1991
72 pages, 34 colour
reproductions, letterpress text,
clothbound
26.5 × 21.5 cm
Edition, Mary Boone Gallery, New
York

the local topography. What I mean is that my photographic options are limited by the weather and the features of the land. Accepting and working with these geographic realities give the image a stronger sense of place.

Visibility often varies from minute to minute. I wait for the moment when the cloud cover drops lower or moves higher to allow for a more characteristic image of the scene. Many of the photographs are taken when it is raining or snowing. The wind is frequently so strong that even with a tripod it is impossible to hold the camera still. I like the fact that the images are entirely subject to such circumstance.

Howard The photographs from *To Place* are beautiful and the quality of the photo-offset lithography is remarkably rich. Do you think of the beauty of the images as a way of engaging the viewer?

Horn The volumes up until *Pooling Waters* are printed on uncoated paper. I wanted to minimise the descriptive value of the image and place the emphasis on atmosphere. When you print on uncoated paper, which is much more difficult than printing on the more commonly used coated paper, the ink, instead of sitting on the surface, is absorbed into the paper and mitigates the flat, graphic nature of the printed image.

While you gain atmosphere or presence when you print this way, you also lose detail, contrast and a certain clarity. Thus, my choice of paper was a key decision in focusing the emphasis of the first books. I made an equally conscious choice when I selected a matt coated paper for the first volume of *Pooling Waters*, in order to emphasize the graphic quality of the photographs.

But to answer the question more directly: the printing technique itself is routine. I have not enhanced the images in any way. The impression of unusual beauty derives from the subject. I selected images to convey the most accurate sense of place. I have more dramatic images that I chose not to use. I don't rely on beauty *per se* to engage the viewer, but I am not about to deny it where it exists either. The case of *Verne's Journey* is unique. It is the only direct address to the landscape itself in any of the works thus far. It focuses on a very small area of Iceland that is known for its extreme diversity of geological form. This diversity is compressed into a narrow peninsula. Snæfellsnes is recognized throughout Iceland as being an unusual and dramatic site.

Howard Do you prefer to exhibit your photographs in books rather than on gallery walls?

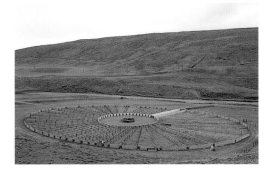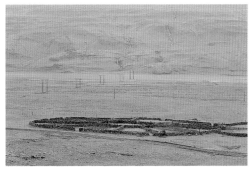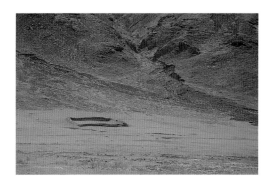

Horn This is an important issue for me. I have never thought of myself as a photographer. Cindy Sherman, for example, is a photographer. Her invention lies in the photographs themselves. Each photograph is a compound image, like a hall of mirrors, belying its origin. In my books the photograph is about information and conveying the palpable nature of Iceland. For me the book form and its means of address are what I'm working with. The photographs play a supporting role.

Howard What is the effect of letterpress in the books?

Horn Letterpress uses individually set lead type to create the impression. Lead type, because it is literally pressed into the paper, is physically, not literally, located on the page. For the typographic images, especially in *Lava*, it allowed me to elevate the visual impact of the book's text components so they carry the same weight as the photographic components. Because each word is pressed into place there is a greater sense of specificity as to its location. Lead type also conveys textural quality and a very high degree of resolution in each letter. For me, it allows the possibility of a typographic drawing. *Lava* is a book of drawings.

Howard Mapping is a recurrent form among the typographic drawings in *To Place*. What is your interest in mapping?

Horn Mapping is a way of ordering things visually. In *Lava* and *Verne's Journey*, I made maps based on location, chronology and quantity. I used them to provide context for what is in the book, and to provide context for the reader/viewer. I think of the maps in *Lava* as combining with the images to form a biography of Iceland.

Howard *Lava* includes photographs of molten rock not *in situ*, but as arranged on a light table in the studio. Why did you isolate the lava from the landscape?

Horn *Lava* is the substance of Iceland. In a sense each image articulates the feel of a different part of the island. Taken together, all of this debris – 'debris' because lava there is so common – conveys the tangible essence of this place. *Lava* in isolation allowed me to share something of the feel of the island without depicting it. I didn't want this landscape reduced to description. (I have yet to reproduce Iceland's landscape

From **To Place – Book II: Folds**
1991
72 pages, 34 colour
reproductions, letterpress text,
clothbound
26.5 × 21.5 cm
Edition, Mary Boone Gallery, New
York

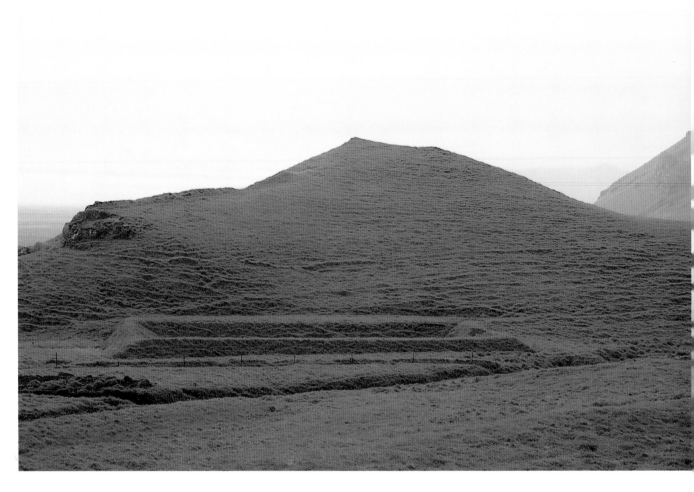

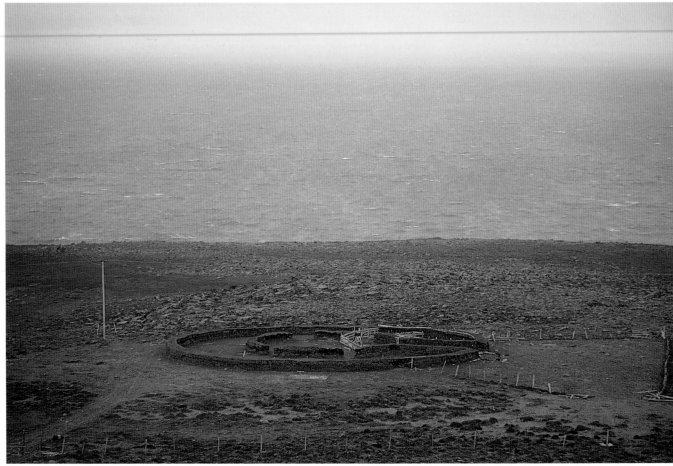

directly except in *Verne's Journey*, where it is disguised as science fiction.)

There is, however, one overall view of Lakagígar, just to give a sense of how all this debris comes together. Laki was the largest lava flow in historic times, in 1783. It dramatically altered the shape as well as the demographics of the island. You have to remember that this is a place where many of the sites have been seen only rarely by anyone. I use these images to compose a surrogate island.

Howard One of the most striking aspects of these images is that even though the lava has been abstracted through the photograph to a graphic remount, the image tells what the lava is made of, and how it feels to the touch, and how it came into being. Isn't this what you find so fascinating about Iceland's landscape in general?

Horn **Certain things were apparent to me from my very first visit to Iceland. One of those things was *how* Iceland is what it is. Natural forces gather there in a self-evident fashion. The how of everything is, simply put, visible. Iceland is so young that the forces of entropy have not eroded the island's geologic origins.**

Early on in my travels I was often confused about the origin of things – certain land formations were so perfect in their geometry that it seemed they had to be the product of artifice. I simply couldn't believe they were natural. It took me a long time to overcome my doubt.

Howard Iceland is a crucial inspiration in your work, but literature seems equally important. Among your memories of Iceland in *Pooling Waters* are frequent instances when the landscape brought to mind the writings of Emily Dickinson, Wallace Stevens, Eudora Welty, among others.

Horn **Literature has given me some of the most exquisite experiences of my life. With books I feel the intimacy of the act of consumption. My experience of Iceland is very close to that intimacy.**

My relationship to the world has always been heavily mediated by language. Words, fragments and images from literature (as well as from other sources) surface everywhere in my experience, whether waking or dreaming. I frequently perceive nature as imitating art, as if the landscape had a memory for literature […]

Baltimore Museum of Art, 1994.

overleaf, From **To Place – Book III: Lava**
1992
96 pages, 16 colour, 29 tritone reproductions, letterpress text
Edition, the artist, New York
clothbound
26.5 × 21.5 cm
Edition, the artist, New York
bottom right, Also **All the Lava Fields of Iceland**
1992
Letterpress print on paper
47 × 62.5 cm
Collections, The Fogg Art Museum, University of Harvard; The Museum of Modern Art, New York; Milwaukie Art Museum; New York Public Library, New York

lraun presthólahraun kerlingarhraun efrihólahraun hildarselshraun rauðhólahraun langahraun myrarselshraun aðaldalshraun mölhvammurhraun ferjuhraun hávhraun skinnstakkahraun þeistareykjahraun fosshraun borgarhraun sveinahraun leirhnúkahraun böndhólshraun neðra-böndhólshraun kjalarhraun tóarhraun langahraun laugaland shraun langahraun hraun hvarfdalahraun hraun bensastaðahraun tungahraun leirhnúðahraun sveinahraun nýjahraun burfellshraun vogahraun markhraun geirastaðahraun cldhraun skaliahraun kóthahraun háhraun timuhraun spanarhraun bugðuhraun yri-sauðahraun innri-sauðahraun sauðahraun stakkahlíðarhraun berserkjahraun n aun rauðahraun hraun laufahraun hraun geirlandshraun kambhraun eldhraun nýja-eldhraun grāhraun skálmabejarhraun kristnitókuhraun keilihraun urðarhraun vörðuhraun hallormstaðarhraun kóthuhraun álfahraun flesarhraun sandahraun bekkjahraun prestahraun veruhraun burstarhraun kodhr

View in a Room (Notes on the *Key and Cues*) 1995

Key and Cue No. 1763
1994
Solid aluminium, plastic
5 × 5 × 70 cm

When I was first becoming familiar with Emily Dickinson's poetry, I found myself reading the 'Index of First Lines'. Since Dickinson did not title her poems, each was posthumously given a number as a reference point. Each of the 1,775 poems is referred to by number or first line. The Index plays an especially important role in locating a Dickinson poem. In reading it, I found myself thinking of the first lines as entrances, tools, maps, signs, connections. I found myself thinking of alphabets, keys, and elemental things, thinking of things that were self-contained yet only beginnings.

From the 1,775 first lines, I selected lines which are complete statements and detached them from the poem. In these instances I saw the statement as self-contained. While the content of the first line may carry the content of the poem it was taken from, the content of a *Key and Cue* has more to do with the particularity that distinguishes Dickinson's poetry as a whole. Each *Key and Cue* carries these qualities and speaks as the part that contains the whole.

The first lines I selected had to have a certain containment (closure) and yet a certain complexity that would hold this completeness open. An experience of a *Key and Cue* is the experience of an entrance; but since every entrance is also a point of departure, the *Key and Cue* prepares the viewer for departure. So while the *Key and Cue* is an object present like any other everyday thing, it is also a cue, a prompt, a signal to something that can only be brought here, wherever the viewer is, by the viewer. Each *Key and Cue* is a view in a room. These are some of the first lines I used in the *Key and Cues*. They are mostly statements of fact.

AIR HAS NO RESIDENCE, NO NEIGHBOR.

TO MAKE A PRAIRIE IT TAKES A CLOVER AND ONE BEE

FREQUENTLY THE WOODS ARE PINK –

LUCK IS NOT CHANCE –

THE ZEROES – TAUGHT US PHOSPHORUS –

TWO BUTTERFLIES WENT OUT AT NOON –

THE MOUNTAINS – GROW UNNOTICED –

Key and Cue No. 351
1994
Solid aluminium, plastic
5 × 5 × 179 cm

Dickinson's recognition or identification of these facts is surprising. She refers, simply and bluntly, to what's happening out there in the world. Her lines are precise – obscure and unthinkable – but obvious, even inevitable. It is their profoundly mundane character which is so unexpected and which balances them on the edge of recognition.

The reading activity in a *Key and Cue* and where the text takes you is somewhere other than where the physical object is – but they're not far from each other either. These parallel and simultaneous layers in the experience address the viewer separately, appealing to different levels of awareness. The *Key and Cue* functions as a hybrid experience, taking the viewer to different places. And although these places are not the same, they exist in the same place. This is both a necessary paradox and a sensible, even predictable circumstance.

The present tense is powerful. To tune the entrance of a given experience to an individual's now is startling and acutely focused. That focus on the now has always been important to me, and it's one of the places I found mirrored in Dickinson.

I HEARD A FLY BUZZ – WHEN I DIED –

Awareness is primary in Dickinson – awareness as tangible in the present tense even after it has become past tense. Dickinson's writings give me the sense that she lived her death, like living anything else, noting it very much in the manner she observed butterflies or clover. Knowledge in Dickinson's writings is posterior to experience, and experience is always in the present tense.

Some time ago I was in a garden looking out among very old trees. It was an experience of pure synthesis, where nothing has a hierarchical relationship to anything else and where everything is somehow equally present, equally affecting. In that realization I recognized Emily Dickinson. Dickinson's language scraped the symbolic out of a form that is wholly symbolic and caused it to function in a non-abstract, non-figurative manner. When Dickinson's words cohere into ideas, they are at once and incomprehensibly both metaphysical and physical. In reading Dickinson's work, I am in the world as it is. There is even the sense of circumventing perception, point of view – cutting out everything in-between and every distinction between the viewer and the view. Her writing doesn't take you anywhere. It confirms 'here', as it is, unimagined, even unseen. All of the paradoxes that constitute her language define it as some other form, one I have no name for. Each thing she names – bees, peace, clover – breaks with symbolic meaning and takes its place in the actual.

From a longer text, 'Among Essential Furnishings', written in response to questions of Judith Hoos Fox, Curator, Davis Art Museum, 1995. Revised version, 1999.

An Uncountable Infinity (For Felix Gonzalez-Torres) 1996

A field of waves, perhaps an ocean: up close two different tiles recur to form a puzzle in which the image of water coheres. Among these tiles a labyrinth forms as my gaze loops between them and the water.

I am attracted to the little edibles, brightly coloured candies mostly, as I partake of the metaphor that would send you around the world. I am a bumble bee – who would pollinate the world with you.

Images of sky, birds, water, murdered people, and certain colours stacked in measures of some critical mass. Each image forms a slice of some lesser but more acute mass that as a letter going out into the world whole, is only completed when it finds the place it is destined for. Each slice signals its own fate.

I am cast into an abrasive and exquisite consciousness.
Everything of me, everything outside of me is tempered by it.

I am laid open.
My skin, my consciousness are turned to glass.
The only risk left now is that of openness.

Framed by sky, buildings, roadways, and signs, the photographs out there on the street – between food and home – bring enigma near. And these enigmas recur. They are riddles that implicate public and private, you and me, us. They open up an Egypt-like space, when Egypt was mostly desert and when Egypt was mostly desert without parking lots, even vacant ones.

An aggressively pretty picture like ones I have seen often in family albums – a memory of two women I have never met. The brilliant colours of the flowers that grow upon their grave only flowers, in their brevity can sustain.

I have no need for sleep, not really,
because closing my eyes brings no distinction to me.
I have vision that works through time, it is always present
and I see even when I don't want to.
I do not need to open my eyes.
My vision has no limitations.
It exceeds me.
It is a relentless, involuntary consciousness.

Gold Mats, Paired – For Ross and Felix
1994–95
Pure gold (99.99%)
124. 5 × 152.5 × 0.002 cm each
Installation, Sammlung Goetz, Munich, 1995

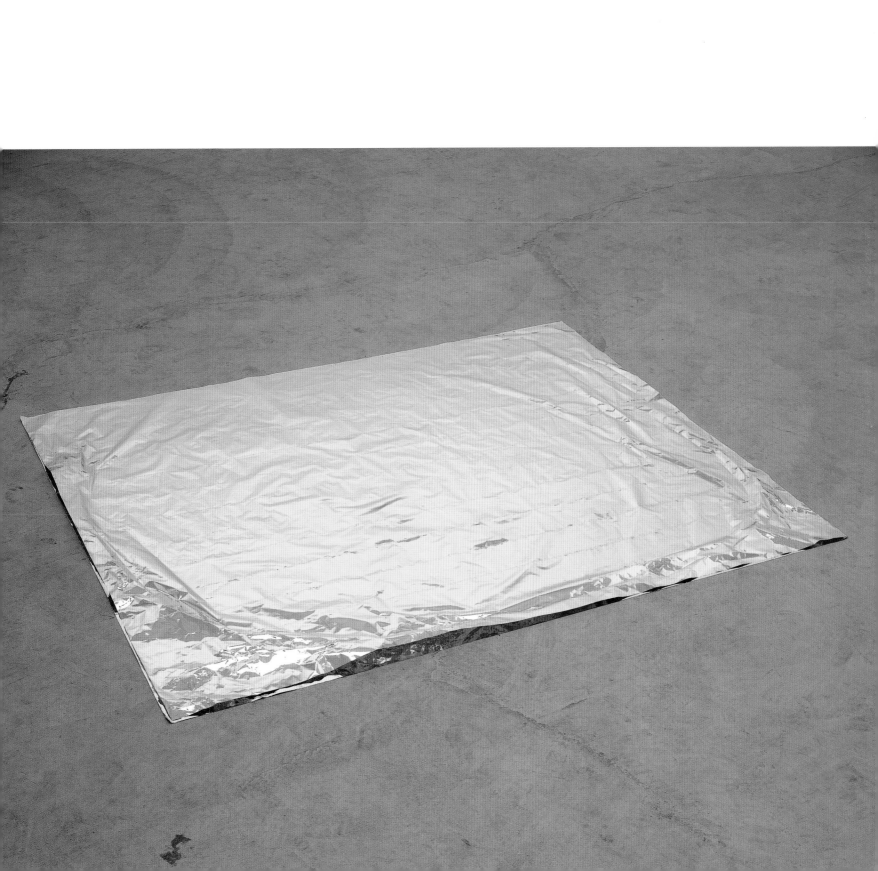

Felix Gonzalez-Torres
right, Installation, Castello di
Rivara, Turin, 1991
l. to r., Untitled (version of
Untitled [Lover Boy], 1989)
1991
Blue sheer
Dimensions variable

Untitled (March 5th) No. 1
1991
Paired mirrors
ø 30 cm each

opposite, Untitled (Placebo –
Landscape for Roni)
1993
Gold cellophane-wrapped candies,
endless supply
Ideal weight 545 kg
Dimensions variable

Two times in precise and harmonic communion.

The present is no longer fugitive
because my future is in the present tense too.

Your knowledge of foreign fruits – papaya, for example – charmed me.

I can participate in possibilities only conceivable now.
If I were inclined to murder it would allow a perfect indifference.

You ask me to identify the words that name me – my portrait includes you, Felix, like
the sky that is a reflection of you.

My awareness has expanded.
It allows me the experience of things closer to nothing than before.
I am witness to their necessity.

Each light bulb on a wire burns a hole in the place it illuminates. Through these holes
the world rushes. The world accumulates about them, self-evident.

A modesty becomes me, the ruse of an intolerable circumstance.

Sometimes your sweets are dusty and I won't take any.

My defenses are tender, gone mostly.
I try to believe that I don't need them anymore.
But my circumstance remains within the realm of normal accidents
and the weather. Of these I am subject still and happily;
they allow me the comforts of uncertainty.
Doubts are my hope.

Each string of beads gently brushes me, parting as I pass through like sedge in a grazing
breeze. They make a dry, complex sound: plastic bead against bead against bead that
extends my relation out into the world more visibly and beyond me. Among these
beads I become the gravity of some other place.

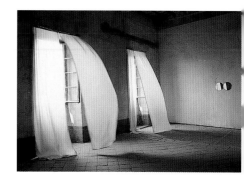

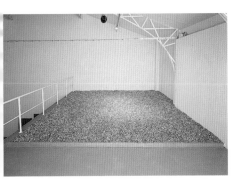

When night comes, I can't participate in *that* darkness.

You call them vultures – but when I look I see a bird or two or three maybe – like dust – suspended in dust of another form.

 You filled your closets with clocks, and your living room and drawers with hundreds, perhaps thousands, of toys: Chilly Willy, Goofy, Lucy, Fred Flintstone, Charlie Brown, Wilma, Minnie Mouse, Pebbles, Rocky, Mickey Mouse, Barney, Betty, Huckleberry Hound, Astro, Sprout, Dough Boy, Casper, Pee-Wee Herman, Little Red Riding Hood and the Wolf, Tasmanian Devil, Donald Duck, Miss Yvonne, Elmer Fudd, Yosemite Sam, George Jetson, Elroy, Dino, Pluto, Snoopy, Roadrunner, Globey, Baby Minnie, Baby Mickey, Chairry, Bam Bam, Tom and Jerry, Cruella De Vil, Popeye, Bugs Bunny, Mister Magoo, Scrooge McDuck, Ignatz, Sneezy, Jolly Green Giant, Quick Draw McGraw, Chip n' Dale, Bullwinkle, Daffy Duck, Huey, Louie, and Dewy, Wile E. Coyote, Droopy, Krazy Kat, Mr. Peabody, Poindexter, Sleepy, Olive Oyl, Pepe le Pew, Pigpen, Happy, Alvin, Grumpy, Porky Pig, Natasha, Eddie Munster, Little Lulu, Abbott and Costello, Brutus, Boris, Daisy Duck, Yogi Bear, Dudley Do-Right, Dumbo, Snagglepuss, Bashful, Dopey, and Tweety Bird – to name only the ones I remember. And some like Mickey and Minnie were a multitude unto themselves. They crowded the mantle and the tables, and the shelves you had built specially for them. They began spreading to other rooms, and then congregating on the floors …

 You took snapshots of your toys paired in unlikely couples and posed in various domestic settings: Eddie Munster and Charlie Brown tucked lovingly into bed together; Barney and Fred standing at a dog-dish-watering hole; Mickey, Minnie, and the extended family gathered for a group portrait on the kitchen counter; Sneezy, Dopey, and the rest of the crew convening for the evening by the old red salad bowl. I have this image of you: up all night with Bam Bam and Elroy working things out.

 You lived the latter part of your life with a future that was mostly certain. (And one that you were privy to.) That private and individual fact saturated your being and became a source. It was one of the contexts from which you acted. Each act acquired the meaning you constructed and the one that lay constant and oceanic beneath: active but unspoken.

 You are more nature, another weather. Your life is a rare form of transparency through which I have observed the world becoming more present to itself and through which I too have become more present to myself.

February 1996, written for the occasion of Felix Gonzalez-Torres' memorial.

Weather Girls Interview with Collier Schorr (extracts) 1997

From **To Place – Book VI:
Haraldsdóttir**
1996
96 pages, 30 colour, 31 duotone
reproductions, clothbound
26.5 × 21.5 cm
Edition, Ginny Williams, Denver

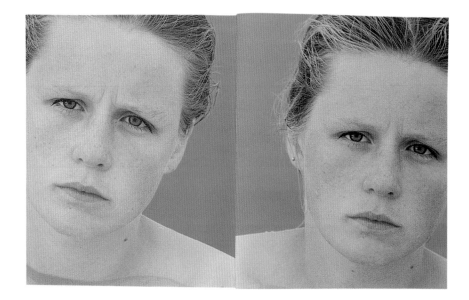

Collier Schorr For the last twenty years you've been visiting Iceland to work on To *Place*, a series of books which you have called an 'Encyclopedia.' What does it mean to make an Encyclopedia?

Roni Horn Originally I thought I would model the series after Plato's *Dialogues*, but then I thought that would be a bit much. After completing the sixth volume, I felt more comfortable with the term 'encyclopedia', which was intended in its most literal sense, as a collection of knowledge. I titled the work *To Place* because I think of Iceland as a verb rather than a noun, in the sense of an active thing, be it geographically, meteorologically, historically, experientially and so on. Each volume is a dialogue between Iceland and myself, the view and the viewer; I see the series structure as a metaphor for the fluidity of identity, since each book alters the meaning of the previous ones.

Schorr The most recent volume, *Haraldsdóttir* (1996), is comprised of 61 almost identical headshots of a young woman who looks like she's just about to leave the water. She's wet, and never gets wetter, she's almost dry, but not quite. It's like a flip book of someone running on the spot. You've used similar images of the same woman in *You Are the Weather* (1994–95), an installation that wrapped around a room. Why these images and how does the work change from book to wall?

Horn I went over to Iceland knowing what I wanted, but not knowing what it looked like. It had something to do with this woman I had met, something about her face communicating an idea of place. I photographed her in water all over Iceland. In *You Are the Weather* I wanted to establish an equivalence between my position as a photographer, the position of the subject and that of the eventual viewer. I edited out all of the material where she was looking off camera. It's in those moments where she becomes an object and in turn where a hierarchical relationship is established with the viewer.

Schorr One has immediate access to the fantasy of her lapping over you.

Horn One of the issues at work in the installations is the paradox of its simultaneous intimacy and anonymity. The photographs have an erotic edge, but no matter how much time you spend with her you will never get any closer to her. She changes and expresses different personalities – if you isolate out the different sequences, she looks first like a hockey player, then a pouty sexy standard; she's a multitude of things. Those

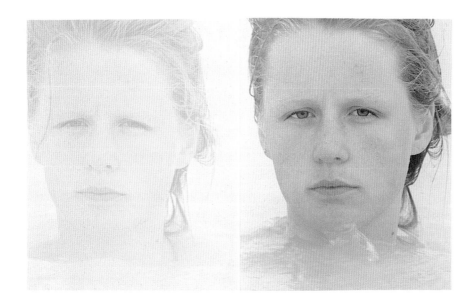

changes, that range of emotion – she looks like she's irritated, like she's angry – were in fact provoked by the weather. It's the sun in her eyes, it's snowing, it's windy. When you are in the room with her it's as though you've provoked those responses; you become the weather. For me, this work is deeply erotic in a genderless way.

On the other hand, in the book you have a hierarchical relationship with her. You hold her in your hands, you manipulate the view, and she comes to you like waves to the shore.

Schorr You've mentioned the disappearance of gender before.

Horn I have always felt androgyny as central to my relationship with both myself and the work. As far as an individual's experience with a given work goes, I throw the issue of self-identity back out to the viewer. This is especially true of *You Are the Weather*, since the backgrounding of my gender invites another range of questioning and exercise of imagination. In the installation, you're in the round. Unlike the book it does not provide a beginning, middle and end. The installation begins anywhere and ends there as well. Its duration is your endurance. I have always thought that the viewer walks into the room and performs the work, although I don't think of my works as particularly theatrical. The more theatrical a work is the more it tends to pacify the viewer. I want the viewer to take an active role.

Schorr It's the difference between watching and participating in the unravelling of an idea.

Horn **Exactly, even with the *Gold Field* (1980–82). I knew when I first made that piece people would talk about how sensational it was. But it's one thing to choose a material that's sensational in itself – as gold is – and it's another to take something ordinary and turn it into something sensational. Conceptually these are two completely different ideas. I was interested in the fact that the individual's experience of gold is never separate from the cultural perception of it. Too much is riding on it, both economically and mythologically. Few of us have had the experience of gold as a simple physical reality, which is what *Gold Field* gave you, spread out there on the floor.**

Schorr When we looked at *Gold Mats, Paired (for Ross and Felix)* (1994–95) in your studio, you spoke about how you finally understood the appeal of gold. We also talked about

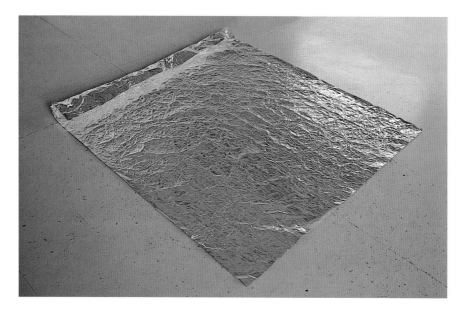

your father who was a pawnbroker, a particularly charged occupation. Your family's income was directly related to the trade and sale of that material.

Horn **The pawn shop thing definitely got me into gold at an early age. But the interesting point was not that gold was this very special material, but that it actually seemed like any other not-so-special material. I became fascinated with why gold was the source of so much mythology and attention.**

When I first made the *Gold Field* and saw it laid out on the floor, I was a little shocked by it. Because it really seemed just this side of nothing. Something like a doormat; in one sense another version of Duchamp's *Breeding Dust* (1920) – a simple levelling of value. But then I started to fold the mat and noticed this outrageous, deep, deep, erotic orange light emanating from the folds. That was how I discovered the splendour of gold. But I wasn't really happy that I had to fold the gold to get the light, it felt too didactic. So I left it as this four by five *Gold Field*, on the floor. It was very plain, but loaded with all these interesting ideas. Thirteen years later, after a lot of work with pairing, I met Felix, who loved the *Gold Field*. In *Gold Mats, Paired (For Ross and Felix)*, one mat is placed on top of another. From between them, firelight glows. It peeps and seeps out from the edges. The light is the gold reflecting off itself. Here is the metaphor for intimacy. Here is the eroticism, the splendour and mythology of gold. As Henry Thoreau wrote: 'I want a closer relation to the sun.'

Schorr For me gold is awash in sentimentality. Your work has a complicated relationship to its emotional content; the way it avoids the sentimental creates a compelling tension.

Horn **My instinct is that maybe the piece would never have existed without Felix and that's why I named it the way I did. I don't know about sentimentality but perhaps sentiment. There is very little irony in my work, but there is a lot of paradox. The logic in my work tends to be developed out of experiential as opposed to primarily visual concerns. This is a small distinction but that order of value helps me to exclude all affect from the work. There are no gratuitous gestures. There is no distinction drawn between appearance and reality. I try to keep them confluent.**

Schorr Your work operates as a continuation of some of the formal arguments of Minimalism – notably, the sculpture as space – but also on a level that would have to be seen as adversarial to Minimalism's rejection of illusionism and metaphor. What does it

Limit of the Twilight
1991
Solid aluminium, plastic
22 × 22 × 137 cm
Collection, Städtisches Museum
Abteiberg, Mönchengladbach,
Germany

mean to recall the objects of Minimalism and does a borrowing of form necessarily signal subversion?

Horn **There is no question that my work related profoundly to the experience of Minimalism, but I think that its focus lies elsewhere. I'm not afraid to flirt with the look of Minimalism. Metaphor is an interesting thing, though. As much as one might work against metaphor, to try and develop a form or a work that is not like anything else, one finds this isn't possible. People will bring metaphor to a work as a way of relating to it. There is a lot of metaphor in my work and that is mostly because I put it there.**

Schorr When you started making Minimal-style objects were you thinking about what you were taking and what you weren't?

Horn **Yes, certainly. For example, *Asphere* (1986), a 13-inch solid steel object that is slightly distorted from sphericity, is especially flirtatious with the Minimalist look, but it is a homage to androgyny. It gives the experience of something initially very familiar, but the more time you spend with it, the less familiar it becomes. I think of it as a self-portrait. Another example would be *Limit of the Twilight* (1991), an aluminium rod with '49 MILES' cast into it in black plastic lettering. It was inspired by an experience I had as a child. I distinctly remember hearing a radio DJ introducing Thelonius Monk's '*Crépuscule* with Nellie', and I've always felt that *crépuscule* – which means twilight – was a word whose beauty approached that of its meaning – its sound alone suggests the nebulous and immeasurable. Twenty years later I was reading a science article and I discovered that twilight has a limit, which is forty-nine miles. From this came the work,**

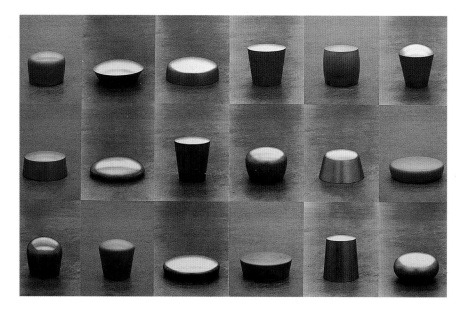

Pair Field
1990–91
Solid copper, solid steel, 2 groups
of 18 unique forms of equal
volume installed in 2 separate
rooms, each group of 18
comprising 1 of the paired objects
Various dimensions, ø 25.5 - 38 ×
10 - 25.5 cm
right, Details
opposite, Installation, room 1 and
room 2, De Pont Foundation for
Contemporary Art, Tilburg, The
Netherlands
Collection, De Pont Foundation for
Contemporary Art, Tilburg, The
Netherlands

an ultra-mechanical, ultra-quantitative object, but in its presence you witness only the pathos of the measurable.

If you look at the early work and what I'm doing today it's pretty consistent. I would talk about the *Gold Field* in terms of mythology, in terms of symbolism and metaphor, and that is what allowed me to take that material and lay it out. The resemblance to Minimalism is just that and no more. Essentially, it revealed the physical reality of the symbol. It is Marilyn Monroe's Norma Jean.

Schorr Upon first viewing *Pair Field* (1990–91) I found the work a bit sterile. After some time I began to recognise the pairings and grasped the notion of sameness. Detecting the homosocial landscape was a crucial step in understanding the motivation behind what I had at first seen as a heavy -handed reworking of a sculptural argument. Here you go beyond a simple theatre of perception and into a theatre of identification.

Horn I can easily imagine your initial perception of sterility. The work is comprised of two identical groups of eighteen objects; each group is placed in a separate room of different dimensions and arranged to produce different interrelationships. It's like a passage in *The Last of The Mohicans* (1826) which compared the experience of walking through a field with that of walking through a forest, describing the way each experience gives you a different sense of yourself.

The dryness of the look is largely to do with the idea of having two identical things, which necessitated the use of machine technology. If you want something identical, you can't make it by hand, it's just not credible. In terms of its appearance, the nature of the objects themselves, I needed to develop a collection of completely different forms that were clearly related to the other members of the group – I needed a strong sense of cohesion to hold the eighteen objects together as one thing. That paradox, of difference and identity needed to be contained in that group. And then I compounded it by duplicating the group while changing their interrelation. Finally, you have two identical things with different identities.

Schorr That piece recalls Allan McCollum's *Over 10,000 Individual Works* (1987–89), where he displayed a multitude of objects that were all slight variations on each other. Here was a completely heterosexual reproductive impulse couched in an ironic production.

Horn I instinctively understood the development of the *Pair* form, with which I began

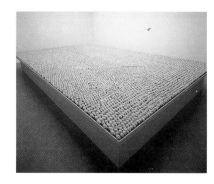

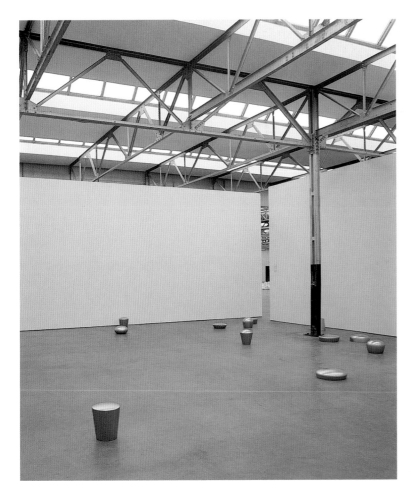
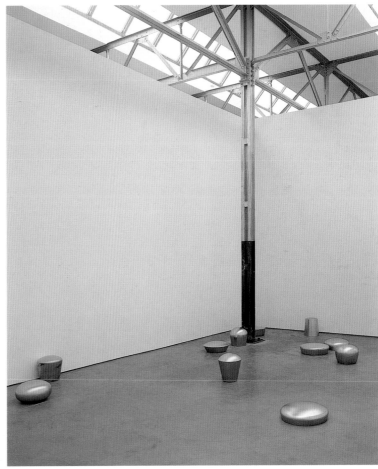

Allan McCollum
Over 10,000 Individual Works
1987–89
Enamel on cast hydrocal
Dimensions variable
Installation, Stedelijk Museum,
Amsterdam

working in 1980, as profoundly (although not exclusively) related to my sexuality and androgyny. But to really talk about the *Pairs* you have to go back to *Piece for Two Rooms* (1986–97). In this work, two identical objects are each placed in separate rooms. The viewer goes from one room to the other, finding in the first room a unique object, but in the second, a familiar experience – because it is the experience of an identical thing. So you go from the experience of something that is completely unique to the experience of it as reductive. And of course the idea of the identical is a paradox since you always have a here and a there, a now and a then. These distinctions go to the foundation of identity.

Schorr It also strikes me that with *Pair Field*, you made a very political piece in a masked form, at a time when artists like Kruger and Holzer were making such literal works.

Horn While my work clearly has political and social content, it is, as you point out, camouflaged – anyway it certainly isn't explicit. But I always thought of Kruger as a very ambitious artist. Not so much in terms of the artefacts produced or the gallery shows, but in terms of her extension: the fact that she consistently sought to broaden the context, distribution and reach of her work. I also felt strongly about the very early Holzer work, but generally the content of this work cannot withstand a more material or object-oriented approach without some compromise of its meaning. I think this is evident in the later work. Work with explicit political content tends to suffer in direct proportion to the permanence of form employed. Work dominated by political and social issues must bear in its form the ephemeral nature of its content. It must risk disappearance […]

frieze, No. 32, London, January/February, 1997, pp. 43-47.

The Nothing That Is 1998

From **To Place – Book IV: Pooling Waters** (Two volume set)
1994
Volume I
96 pages, 27 colour, 25 duotone reproductions
Volume II
176 pages, 36 texts, 1 colour, 3 duotone reproductions, clothbound, 26.5 × 21.5 cm each
Edition, Verlag der Buchhandlung Walther König, Cologne

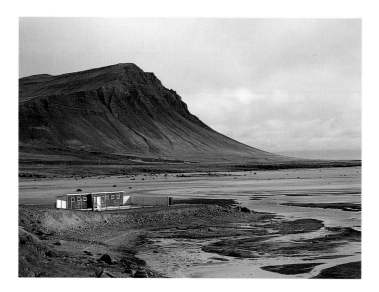

I grew up with trees. I count them among the most important things in my life. But oddly, when I come to Iceland with its treeless landscape I never miss them. Over the years of travel here the open, unobstructed views of the island have also become very important to me. These views are the trees of Iceland. Because one of the great qualities of the tree is its way of relating things: the earth to the sky; the light to the dark; the wind among its leaves to the stillness that surrounds it; the small spaces within the tree to the vast spaces it inhabits. But here in Iceland the view takes on this role and in doing so expresses a wholly unique sense of place. The weather is a big part of this sense of place, and a view here is never without it. It allows a glance at the rolling past and sometimes what's to come. The view contains the distant and the near often with equal clarity. It lays out the shape of the planet with an expansiveness and transparence that exists in few other places. It holds you in a solitude that enlarges you. The view relates you to the world, which in Iceland is mostly a world of natural things, rocks and vegetation and water: complex, multifarious things that are also remarkably young.

I grew up in New York City and its early suburbs. My first trip abroad, when I was nineteen, brought me to Iceland in 1975. Since this trip I have come here once, sometimes twice, a year, every year. On one occasion back in 1979 I was able to stay for five months. During this period I spent a fair part of my trip out in the landscape with a tent, travelling by motorcycle. By the end of my stay, my travels had taken in the whole of Iceland, most notably the interior. The scale of the island made an enormous impression on me. It is big enough to get lost on, but small enough to find oneself.

Since then the roads, especially rough (but having a way of keeping a traveller in close contact with the land both physically and psychologically) have been primed for faster, more convenient travel. However, with the paved road and accelerated rate of passage, I noticed my relationship to the land becoming more distant, even abstracted. To maintain contact with it required greater responsibility on the part of the traveller. This seemed a small price to pay for the extensive quality of life enhancements that such development brought.

Among the many advantages that Iceland enjoys (though I do not believe recognizes) is its unique position in history relative to those of other modern cultures. That is, because Iceland has experienced delayed economic development, the country is fortuitously out of sync with other modern cultures. You are out of sync because your environment, unlike those of other modern societies, is still intact. This places the country now, at the end of the second millennium, in a critical position to observe the destruction that other societies have brought upon their environment through flawed

and unchecked development and exploitation of natural resources.

Iceland is in a position to bear witness to these dubious fruits. And with this knowledge it must question the extent and nature of development it wishes to pursue. Unlike other cultures whose major development is yet to come, Iceland does not suffer from rampant illiteracy or ignorance brought about by a censored press. You do not suffer pervasive poverty, overpopulation, or recurring natural disasters in the form of drought or floods or unchecked disease.

Up until very recently it seems that exploitation of natural resources has been limited by the size of your economy. But now as the economy grows society is more willing to consider ever more invasive methods of expansion in the service of ever increasing levels of affluence. And with this new potential a greater willingness and most definitely a greater technological capacity to alter nature is pressed forward as necessity.

As a foreigner I have watched with admiration Iceland's persistent refusal to allow foreign influences to compromise your language. I have admired the extraordinary literature that you have invented and which is such a profound part of your identity. And admired also your early architecture and indigenous building, much of which was unique to your culture. And then there are the many enlightened aspects of your social culture: among the most notable – the pragmatic tolerance of intimate union and the responsibility taken for its outcome.

But now when I come to the island I wonder whether you see the fast rate of change that your society has undergone, especially in the last fifteen years, and how it now begins to affect the fragile ecologies that surround you. The nature that surrounds you is especially fragile and especially glorious because it is unusually young. And now, because your capacity to alter and destroy nature is greater than ever before.

Modern society has experienced a seemingly uncontrollable appetite for consumption – often well in excess of individual need. The resultant over-exploitation of natural resources has destroyed many underlying organic equilibria, now experienced in part with ever more frequent catastrophic events of weather as well as pollution, both in the form of toxins and invasive manipulations of the environment. Iceland is in a unique position to make choices that will bear profound influence on your identity as a people. It is a choice that must reflect your knowledge of other cultures and how they have, at first through ignorance and then through wantonness, destroyed their environment. In the United States, for a large portion of the population, one's health is no longer one's own. It is degraded by toxins that, though unseen, are so

From **To Place – Book IV: Pooling
Waters** (Two volume set)
1994
Volume I
96 pages, 27 colour, 25 duotone
reproductions
Volume II
176 pages, 36 texts, 1 colour, 3
duotone reproductions,
clothbound, 26.5 × 21.5 cm each
Edition, Verlag der Buchhandlung
Walther König, Cologne

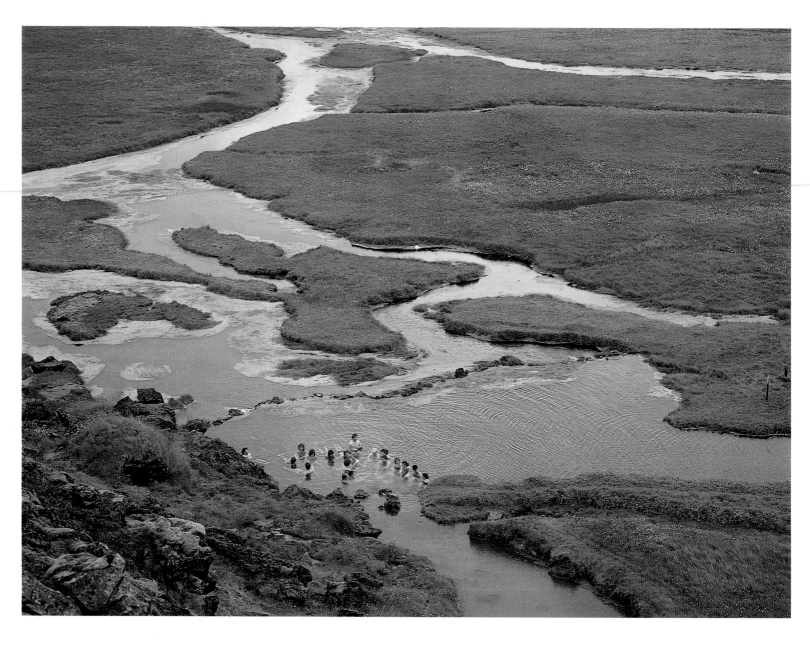

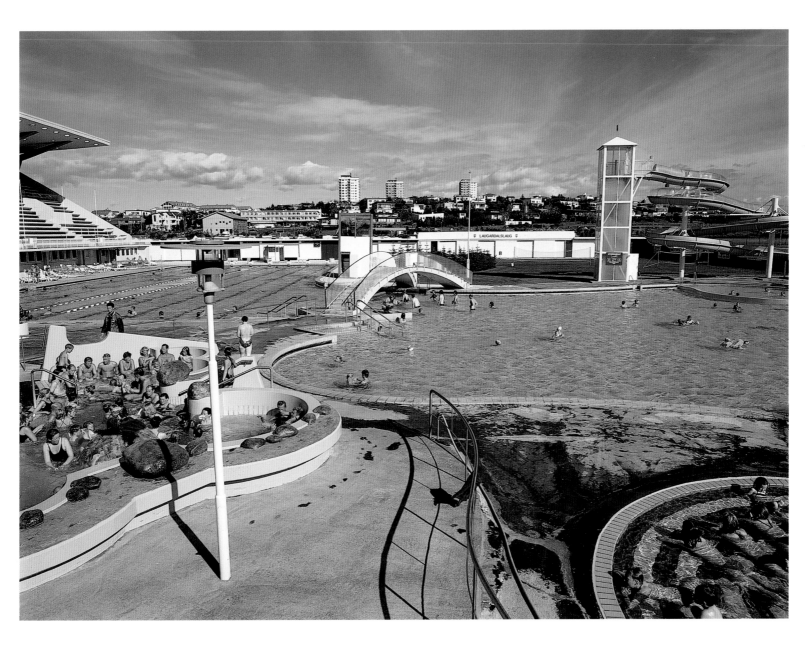

pervasive they cannot be kept out of the body. These are choices that must assess the real value of development, not just in physical and quantitative terms, but in spiritual and psychological terms as well. Many post-industrial – and/or over-populated countries have polluted their waters, their land and their air. In some places to an extent that makes them uninhabitable. It is a pollution that is toxic and most often irreversible; a pollution that has deeply undermined quality of life. It is also a pollution that destroys humanity even as humanity fights for the right to pollute.

Excessive development and the over-use of natural resources is a choice. It is not based in necessity. Development that results in the introduction of pollution to the Icelandic environment cannot be regarded as a viable option because it will ultimately, though not immediately, degrade it. Today you have the knowledge, looking out over the ocean that so fortunately surrounds you, that other cultures early on may not have had and later did not care to respect. You have the choice to implement the use of renewable resources to sustain your economy. You have the choice to utilize less invasive methods of production and the choice to produce things that do not result in irreversible damage to your environment.

This essay is motivated in particular by my fear of the loss of the Highlands. But as I write I see that it applies to the island ecology as a whole. With each visit to Iceland I become ever more anxious concerning these issues. Yesterday as I was driving out of Reykjavík I was shocked to find myself comparing the view out of my window to that of New Jersey in the early 1960s. Iceland has born a deep influence in my professional development, which in the case of the artist is a deeply personal matter as well. Over the years I have felt the necessity for my returns here growing greater still.

Which brings me to the crux of the matter – facing the potential loss of the Highlands. It won't happen right away – first you will build a dam in some remote corner. (In the belief that you can power X, Y, and Z industries, in the belief that you can expand your economy and affluence. You won't concern yourself now with the fact that these industries will most likely pollute the water and the air. You won't discuss the fact that this is really the first of many dams.) Then you will flood a valley. (Never mind that it is the only valley like it in the world. Perhaps you will convince yourself that the resulting lake has it's own beauty, perhaps even accept it as more nature – even though you know it is really artifice.) Along with the dam will come the roads and various other civil infrastructures. (And you will drive these roads and imagine a truly wild place – perhaps one that no one has ever been to before – but in reality these roads will turn the whole of the interior into a parody of itself. Now it is merely more domesticated

space.) Along with the roads greater access for everyone. And along with this access a level of use that will quickly dominate and subdue the wild and its unknown.

The Highlands, while often referred to as a vast, empty space, is neither vast nor empty. The American poet Wallace Stevens names precisely what the Highlands is so profoundly full of. In the poem *The Snow Man* he writes:

> *For the listener who listens in the snow*
> *And nothing himself, beholds*
> *Nothing that is not there and the nothing that is.*

In my experience the Highlands is one definition of the nothing that is. And the nothing that is – is synonymous with the real. *The real cannot be mitigated without destroying it.* The Highlands are not for everyone. To enhance its accessibility is to deny what it is. An individual who wishes to travel the Highlands must be equipped in oneself both psychologically and physically – and not the other way around. The Highlands is a desert, it will take your measure. It cannot be made into a place for the casual visitor.

Your Highlands – while lauded as the single largest unexploited block of land in Europe – is, relatively speaking, tiny. (Not even the size of Ireland.) Once you have compromised it, in a matter of one generation or two at the most your identity as a people will be altered. Iceland will become a place dominated by human presence. The balance of identity will tip – away from the majestic solitude of the interior – away from a place largely unoccupied, uninhabited, unaltered – away from the possibility of a place more clear and clean and pure than not – away from a place that expresses vastness and absoluteness, and all that exceeds us – away from a place that is exquisitely distin-guished simply in being what it is – away from the many things I come to this island to experience. These are the things Icelanders have been nurtured on, perhaps unknow-ingly, that give this culture its remarkable difference; its utterly unique sense of place.

Iceland has a choice. The destruction of the Highlands is not necessary to your cultural and economic development. You do not need its resources to live comfortably. Encroaching upon its fragile ecologies even to what is erroneously perceived as a small degree will destroy it. It won't necessarily be an obvious change, but it will be radical and it will be irreversible. It will weaken your identity as a people by taking away from future generations unaltered and unoccupied land that exists today in a scale that expresses and sustains the power and presence of non-human things.

Morgunbladid, daily newspaper, Reykjavík, 6 September, 1998.

Some Notes on Icelandic Architecture (extract) 1999

Sundhöll Reykjavíkur, 1928 (Gudjón Sammúelsson)

This building, deeply appreciated by its devoted regulars, offers what is perhaps the most curious architectural experience in Reykjavík. In the pool hall are all the simple riches of an open and well proportioned space. The tiling of the pool in Iceland's favoured green is a delectable detail and so too are the vertical clerestories of small-paned windows that light the hall with a distilled and shadowless light all day long. Down below: for women, over: for men, are the locker pools – literally a collection of lockers and changing rooms. Here is a structure disguised in the language of the familiar and the everyday. But this is only a disguise. Featured in its labyrinthine floorplan is a network of doors that are simultaneously open and closed. This may sound like a simple matter but they present a beguiling paradox – one that even as I stand in front of them eludes my grasp. It's impossible to imagine where a network of such doors can lead; but like a game of chess, it is too complex and the options too many to be known except through the play. The tiling of this collection of rooms and corridors is simple. In fact the white horizontal tiles that cover the walls and halls are plain as tiles go. But it was with some surprise when I recognized that these tiles covering the entire structure both inside and out formed one surface; for there are no edges in this collection of spaces, no simple planes intersecting in lines. Instead the corners, interior and exterior, are melded into a single curved surface as are the top and bottom of this structure. Inside and out are fused into a singular unending form. Intensifying this Möbius of tactile and spatial continuity are the mirrors that reflect and compound the complex symmetries of the locker pool. Add to this collection – the peep holes; a peep hole punctuates each locker door at eye level. Through it you see the next peep hole and door and hall and on and on. Here in this net of intricate and uninterrupted visual flow is an expression of (mostly) unseen but sensible infinities at least one of which is the voyeur's labyrinth.

Morgunbladid, daily newspaper, Reykjavik, March 1999. Revised April 1999.

On *Yous in You* Interview with Franziska Baetcke 1999

Franziska Baetcke In 1995 you were commissioned, for the project 'Bahnhof Ost Basel',
to design a passage for pedestrians and cyclists on the east side of the railway station in
Basel, Switzerland (*Yous in You*, 1997–2000, permanent installation). Before accepting,
you asked for six months to think about the project. How did you use this time?

Roni Horn **Architectural commissions are interesting because you have a naturally
complex circumstance – a real world circumstance, rather than a setting which has
been idealized to allow for an aesthetic event. These situations interest me because of
this complexity, but a commitment comes out of a knowledge of the particular place.
I needed time to understand the site and how I could work with it. During this time
I decided to work with the pedestrian walkway area because there was more
opportunity for interaction with people using the space.**

Baetcke In Basel you were confronted with an unusually scaled architectural project.
How did you define the necessary specifics of your project?

Horn **In this situation you have a walkway which will eventually be used by pedestrian
commuters on a daily basis. How can you be present in this public context in a way that
recognizes and engages the site? What is the address to the daily user of the site?
That is where the issue of necessity resides: in establishing an integral relationship
to the site. *Yous in You* is site-specific. The concept is generated in dialogue with the
architectural setting and social circumstance presented by the site.**

Baetcke Was your decision to do the project influenced by the fact that the architectural
frame had been designed by Donald Judd?

Horn **There is an idea of the work as a homage to Don. That occurred to me when
I made the commitment.**

Baetcke The rubber and concrete elements in your piece are cast from moulds of a
particular basalt formation found in Kirkjugólf in Iceland. Why did you choose this motif?

Horn **It's an unusual formation, but it typifies Iceland. You have basalt all over the place**

Yous in You
1997–2000
Photograph, marker pen
Working drawing for walkway of
alternating hard and soft rubber
tiles cast from Kirkjugólf
geological formation
l. 83 m
Depth 5 cm
Permanent installation, Basel
Bahnhof Ost, Basel

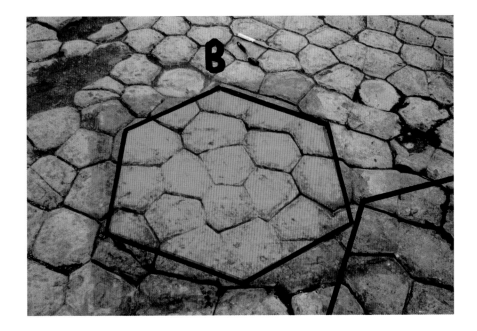

but this particular form of it is unique. Part of the concept of *Yous in You* was based on the possibility of placing one part of the world into another. Geographically, I am taking a little piece of Iceland and inserting it into Switzerland. But then, you might ask, why this mass of rubber? There is an idea of place associated with the responsivness of rubber. Rubber is not reflective like stone. Stone is hard, it reflects sound and it reflects your weight. Rubber absorbs your weight, it absorbs your sound, it absorbs your presence. That is another idea of place. But Iceland itself is not part of the picture. It just happens to be this form which I knew would express a completely different idea of place. The idea of *Yous in You* was to compound Basel with another place, to compound the simple geometry of the architecture with another form.

Baetcke The working title of your project was *Interior Landscape*; the actual title is *Yous in You*. What does this title mean?

Horn *Yous in You* refers to the plural within the singular. When you move through a space there is the objective physical presence of the individual, but then there is the interior voice or voices. And for me the idea of *Yous in You* is in recognizing and cultivating these voices – increasing the volume of them by creating a situation that promotes self-reflexive awareness in a public setting. *Yous in You* is a landscape to catalyse self-reflexive knowing. It's a mirror for the unseen.

Baetcke How did you get to this image?

Horn The floor is an interesting form because it's a structural necessity but it's also an interface between personal, visceral, physical reality and geology, geography and what's out there. It is the place where you connect yourself to the globe. The other issue is that I don't want to go into these vast spaces and occupy them. That is, I don't want to fill the space up, either physically or visually. I'm interested in giving a nuance to the setting which allows someone, in using the space, a more active relationship to it. That's it. Still it's not a simple thing. The realization of a piece like this is extremely complicated technically and physically, but it's dominated by this basic idea of human dialectic. This is what I want to be strongly present in the form. It would have been another thing to put something in the space that fills it up and overwhelms. People are

Yous in You
1997–2000
Collage, ink
Working drawing for walkway of
alternating hard and soft rubber
tiles cast from Kirkjugólf
geological formation
l. 83 m
Depth 5 cm
Permanent installation, Basel
Bahnhof Ost, Basel

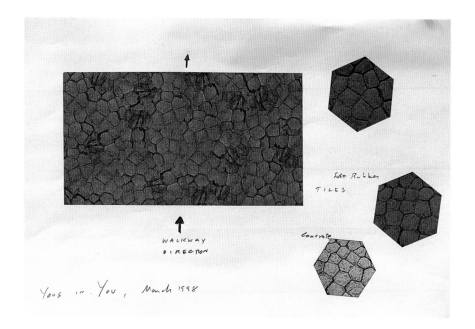

impressed with things that overwhelm them. That's something to do with the human condition. If you are overwhelming you are present. But the experience of being overwhelmed is always the same – in the most exotic setting or the most mundane one. I want the experience that differentiates you from the rest of the world. This is where I try to place the work – in this dynamic.

Baetcke You decided to place your work on the floor only. Did you ever think about integrating the walls or the ceiling?

Horn **Not once the concept started to become more clear. *Yous in You* wants primarily a physical and sensible relationship to the pedestrian, not a strongly visual one. Also, it should be noted that *Yous in You* is not placed on the floor. It *is* the floor.**

Baetcke Now it is as if the work is almost invisible, experienced only by touching it, by walking on it.

Horn **Sensual experience is something intrinsic, something you take with you wherever you go. It is like the experience of water; nobody needs to talk to you about that. You know what it is. It is a less articulate area of experience that is deeply human and potentially very individual. Of course I can sit here and say this is what I am doing, these are the ideas, and this is the kind of intellectual tradition which involves language in a descriptive sense to articulate what I consciously and intellectually desire. But there are other languages, for instance the language of the body dealing with physical resistance and attraction on the planet Earth, and the language of the senses which allow you an intuitive, common sense-based knowledge of an experience. Everybody shares this, but how many of us really deal with sensual and sensed reality? And still it is a part of who you are and where you are going. You can't divorce yourself from this kind of knowledge but you can disregard it or undervalue it to the point where it no longer feeds your experience of the world. But a conflict is generated by this act of repression. In fact, what we see is a history evolving of ever more complete separation from sensual knowing. *Yous in You* is located in the schism that occurs between your own internal, corporeal inclinations and the expectations and assumptions laid over this knowledge, which thwart this way of knowing.**

Baetcke Would you say *Yous in You* deals with the unexpected in a public urban space; with this little shock of intimacy waiting for the pedestrian?

Horn **Are you talking about having a sensual experience in public space? For some people that can be very disturbing, for others it is going to be exciting. The piece is very quiet, it wants to engage the pedestrian's mundane reality. Something happens where your sense of yourself in the world opens up a little and stretches out.**

Baetcke As you mentioned, *Yous in You* does not directly refer to Iceland, yet Iceland is still somehow its source. What do your frequent travels to Iceland mean to you? I don't see you either as a regular tourist or as just using Iceland as a source of artistic inspiration. Iceland seems to be deeply connected with your work.

Horn **Are you aware of how unique Switzerland is geologically? The physical reality of Switzerland is remarkable. I don't find Iceland any more unique than that. It's more foreign to you perhaps. It's more foreign to most people. The idea of North is. But Iceland is just five hundred miles off the coast of Scotland. People think of it as thousands of miles north into the Arctic tundra. *Yous in You* does quote Iceland but not exclusively. My relationship to Iceland is very personal in some ways. Somebody once said Iceland was my Carrara marble. That's right: I work with Iceland the way Louise Bourgeois might work with marble. You take it as a base line and you develop it into a form that expresses your concerns. It's not just a physical substance, it's an identity, it's an idea of substance. I think that would be the role of Iceland here in Bahnhof Ost. Here in Basel, Iceland is just an idea of 'other'.**

Baetcke The colour of the rubber surfaces you use for *Yous in You* is rarely used in urban spaces. Why did you choose this colour?

Horn **As you said, it is a virtually invisible piece. The colour is a key part of the work in terms of giving it a little visibility. The early commercial rubbers from the 1930s and 1940s came in this earthen orange colour. I like the connection made in this colour between the organic and the artificial – the association with the early vulcanized rubbers and with terracotta and earth in general.**

Basalt formation near
Aldeyjarfoss, Iceland
1994
Previously unpublished colour
photograph from the artist's
archive

Baetcke In 1991–92 you wrote the text 'Roads Lack Dedication'. Does this text relate to *Yous in You*?

Horn **Yes. 'Dedication' is an interesting word. Aside from its association with social relations it has another more technical meaning: a form which can only fit in one way. If you try to change the orientation it won't fit in. This is dedication. 'Roads Lack Dedication' means there is no orientation that matters. Paths have this very specific relationship to where they are. You can't simply rotate them or move them over a hundred feet. The path is a very delicate form, it's specific to exactly where it's located and the material of its location. With a road these things don't matter. If you are going on a road through the Swiss Alps or through the Grand Canyon, the road itself is not much different. You can be more or less in the same place because the road is not specific to its location. But a path is different because it goes from here to there specifically and not from some other here to there. That is what a path is. About specificity, about irreversibility.**

Baetcke Relating this to *Yous in You*: is it your intention to turn the passage for pedestrians at the Bahnhof Ost into a path and to give it a specific meaning?

Horn **I think a path is specific to its immediate circumstance. There is an idea of the path as individual identity. Its scale is keyed to individual need. On the other hand, a road is a civic event. The road is an expression of a culture's controlling, using, conquering of the space it occupies. Every culture, it seems, wants to establish a relationship to a scale that exceeds it. That is what civil infrastructure is about: relating human presence to the scale of nature – nature which always exceeds the scale of human presence. That is where the invention of the road comes in. But the path is inherent in human nature; it has much more to do with how you relate to a place individually.**

Baetcke What about the use of benches?

Horn **What I know is there will be this sensuous soft rubber and I know I'm going to want to sit on that rubber. The idea of the bench is as an offering of rest and**

Basalt formation, Kirkjugólf,
Iceland
1994
Previously unpublished colour
photograph from the artist's
archive

amusement. How people will use that building, I don't know. Come out, sit in the courtyards, maybe have lunch. The sensuality of that rubber has a complex form, it is not just like looking at something. The body is engaged. I also thought this would be an opportunity to linger in a place which is not really offering that. It is definitely a passage, but we will see.

Baetcke You have realized works in architectural contexts before. Has the scale of the Bahnhof Ost project been special to you?

Horn **It is a unique situation to have a site which is so long. Given a 200-metre distance (a rare occasion) I am working around the simple and complex concept of 'the difference between here and there'. On this scale you have the opportunity to differentiate parts of the space in a way that only becomes evident as the pedestrian walks along. That is where the soft and hard rubbers come in. How to articulate difference in a very simple setting. And the longer the walkway gets the simpler it gets. The size actually gives me more opportunity to develop the nuances, because I needed fifty feet just to get the idea of softness or hardness, to make them present in their differences. Fifty feet is already a big distance architecturally, but it is still only ten per cent of the whole piece, just one word in a sentence. I needed the length because I wanted the difference between short and long in there as well. That way I could play with the phrasing and syntax. I could draw out, for example, the soft area and then I could break this up into short changes between the different rubbers. But you won't walk through it noting soft and hard. The experience of the soft and hard rubber will be more like changing daylight in a room: darker moments will make you more aware of lighter ones and vice versa. Subtlety can bring out more of you, in terms of what you see or feel. It extends you out into the world. And then in a few weeks maybe you'll be walking along and you'll start wondering about the difference; you don't know what the difference is, you're not even sure it's there – you may never know what the difference is. But you know, from here to there, that there is a difference. You know this because you have physically experienced it. But you don't have any visual confirmation that the differences exist. In this ambiguity and self-reflection *Yous in You* becomes part of who you are when you're on it.**
Kunsthalle Basel, January 1999.

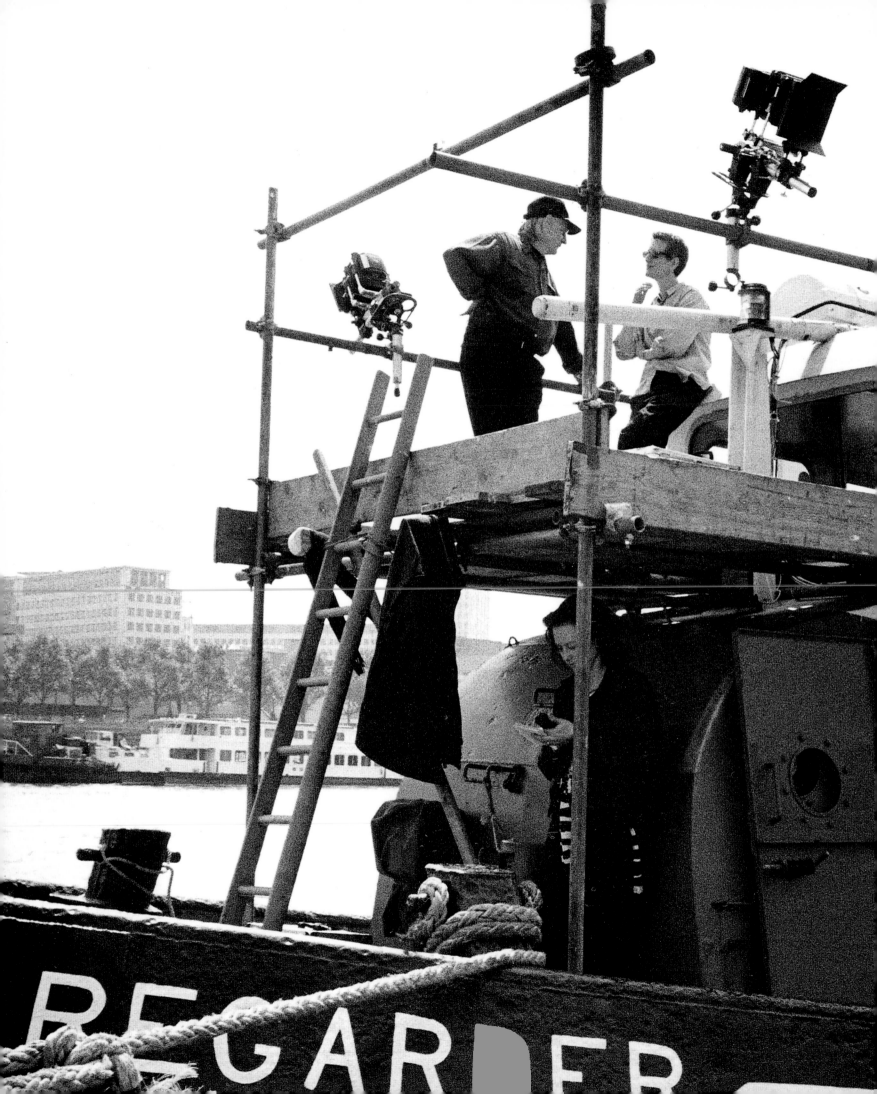

Contents

Roni Horn Born 1955 in New York, lives and works in New York

Selected exhibitions and projects
1975–84

1975
Studies, BFA with Honours, Rhode Island School of
Design, Providence

First travels to Iceland

1978
Receives Ford Foundation Grant, Yale University, New
Haven, Connecticut

Studies, MFA, Yale University, New Haven, Connecticut

Yale University Art Gallery, New Haven, Connecticut
(solo)

Receives Alice Kimball Traveling Fellowship, Yale
University, New Haven, Connecticut

1980
Kunstraum, Munich (solo)
Cat. *Roni Horn*, Kunstraum, Munich, text Hermann
Kern

Clocktower, Institute for Art and Urban Resources,
Long Island City, New York (solo)
Cat. *Exhibitions at P.S. 1 and the Clocktower*, Institute
for Art and Urban Resources, Long Island City, New
York, no text

'The Material Object',
Hayden Gallery, Cambridge, Massachusetts (group)
Cat. *The Material Object*, Hayden Gallery, Cambridge,
Massachusetts, text Kathy Halbreich

1983
Receives Humanities Development Grant, Colgate
University, Hamilton, New York

Artist's project, 'Notes from Dyrhólaey', *Museum
journaal*, No. 3, Amsterdam

Permanent installation, *Cobbled Lead(s)* (Destroyed)
Glyptothek Museum, Munich

Kunstforum, Lenbachhaus Museum, Munich (solo)

Kunstraum, Munich (solo)
Cat. *Roni Horn*, Kunstraum, Munich, texts Helmut
Friedel, Barbara Hammann, Luise Horn

Kunstraum, Munich (group)

1984
Receives NEA Artist's Fellowship, Washington, DC

Barbara Braathen Gallery, New York (group)

Selected articles and interviews
1975–84

1980
Morschel, Jurgen, 'Space through Compressed
Sculpture', *Suddeutsche Zeitung*, Munich, 3 April

1983

RONI HORN

COBBLED LEAD(S)
GLYPTOTHEK MUNICH 1983

Rein, Ingrid, 'Still Waters are Deep', *Suddeutsche
Zeitung*, Munich, 3 November
Rein, Ingrid, 'Still Waters are Deep', *Artforum*, New
York, February, 1984
Schneider, H., 'Roni Horn', *Die Zeit*, Frankfurt, 18
November
Weskott, Hanne, 'Kunstraum, Munich', *Kunstforum*,
Vol. 69, Cologne, February, 1984

1984

RONI HORN

KUNSTRAUM MUNCHEN

Glozer, Laszlo, *Suddeutsche Zeitung*, Munich, October
Pradel, Jean-Louis, *World Art Trends 1983–84*, Harry
Abrams, New York

Selected exhibitions and projects
1985–87

1985
Burnett Miller Gallery, Los Angeles (solo)

Galerie Maeght Lelong, New York (solo)

Gallery Shimada Yamaguchi, Tokyo (group)

Jatta Vondran, Dusseldorf (group)

Alfred Kren Gallery, New York (group)

Lorence-Monk Gallery, New York (group)

Burnett Miller Gallery, Los Angeles (group)

1986
Receives NEA Artist's Fellowship, Washington, DC

Neuberger Museum, Purchase, New York (solo)

Burnett Miller Gallery, Los Angeles (solo)

Chris Middendorf Gallery, Washington, DC (group)

Barbara Krakow Gallery, Boston (group)

Diane Brown Gallery, New York (group)

1987
Galerie Maeght Lelong, New York (solo)

Galerie Maeght Lelong, Paris (solo)

Galerie Maeght Lelong, New York (group)

Thomas Segal Gallery, Boston (group)

'Lead',
Hirschl and Adler Modern, New York (group)
Cat. *Lead*, Hirschl and Adler Modern, New York, text
Klaus Kertess

'Similia/Dissimilia',
Kunsthalle, Dusseldorf, toured to **Wallach Art Center**,
New York; **Leo Castelli Gallery**, New York (group)
Cat. *Similia/Dissimilia*, Kunsthalle, Dusseldorf,
Germany/Rizzoli, New York, texts Rainer Crone, Linda
Norden

Artist's project, *Bomb*, New York, Winter

Selected articles and interviews
1985–87

1985
Muchnic, Suzanne, 'Roni Horn: Burnett Miller Gallery',
Los Angeles Times, 29 March

Brenson, Michael, 'Roni Horn', *New York Times*, 16
August

Saunders, Wade, 'Talking Objects: Interviews with Ten
Younger Sculptors', *Art in America*, New York,
November

1986

Brenson, Michael, 'Roni Horn', *New York Times*, 28
February

Garner, Colin, 'Roni Horn/Arnaulf Rainer', *Los Angeles
Times*, November

1987
Gookin, Kirby, 'Roni Horn: Galerie Lelong', *Artforum*,
New York, May, 1988
Johnson, Ken, 'Roni Horn: Galerie Lelong', *Art in
America*, New York, April, 1989
Morgan, Robert C., 'Roni Horn: Galerie Lelong', *Arts
Magazine*, New York, May, 1988

Schmidt-Wulffen, Stephan, 'Similia/Dissimilia', *Flash
Art*, Milan, November–December

Mennekes, Friedhelm, 'New York, New York', *Kunst und
Kirche*, Frankfurt, April

Selected exhibitions and projects
1988–89

1988

Receives, AVA 7, Awards in the Visual Arts, Winston-Salem, North Carolina
Book, *Awards in the Visual Arts*, Winston-Salem, North Carolina, text Donald Kuspit

Book, *Roni Horn: Pair Objects I, II, III*, Galerie Lelong, Paris and New York, text Jeremy Gilbert-Rolfe

Winston Gallery, Washington, DC (solo)

Detroit Institute of Arts (solo)

Susanne Hilberry Gallery, Birmingham, Michigan (solo)

Mario Diacono Gallery, Boston (solo)
Cat. *Unique Forms of Deviation in Space*, Mario Diacono Gallery, Boston, text Mario Diacono

Permanent installation, *Things That Happen Again*, on loan from the Donald Judd Foundation, **Chinati Foundation**, Marfa, Texas (solo)

Susanne Hilberry Gallery, Detroit (group)

Zola Lieberman Gallery, Chicago (group)

'The Inscribed Image',
Lang-O'Hara Gallery, New York (group)

'AVA',
Los Angeles County Museum of Art, toured to
Carnegie-Mellon University Art Gallery, Pittsburgh;
Virginia Museum of Fine Arts, Richmond (group)

'Works on Paper',
Pamela Auchincloss Gallery, New York (group)

1989
Jay Gorney Modern Art, New York (solo)

Galerie Annemarie Verna, Zurich (solo)

Paula Cooper Gallery, New York (solo)

'Non-representation',
Anne Plumb Gallery, New York (group)

Selected articles and interviews
1988–89

1988

Kessler, Pamela, 'Roni Horn', *Washington Post*, Washington, DC, 5 February
Thorson, Alice, 'Roni Horn', *Washington Times*, Washington, DC, 21 January

Miro, Marsha, 'Honesty Finds Form in Warm Copper Pair', *Detroit Free Press*, 15 October
Hakanson Colby, Joy, 'Roni Horn Prefers Playing Solo', *Detroit News*, 25 October

Levin, Kim, 'Choices', *Village Voice*, New York, 23 February
Kimmelman, Michael, 'Uptown, Novices and Modern Masters', *New York Times*, 26 February
Smith, Roberta, 'Roni Horn', *New York Times*, 7 March
Gilbert-Rolfe, Jeremy, 'Non-representation in 1988: Meaning-production Beyond the Scope of the Pious', *Arts Magazine*, New York, May

1989
Morgan, Robert C., 'Roni Horn: Jay Gorney Modern Art', *Arts Magazine*, New York, Summer

Gilbert-Rolfe, Jeremy, 'The Current State of Non-Representation', *Visions: Art Quarterly*, Los Angeles, Spring

RONI
HORN

October 21–November 12, 1988

MARIO DIACONO
84 PETERBOROUGH STREET
BOSTON

Selected exhibitions and projects
1989–91

'Prospect 89',
Kunstverein, Frankfurt (group)
Cat. *Prospect 89*, Kunstverein, Frankfurt, texts Peter
Weiermair, et al.

'A Decade of American Drawing',
Daniel Weinberg Gallery, Los Angeles (group)

1990
Receives NEA Artist's Fellowship, Washington, DC

Receives Guggenheim Fellowship, New York

Artist's book, *To Place – Book I: Bluff Life*, Peter Blum
Edition, New York

Leo Castelli Gallery, New York (solo)

Museum of Contemporary Art, Los Angeles (solo)
Cat. *Roni Horn: Surface Matters*, Museum of
Contemporary Art, Los Angeles, text Klaus Kertess

Margo Leavin Gallery, Los Angeles (solo)

Paula Cooper Gallery, New York (solo)

Artist's Project, 'For Thicket No. 3 – Kafka's
Palindrome: A Project for Artforum', *Artforum*, New
York, Summer

Artist's Project, *Paris Review*, Vol. 116, New York, Fall

'Quotations',
Galerie Annemarie Verna, Zurich (group)

'Drawings',
Aargauer Kunsthaus, Arrau, Switzerland (group)

'Sculptor's Drawing',
Baltimore Museum of Fine Arts (group)

'Recent Drawings',
Whitney Museum of American Art, New York (group)

Margo Leavin Gallery, Los Angeles (group)

1991
Artist's book, *To Place – Book II: Folds*, Mary Boone
Gallery, New York

Westfälisches Kunstverein, Münster, Germany;
Städtisches Museum Abteiberg, Mönchengladbach,
Germany (solo)

Whitney Museum of
American Art

February 27 – May 6, 1990

Recent Drawing

Roni Horn

Charles Ray

Jim Shaw

Michael Tetherow

Selected articles and interviews
1989–91

Baker, Kenneth, 'The Atomized Self', *Art Coast*, Santa
Monica, March–April
Thompson, Mimi, 'Roni Horn: Interview', *Bomb*, New
York, Summer

1990

Geer, Suvan, 'Horn Tests Her Mettle', *Los Angeles Times*,
3 May
Spector, Buzz, 'Roni Horn', *Art Issues*, No.13, Los
Angeles, September–October
Wilson, William, 'Roni Horn and the Art of
Abstraction', *Los Angeles Times*, 22 April

Knight, Christopher, 'Drawings as Tangible as
Sculpture', *Los Angeles Times*, 23 November

The Paris Review
116 $6.00 £3 50F

Maya Angelou, Mario Vargas Llosa Interviews
Georges Perec, Mona Simpson Fiction
John Ashbery, Catherine Bowman Poetry
Gertrude Stein Feature

TIGER

Nicholson, Chuck, 'A Magical Sense of Place', *ArtWeek*,
San Jose, 24 May
Baker, Kenneth, 'Physical Precision: Notes on Some
Recent Sculpture', *Artspace*, Albuquerque, September

1991

van den Boogerd, Dominic, 'Roni Horn: dingen die
opnieuw beginnen', *Archis*, Amsterdam, May

Selected exhibitions and projects
1991–92

Cat. *Things That Happen Again*, Städtischen Museum Abteiberg, Mönchengladbach/Westfälisches Kunstverein, Münster, texts Rudi Fuchs, Hannelore Kersting

Jablonka Galerie, Cologne (solo)

Westfälisches Landesmuseum, Münster (solo)

Mary Boone Gallery, New York (solo)

'1991 Whitney Biennial',
Whitney Museum of American Art, New York (group)
Cat. *1991 Whitney Biennial*, Whitney Museum of American Art, New York/W. W. Norton and Co., New York, texts R. Armstrong, J. Hanhardt, R. Marshall, Lisa Phillips

1992
Artist's book, *To Place – Book III: Lava*, Distributed Art Publishers, New York

Jablonka Galerie, Cologne (solo)

New Museum for Living Art, Reykjavík (solo)

Galerie Annemarie Verna, Zürich (solo)

'Documenta IX',
Kassel, Germany (group)
Cat. *Documenta IX*, Edition Cantz, Stuttgart, texts Jan Hoet, et al.

De Pont Foundation for Contemporary Art, Tilburg, The Netherlands (group)

'A Second Thought About Landscape Photography',
Centre d'Art Contemporain du Domaine de Kerguehennec, Bignan, France (group)

'Drawn in the 90s',
Organized by Independent Curators Inc., New York
Katonah Museum of Art, New York; **Illingworth Kerr Gallery**, Alberta College of Art, Calgary, Canada;
Huntsville Museum of Art, Alabama (group)
Cat. *Drawn in the 90s*, Independent Curators Inc., New York, texts Sean Rainbird, Joshua P. Smith

'All Words Suck',
Anders Tornberg Galleri, Lund, Sweden (group)
Rubin Spangle Gallery, New York (group)

Selected articles and interviews
1991–92

Bass, Ruth, 'Roni Horn', *ARTnews*, New York, January 1992
Princenthal, Nancy, 'Roni Horn', *Art in America*, New York, February, 1992
Smith, Roberta, 'Roni Horn', *New York Times*, 8 November
Whitesell, Richard, 'Roni Horn', *Flash Art*, Milan, November–December

Newhall, Edith, 'Fall Preview: Roni Horn', *New York Magazine*, 23 September
O'Rourke, Meg, 'The Weight of the Word', *Arts Magazine*, New York, November
Schneider, Christine M., 'Roni Horn', *Noëma*, No. 35, Salzberg, 2 April

1992

Liebman, Lisa, 'The What and Who of Documenta IX', *Interview*, New York, June

RONI HORN

ERÖFFNUNG
FREITAG, 21. FEBRUAR
19–21 UHR
21. FEBRUAR–21. MÄRZ 1991
JABLONKA GALERIE
VENLOER STRASSE 21, 5000 KÖLN 1
0221-526867

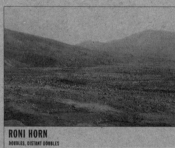

RONI HORN
DOUBLES, DISTANT DOUBLES
(RECENT DRAWINGS)

ERÖFFNUNG
FREITAG, 27. NOVEMBER, 19–21 UHR
27. NOVEMBER 1992–16. JANUAR 1993

JABLONKA GALERIE
VENLOER STRASSE 21, 5000 KÖLN 1
TEL. 0221-526867, FAX 525569

1993

Jablonka Galerie, Cologne (solo)

Margo Leavin Gallery, Los Angeles (solo)

Matthew Marks Gallery, New York (solo)

'Rare Spellings: Selected Drawings/Zeichnungen
1985–92',
Kunstmuseum, Winterthur, toured to
Geméenttemuseum, The Hague; **Weiner Secession**,
Vienna; **Kunstverein**, Cologne (solo)
Cat. *Rare Spellings: Selected Drawings/Zeichnungen
1985–92*, Kunstmuseum, Winterthur/Richter Verlag,
Dusseldorf, text Dieter Schwarz

ÖNNUR HÆÐ, Reykjavík (solo)

Mary Boone Gallery, New York (solo)

'21st Century',
Kunsthalle, Basel, Switzerland (group)

'Drawing the Line Against AIDS',
Peggy Guggenheim Collection, Venice (group)
Cat. *Drawing the Line Against AIDS*, American
Foundation for AIDS Research, New York, texts
Mathilde Krim, Achille Bonito Oliva, Elizabeth Taylor

1994
Artist's book, *To Place – Book IV: Pooling Waters*, 2
Vols., Walther König, Cologne

Artist's writing, 'Among Judd', *Artforum*, New York,
Summer

Artist's writing, 'Among Judd', *Guggenheim Magazine*,
New York, Summer

Artist's project, 'Verne's Journey', *Parkett*, No. 39,
Zurich

'Inner Geography',
Baltimore Museum of Art, Maryland, toured to **List
Visual Arts Center**, Massachusetts Institute of
Technology, Cambridge; **Yale University Art Gallery**,
New Haven, Connecticut (solo)
Cat. *Inner Geography*, Baltimore Museum of Art,
Maryland, texts Roni Horn, Jan Howard

De Pont Foundation for Contemporary Art, Tilburg,
The Netherlands (solo)
Cat. *Roni Horn: Being Double*, De Pont Foundation for
Contemporary Art, Tilburg, The Netherlands, text
Nancy Spector

Invitation card, De Pont Foundation for Contemporary Art,
Tilburg, The Netherlands

Ingolfsson, Einar Falur, 'A Need for the Island',
Morgunblatit, Reykjavík, 7 March
Jolles, Claudia, 'Roni Horn', *Kunst-Bulletin*, Zurich,
Summer

1993
Smolik, Noemi, 'Roni Horn', *Artforum*, New York, May

Reindl, Uta M., 'Roni Horn', *Kunstforum*, Cologne,
January–February

MacAdam, Barbara, 'Roni Horn: Mary Boone Gallery',
ARTnews, New York, December
Padon, Thomas, 'Roni Horn: Mary Boone Gallery',
Sculpture, Washington, DC, January–February, 1994

Kazangian, Dodie, 'Poetry in Place', *Vogue*, New York,
September

1994

Israel, Nico, 'Roni Horn: Inner Geography', *Artforum*,
New York, April, 1995
Johnson, Ken, 'Material Metaphors', *Art in America*,
New York, February

Selected exhibitions and projects
1994–95

Matthew Marks Gallery, New York (solo)

Texas Gallery, Houston, Texas (solo)

'Drawings',
Frith Street Gallery, London (group)

'Photographs',
Frith Street Gallery, London (group)

'Das Américas',
Galeria Luisa Strina, São Paulo (group)
Cat. *Das Américas*, Galeria Luisa Strina, São Paulo, text
Carlos Basualdo

'Photography',
Margo Leavin Gallery, Los Angeles (group)

1995
Artist's book, *To Place – Book IV: Verne's Journey*,
Walther König, Cologne

'Gurgles, Sucks, Echoes',
Matthew Marks Gallery, New York; **Jablonka Galerie**,
Cologne (solo)
Cat. *Gurgles, Sucks, Echoes*, Matthew Marks Gallery,
New York/Jablonka Galerie, Cologne, text Lynne
Tillman

'Currents 61: Roni Horn',
St. Louis Art Museum, Missouri (solo)
Cat. *Currents 61: Roni Horn*, St. Louis Art Museum,
Missouri, text Charlie Wylie

'Felix Gonzalez-Torres, Roni Horn',
Sammlung Goetz, Munich (solo)
Cat. *Felix Gonzalez-Torres, Roni Horn*, Sammlung Goetz,
Munich, texts Felix Gonzalez-Torres, Roni Horn,
Christiane Meyer-Stoll, Nancy Princenthal, Nancy
Spector, Robert Storr

'Making Being Here Enough: Installations from 1980–
1995',
Kunsthalle, Basel; **Kestner-Gesellschaft**, Hannover
(solo)
Cat. *Making Being Here Enough: Installations from
1980–1995*, Kunsthalle, Basel/Kestner-Gesellschaft,
Hannover, texts Roni Horn, Thomas Kellein

RONI HORN
MAKING BEING HERE ENOUGH
Skulpturen, Zeichnungen, Bücher

8. September bis
29. Oktober 1995

KESTNER-GESELLSCHAFT
HANNOVER

Selected articles and interviews
1994–95

Smith, Roberta, 'Roni Horn', *New York Times*, 29 April

1995

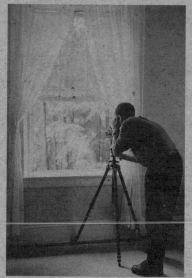

Edelman, Robert G., 'Roni Horn', *Art in America*, New
York, July
Glueck, Grace, 'Roni Horn', *New York Observer*, 27
February

Parr, Debra Riley, 'Roni Horn', *New Art Examiner*,
Chicago, May

Roni Horn in the bedroom of Emily Dickinson

Naumann, Volker, 'Hirnschweiss, Körperschweiss,
einsam', *Tages Anzeiger*, Zurich, 29 June
Meyer, Ulrike, 'Topologische Betrachtungen, Roni Horn
– Zwei Ausstellungen in Basel', *Neue Zürcher Zeitung*,
Zurich, 4 July
Schenk-Sorge, Jutta, 'Roni Horn', *Kunstforum*,
Cologne, November–January
Schiess, Robert, 'Roni Horn mit Zwei Ausstellungen
Geehrt', *Safellanbjchaftliche bz Zeitung*, Zurich, 12
June
Suche, Stete, 'Kunst', *Annabelle*, Zurich, 16 June, 1995
Zoller, Paul, 'Roni Horn und Gerhard Merz in der
Kunsthalle Basel: Eine helle Halle, Gold und ewichtige
Worte', *Aargauer Tagblatt*, Zurich, 21 June
Bauermeister, Volker, 'Draussen ist alles andere',
Frankfurter Allgemeine Zeitung, No. 152, Frankfurt, 4
July
Vachtova, Ludmila, 'Myrdalur und Undirfell', *Die
Weltwoche*, Zurich, 29 June
Gassert, Sigmund, 'Die Amerikanische Künstlerin Roni
Horn in Basel: Wille Der Erlösung', *Dreiland-Zeitung*,
Zurich, 17 August
Herstatt, Claudia, 'Meteoriten vom Himmel über
Island', *art*, Hamburg, September
Spinelli, Claudia, 'Hiersein soll genügen: Ein Gespräch
mit Roni Horn', *Kunst-Bulletin*, Zurich, October

Selected exhibitions and projects
1995–96

'Roni Horn: Zeichnungen',
Museum für Gegenwartskunst, Basel, Switzerland
(solo)
Cat. *Roni Horn: Zeichnungen*, Cantz Verlag, Ostildern,
text Dieter Koepplin

Galleria Alfonso Artiaco, Naples (solo)

'Corners',
Paula Cooper Gallery, New York (group)

'Untitled (Reading Room)',
Margo Leavin Gallery, Los Angeles (group)

'Summer 1995',
Matthew Marks Gallery, New York (group)

'Works on Paper',
Matthew Marks Gallery, New York (group)

'In a Different Light',
University Art Museum, Berkeley, California (group)
Cat. *In a Different Light*, City Lights Books, San
Francisco, texts Nayland Blake, Lawrence Rinder, et al.

'Word for Word',
Beaver College Art Gallery, Glenside, Pennsylvania
(group)

'Meister Werke aus dem Kupferstich Kabinett Basel',
Westfälisches Landesmuseum, Munster (group)
Cat. *Meister Werke aus dem Kupferstich Kabinett Basel*,
Verlag Gerd Hatje, Ostfildern, Germany, text Dieter
Koepplin

1996
Artist's book, *To Place – Book VI: Haraldsdóttir*, Ginny
Williams, Denver, Colorado

Artist's Residency, Engelhard Foundation, Bequia,
Venezuela

'Earths Grow Thick (Works after Emily Dickinson)',
Wexner Center for the Arts, Columbus, Ohio, toured to
Davis Museum and Cultural Center, Wellesley College,
Massachusetts; **Henry Street Gallery**, University of
Washington, Seattle (solo)
Cat. *Earths Grow Thick*, Wexner Center for the Arts,
Columbus, Ohio, texts Amada Cruz, Sherri Geldin, Felix
Gonzalez-Torres, bell hooks, Judith Hoos Fox, Roni
Horn, Sarah J. Rogers

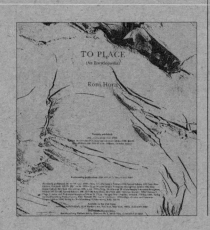

Selected articles and interviews
1995–96

Richardson, Brenda, 'Curator's Exhibition Review',
Friends of Modern Art Newsletter, Baltimore Museum of
Art, September
James, Jamie, 'Horn and Holbein', *ARTnews*, New York,
November

Barucco, Simona, 'Mostre, Roni Horn alla Galléria
Artiaco', *Il Giornale di Napoli*, Naples, 13 September
Trimarco, Angelo, 'La Prima Volta di Roni Horn,
Minimalista Usa', *Il Mattino*, Naples, 2 October

Karmel, Pepe, 'The Corner as Trap, Symbol, Vanishing
Point, History Lesson', *New York Times*, 21 July

Morgan, Susan, 'Art Fire and Iceland', *Elle*, New York,
April
Oberbauer, Chritina, *Jahrbuch '95*, Institut für
moderne Kunst Nürnberg

1996
Princenthal, Nancy, 'Page for Page', *Bookforum*, New
York, Summer, 1997

Conner, Jill, 'Roni Horn: Earths Grow Thick', *Art Papers*,
Vol. 22, No. 3, Atlanta, May–June, 1998
Mitchell, Ben, 'Fragments: Notes on Poetry and Art
(Emily Dickinson's Poetry in Roni Horn's Art)',
ArtWeek, Vol. 29, San Jose, March
Temin, Christine, 'Weaving Dickinson's Words into
Three Dimensions', *Boston Globe*, 11 December
Silver, Joanne, 'Sculptor Captures Dickinson's Slant on
Metal', *Boston Herald*, 22 November
Sherman, Mary, 'Roni Horn Shows Poet's Metal',
Cambridge Tab, Cambridge, Massachusetts, 26

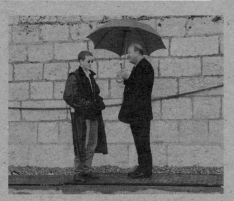

l. to r., Roni Horn, Hans Zwimpfer

Selected exhibitions and projects
1996–97

'Five Installations',
Matthew Marks Gallery, New York (solo)

Galerie Ghislaine Hussenot, Paris (solo)

Artist's project, 'Traveling Eye', *Profil*, Nos. 30–33,
Vienna, 22 July; 29 July; 5 August; 12 August

Permanent installation, *You Are the Weather (Munich)*,
German Meteorological Authority, Munich

'Thinking Print: Books to Billboards, 1980–95',
The Museum of Modern Art, New York (group)
Cat. *Thinking Print: Books to Billboards, 1980–95*, The
Museum of Modern Art, New York/Harry Abrams, New
York, text Deborah Wye

'De Beuys a Trockel: Dessins contemporains du
Kunstmuseum de Bâle',
Musée d'Art Moderne, Centre Georges Pompidou,
Paris (group)
Cat. *De Beuys a Trockel: Dessins contemporains du
Kunstmuseum de Bâle*, Centre Georges Pompidou,
Paris, text Dieter Koepplin

RONI HORN
FIVE INSTALLATIONS
11 FEBRUARY–14 APRIL 1996

OPENING SATURDAY 10 FEBRUARY 6–8 PM

MATTHEW MARKS GALLERY
522 WEST 22ND STREET
THURSDAY–SUNDAY 12–6
TEL 212 861 9455 FAX 212 861 9382

'Artist's Books',
Brooke Alexander Gallery, New York (group)

'Open Secrets',
Matthew Marks Gallery, New York; **Fraenkel Gallery**,
San Francisco (group)
Cat. *Open Secrets*, Matthew Marks Gallery, New York/
Fraenkel Gallery, San Francisco, texts J. Fraenkel,
Matthew Marks

'Recent Acquisitions,'
The Museum of Modern Art, New York (group)

1997
Artist's book, *You Are the Weather*, Scalo Verlag, Zurich

Fotomuseum, Winterthur, Switzerland (solo)

Jablonka Galerie, Cologne (solo)

Selected articles and interviews
1996–97

November
Sherman, Mary, 'Artist Shows Poet's Metal',
Framingham Tab, Framington, Massachusetts, 19
November

Drolet, Owen, 'Roni Horn', *Flash Art*, Milan, May–June
Schwendener, Martha, 'Five Installations', *Time Out*,
New York, 6–13 March
Richard, Frances, 'Roni Horn', *Artforum*, New York,
December, 1997
Volk, Gregory, 'Roni Horn at Matthew Marks', *Art in
America*, New York, July

Temin, Christine, 'Images that will Outlive the Year',
Boston Sunday Globe, 29 December

Glasoë, C.; Montgomery; K.; et al., *In the Margins: 19
Interviews*, Montgomery Glasoe Fine Art, Minneapolis
Kisters, Jürgen, 'Im Spinnennetz des Unbekannten',
Kölner Stadt-Anzeiger, No. 295, Cologne, 19 December
Deitcher, David, 'Death and the Marketplace', *frieze*,
No.29, London, June–August
Camus, Renaud, 'Tricks', *frieze*, No.29, London, June–
August

1997
Cotter, Linda, 'Face Value: Roni Horn Photographs a
Mystery Lady', *Out Magazine*, New York, May

Etter, Ludmilla, 'Der Bildprozess als Thema – Roni Horn
und Axel Hütte in Winterthur', *Neue Zürcher Zeitung*,
Zurich, 4 February

B., S., 'Ganz kurz blitzt die Idee der Identität auf',
Kölner Stadt-Anzeiger, No. 117, Cologne, 23 May

Selected exhibitions and projects
1997

Raffaella Cortese, Milan (solo)

Ingolfsstræti 8, Reykjavík (solo)

'Untitled (Flannery) and Pooling – You',
Matthew Marks Gallery, New York (solo)

'You are the Weather',
**Institut für moderne Kunst Nürnberg in der
SchmidtBank-Galerie**, Nürnberg (solo)

'Roni Horn: Eine Installation',
Ludwig Forum für Internationale Kunst, Aachen
(solo)

Artist's project, 'Nicht Hier Sein', *Kunst und Kirche*, No.
2, Frankfurt

Artist's Project, *Hyperfoto*, Nos. 3–4, Oslo

Artist's writing, 'I Go to Iceland', *More Boreal*,
Edinburgh Review, Autumn

'Sleight of Mind: The Angle of a Landscape', (with
Gabriel Orozco)
Center for Curatorial Sudies, Bard College,
Annandale-on-Hudson, New York (solo)

Galerie nächt St. Stephan, Vienna (group)

XLVII Venice Biennale (group)
Cat. *La Biennale di Venezia XLVII Esposizione
Internationale d'Arte*, Electa, Venice, text Germano
Celant

'Density of the Unimaginable Museum',
**Centre d' Art Contemporain du Domaine de
Kerguehennec**, Bignan, France (group)

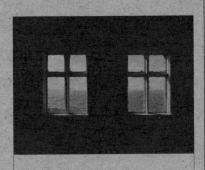

RONI HORN Eine Installation

Zur Eröffnung der Ausstellung
am Sonntag, dem 28. September 1997,
um 12 Uhr im Ludwig Forum
laden wir Sie und Ihre Freunde herzlich ein.

Einführung: Dr. Thomas Kellein
Direktor der Kunsthalle Bielefeld

28. Sept. bis 16. Nov. 1997, Di. + Do. 10–17, Mi. + Fr. 10–20, Sa. + So. 11–17 Uhr;
Freunde des Ludwig Forums und Ludwig Forum für Internationale Kunst,
Jülicher Straße 97-109, 52070 Aachen, Tel. 0241/18070, Fax 0241/1607101

Selected articles and interviews
1997

Hucht, Margarete, 'Eine unbekannte Schöne aus
Island', *Kölnische Rundschau*, Cologne, 8 May

Gravano, Viviana, 'La photographia di Roni Horn', *Il
Giornale Dell'Arte*, No. 156, Turin, June
Leonelli, Laura, 'Roni Horn: Disponibile alla
contemplazione del centro', *Il Sole 24 Ore*, No. 177,
Milan, 29 June
Pioselli, Alessandra, 'Roni Horn', *Flash Art*, Milan,
Summer

Johnson, Ken, 'Roni Horn', *New York Times*, 10 October

Bianchi, Paolo, 'Ästhetik des Reisens', *Kunstforum*, No.
137, Cologne, June–August
Fontana, Sara, 'Roni Horn', *Tema Celeste*, Milan,
September–October
Langen, Andreas, 'Von fern, ganz nah', *Stuttgarter
Zeitung*, Stuttgart, 1 January
Lee, Pamela, Mehring, et al., *Drawing is Another Kind of
Language*, Harvard University Art Museum, Cambridge/
Daco-Verlag Günter Bläse, Stuttgart
Marcoci, Roxana; et al., *New Art*, Harry Abrams, New
York
Obrist, Hans Ulrich; Rollig, Stella, *Travelling Eye*,
Museum in Progress, Oktagon Verlag, Vienna
Sussler, Betsy, *Bomb: Speak Art!*, New Art Publications
Inc., New York
Schorr, Collier, 'Weather Girls: Interview with Roni
Horn', *frieze*, No. 32, London, January–February

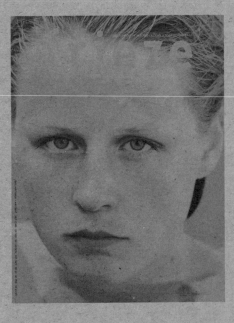

Selected exhibitions and projects
1997-98

1998

Artist's book, *To Place – Book VII: Arctic Circles*, Ginny Williams, Denver, Colorado, 1998

Receives Sculpture Award, Sculpture Center, New York

Receives Alpert Award in the Arts, Santa Monica

Artist's writing, 'Thetta Ekkert Sem Er', *Morgunbladid*, Reykjavík, 6 September

Artist's project, 'You are the Weather', *Le Monde diplomatique*, Berlin, September

'You are the Weather',
De Pont Foundation for Contemporary Art, Tilburg, The Netherlands (solo)

Museum für Gegenwartskunst, Basel (solo)

Galleri Stefan Andersson AB, Umea, Sweden (solo)

Patrick Painter Inc., Los Angeles (solo)

Galerie Xavier Hufkens, Brussels (solo)

Artist's project, *Siksi*, Vol. 13, Nos. 3–4, Helsiki

'Maverick',
Matthew Marks Gallery, New York (group)

'View 2',
Mary Boone Gallery, New York (group)

'Everyday',
11th Sydney Biennale (group)
Cat. *Everyday: 11th Biennale of Sydney*, Sydney, texts Jonathan Watkins, et al.

'Fast Forward',
Kunstverein, Hamburg (group)

'Sea Change: The Seascape in Contemporary Photography',
Center for Creative Photography, University of Arizona (group)
Cat. *Sea Change: The Seascape in Contemporary Photography*, Center for Creative Photography, University of Arizona, texts Trudy Wilner Stack, James Hamilton-Paterson

'Contemporary Art: The Janet Wolfson de Botton Gift',
Tate Gallery, London (group)
Cat. *Contemporary Art: The Janet Wolfson de Botton Gift*, Tate Gallery, London, texts Monique Beudert, Sean Rainbird

De Pont 6
winter 1997 · 1998

Quarterly Bulletin · Volume 3 no. 1 · January 1998
De Pont Foundation for Contemporary Art · Wilhelminapark · Tilburg
tel 31 13 543 83 00 · Open Tuesday through Sunday, 11 am -5 pm,
closed Monday

Selected articles and interviews
1997-98

1998

MAVERICK

Jean-Marc Bustamante Peter Fischli & David Weiss
Katharina Fritsch Roni Horn Thomas Schütte Andreas Slominski

7 February to 11 April 1998 Opening Saturday 7 February 6–8pm Matthew Marks Gallery 522 West 22 Street New York Tel 212-243-0200 Fax 212-243-0047

Ford, Tom, 'Light', *Visionaire*, No. 24, New York
Schorr, Collier, 'Still', *Parkett*, No. 54, Zurich, 1998–99
Gunnarsson, Styrmir, 'A Unique Vision of Iceland', *Parkett*, No. 54, Zurich, 1998–99
Gorovoy, Jerry, 'Standing on the Circumference of Roni Horn's "Asphere"', *Parkett*, No. 54, Zurich, 1998–99
Lewis, Diane, 'Notes from an Archit
iect', *Parkett*, No. 54, Zurich, 1998–99
Scott, Sue, *The Edward R. Broida Collection*, Orlando Museum of Art, Florida

Selected exhibitions and projects
1998–2000

1999
Zugspitze, Munich (solo)

'Pi',
Jablonka Galerie, Cologne (solo)

'Pi',
Matthew Marks Gallery, New York (solo)

'Pi',
Haus der Kunst, Bayerische
Staatsgemäldesammlungen, Munich (solo)
Cat. *Roni Horn: Pi*, Staatsgalerie kunst, Munich/Hatje
Cantz Verlag, Munich, text Carla Shulz-Hoffman

Artist's writing, 'Nokkrar Athugasemdir um Íslenska
Byggingarlist', *Lesbók Morgunbladid*, Reykjavik, 10
April

Raffaella Cortese, Milan (solo)

Musée d'Art Moderne de la Ville de Paris (solo)
Cat. *Events of Relation*, Musée d'Art Moderne de la Ville
de Paris/capc Musée d'art contemporain, Bordeaux,
texts Laurence Bossé, Marie Laure Bernadac, Nancy
Spector

Permanent installation, *Yous in You*,
Bahnhof Ost, Basel
Cat. 'Ein Stück: Island in Basel', Lars Müller, Baden,
texts Roni Horn, et al.

capc Musée d'art contemporain de Bordeaux, France
(solo)

2000
Listasafn Islands, (National Mueumof Art) Reykjavik
(solo)

Castello di Rivoli, Turin (solo)

Lannan Foundation, Santa Fe (solo)

Artist's book, *Another Water (The River Thames, for
Example)*, Scalo Verlag, Zurich and New York

Selected articles and interviews
1998–2000

Spector, Nancy, '"Untitled (Flannery)" – A
Condensation of Acts', *Parkett*, No. 54, Zurich,
1998–99
Ormarsson, Orri Páll, ' Thar sem Hjartad Slflr', *Lesbök
Morgunbladid*, Reykjavik, 19 September

1999

von Keitz, Kay, 'Stimmungen rund um ein Holzhaus',
Kölner Stadt-Anzeiger, No. 42, Cologne, 19 February

Smith, Roberta, 'Roni Horn', *New York Times*, 7 May

Grockel, Cornelia, 'Roni Horn: "Pi"', *Kunstforum*,
Munich, July–August
Sonna, Birgit, 'Der Blick auf sich selbest', *Suddeustche
Zeitung*, Munich, April
Hamel, Christine, 'Mit klarem Blick auf das Land der
Einsamkeit', *Suddeustche Zeitung*, Munich, April
Oliv, Joachim, 'Vom Kreislauf der Dinge', *Münchner
Merkur*, Munich, May
Goetz, Joachim, 'Kosmopolitin zwischen Island und
Manhattan', *Landshuter Zeitung*, Munich, June

Boxer, Sarah, 'The Guggeneim Sounds the Alarm: It
Ain't Necessarily So', *New York Times*, 19 March
Bonami, Francesco; Obrist, Hans Ulrich, *Dreams*,
Castelvecchi, Rome

Baker, Kenneth, 'Physical Precision: Notes on Some Recent Sculpture', *Artspace*, Albuquerque, September–October, 1990

Barucco, Simona, 'Mostre, Roni Horn alla Galleria Artiaco', *Il Giornale di Napoli*, Naples, 13 September, 1995

Bass, Ruth, 'Roni Horn', *ARTnews*, New York, January 1992

Basualdo, Carlos, *Das Américas*, Galerie Luisa Strina, São Paulo, 1994

Bauermeister, Volker, 'Draussen ist alles andere', *Frankfurter Allgemeine Zeitung*, No. 152, Frankfurt, 4 July, 1995

Bernadac, Marie Laure, *Events of Relation*, Musée d'Art Moderne de la Ville de Paris/capc Musée d'art contemporain, Bordeaux, 1999

Beudert, Monique, *Contemporary Art: The Janet Wolfson de Botton Gift*, Tate Gallery, London, 1998

Bianchi, Paolo, 'Ästhetik des Reisens', *Kunstforum*, No. 137, Cologne, June–August, 1997

Blake, Nayland, *In a Different Light*, City Lights Books, San Francisco, 1995

Bode, Peter, 'Dieser Traum vom Ich', *Allgemeine Zeitung*, Frankfurt, May, 1999

Bonami, Francesco, *Dreams*, Castelvecchi, Rome, 1999

Bossé, Laurence, *Events of Relation*, Musée d'Art Moderne de la Ville de Paris/capc Musée d'art contemporain, Bordeaux, 1999

Boxer, Sarah, 'The Guggeneim Sounds the Alarm: It Ain't Necessarily So', *New York Times*, 19 March, 1999

Brenson, Michael, 'Roni Horn', *New York Times*, 16 August, 1985

Brenson, Michael, 'Roni Horn', *New York Times*, 28 February, 1986

Camus, Renaud, 'Tricks', *frieze*, No.29, London, June–August, 1996

Conner, Jill, 'Roni Horn: Earths Grow Thick', *Art Papers*, Vol. 22, No. 3, Atlanta, May–June, 1996

Cotter, Linda, 'Face Value: Roni Horn Photographs a Mystery Lady', *Out Magazine*, New York, May, 1997

Crone, Rainer, *Similia/Dissimilia*, Kunsthalle Dusseldorf, Germany/ Rizzoli, New York, 1987

Cruz, Amada, *Earths Grow Thick*, Wexner Center for the Arts, Columbus, Ohio, 1996

Deitcher, David, 'Death and the Marketplace', *frieze*, No.29, London, June–August, 1996

Diacono, Mario, *Unique Forms of Deviation in Space*, Mario Diacono Gallery, Boston, 1988

Drolet, Owen, 'Roni Horn', *Flash Art*, Milan, May–June, 1996

Edelman, Robert G., 'Roni Horn', *Art in America*, New York, July, 1995

Etter, Ludmilla, 'Der Bildprozess als Thema – Roni Horn und Axel Hütte in Winterthur', *Neue Zürcher Zeitung*, Zurich, 4 February, 1997

Fontana, Sara, 'Roni Horn', *Tema Celeste*, Milan, September– October, 1997

Ford, Tom, 'Light', *Visionaire*, No. 24, New York, 1998

Fraenkel, J., *Open Secrets*, Fraenkel Gallery, San Francisco/ Matthew Marks Gallery, New York, 1996

Friedel, Helmut, *Roni Horn*, Kunstraum, Munich, 1983

Fuchs, Rudi, *Things That Happen Again*, Städtischen Museum Abteiberg Mönchengladbach; Westfälischer Kunstverein, Münster, 1991

Garner, Colin, 'Roni Horn/Arnaulf Rainer', *Los Angeles Times*, November, 1986

Gassert, Sigmund, 'Die Amerikanische Künstlerin Roni Horn in Basel: Wille Der Erlösung', *Dreiland-Zeitung*, Zurich, 17 August, 1995

Geer, Suvan, 'Horn Tests Her Mettle', *Los Angles Times*, 3 May, 1990

Geldin, Sherri, *Earths Grow Thick*, Wexner Center for the Arts, Columbus, Ohio, 1996

Gilbert-Rolfe, Jeremy, *Roni Horn: Pair Objects I, II, III*, Galerie Lelong, Paris and New York, 1988

Gilbert-Rolfe, Jeremy, 'Non-representation in 1988: Meaning-production Beyond the Scope of the Pious', *Arts Magazine*, New York, May, 1988

Gilbert-Rolfe, Jeremy, 'The Current State of Non-representation', *Visions: Art Quarterly*, Los Angeles, Spring, 1989

Glasoe, C., *In the Margins: 19 Interviews*, Montgomery Glasoe Fine Art, Minneapolis, 1996

Glozer, Laszlo, *Suddeutsche Zeitung*, Munich, October, 1984

Glueck, Grace, 'Roni Horn', *New York Observer*, 27 February, 1995

Goetz, Joachim, 'Kosmopolitin zwischen Island und Manhattan', *Landshuter Zeitung*, Munich, June, 1999

Gonzalez-Torres, Felix, *Earths Grow Thick*, Wexner Center for the Arts, Columbus, Ohio, 1996

Gookin, Kirby, 'Roni Horn: Galerie Lelong', *Artforum*, New York, May, 1988

Gorovoy, Jerry, 'Standing on the Circumference of Roni Horn's "Asphere"', *Parkett*, No. 54, Zurich, 1998–99

Gravano, Viviana, 'La photographia di Roni Horn', *Il Giornale Dell'Arte*, No. 156, Turin, June, 1997

Grockel, Cornelia, 'Roni Horn: "Pi"', *Kunstforum*, Munich, July–August, 1999

Gunnarsson, Styrmir, 'A Unique Vision of Iceland', *Parkett*, No. 54, Zurich, 1998–99

Hakanson Colby, Joy, 'Roni Horn Prefers Playing Solo', *Detroit News*, 25 October, 1988

Halbreich, Kathy, *The Material Object*, Hayden Gallery, Cambridge, Massachusetts, 1980

Hamel, Christine, 'Mit klarem Blick auf das Land der Einsamkeit', *Suddeustche Zeitung*, Munich, April, 1999

Hamilton-Paterson, James, *Sea Change: The Seascape in Contemporary Photography*, Center for Creative Photography, University of Arizona, 1998

Hammann, Barbara, *Roni Horn*, Kunstraum, Munich, 1983

Herstatt, Claudia, 'Meteoriten vom Himmel über Island', *art*, Hamburg, September, 1995

Hooks, Bell, *Earths Grow Thick*, Wexner Center for the Arts, Columbus, Ohio, 1996

Hoos Fox, Judith, *Earths Grow Thick*, Wexner Center for the Arts, Columbus, Ohio, 1996

Horn, Luise, *Roni Horn*, Kunstraum, Munich, 1983

Horn, Roni, 'Notes from Dyrhólaey', *Museum journaal*, No. 3, Amsterdam, 1983

Horn, Roni, *Bomb*, New York, Winter, 1987

Horn, Roni, *To Place – Book I: Bluff Life*, Peter Blum Edition, New York, 1990

Horn, Roni, 'For Thicket No. 3 – Kafka's Palindrome: A Project for Artforum', *Artforum*, New York, Summer, 1990

Horn, Roni, *Paris Review*, Vol. 116, New York, Fall, 1990

Horn, Roni, *To Place – Book II: Folds*, Mary Boone Gallery, New York, 1991

Horn, Roni, *To Place – Book III: Lava*, Distributed Art Publishers, New York, 1992

Horn, Roni, *To Place – Book IV: Pooling Waters*, 2 Vols., Walther König, Cologne, 1994

Horn, Roni, 'Verne's Journey', *Parkett*, No. 39, Zurich, 1994

Horn, Roni, *Inner Geography*, Baltimore Museum of Art, Maryland, 1994

Horn, Roni, 'Among Judd', *Artforum*, New York, Summer, 1994

Horn, Roni, 'Among Judd', *Guggenheim Magazine*, New York, Summer, 1994

Horn, Roni, *To Place – Book IV: Verne's Journey*, Walther König, Cologne, 1995

Horn, Roni, *Making Being Here Enough: Installations from 1980– 1995*, Kunsthalle, Basel/Kestner Gesellschaft, Hannover, 1995

Horn, Roni, *Felix Gonzalez-Torres, Roni Horn*, Sammlung Goetz, Munich, 1995

Horn, Roni, *To Place – Book VI: Haraldsdóttir*, Ginny Williams, Denver, Colorado, 1996

Horn, Roni, *Earths Grow Thick*, Wexner Center for the Arts, Columbus, Ohio, 1996

Horn, Roni, 'Nicht Hier Sein', *Kunst und Kirche*, No. 2, Frankfurt, 1997

Horn, Roni, *Hyperfoto*, Nos. 3–4, Oslo, 1997

Horn, Roni, 'I Go to Iceland', *More Boreal*, Edinburgh Review, Autumn, 1997

Horn, Roni, *To Place – Book VII: Arctic Circles*, Ginny Williams, Denver, Colorado, 1998

Horn, Roni, *Siksi*, Vol. 13, Nos. 3–4, Helsiki, 1998

Horn, Roni, 'Thetta Ekkert Sem Er', *Morgunbladid*, Reykjavik, 6 September, 1998

Horn, Roni, 'You are the Weather', *Le Monde diplomatique*, Berlin, September, 1998

Horn, Roni, 'Nokkrar Athugasemdir um êslenska Byggingarlist', *Lesbók Morgunbladid*, Reykjavik, 10 April, 1999

Horn, Roni, *Another Water (The River Thames, for Example)*, Scalo Verlag, Zurich and New York, 2000

Howard, Jan, *Inner Geography*, Baltimore Museum of Art, Maryland, 1994

Hucht, Margarete, 'Eine unbekannte Schöne aus Island', *Kölnische Rundschau*, Cologne, 8 May, 1997

Ingolfsson, Einar Falur, 'A Need for the Island', *Morgunblatit*, Reykjavik, 7 March, 1992

Israel, Nico, 'Roni Horn: Inner Geography', *Artforum*, New York, April, 1995

James, Jamie, 'Horn and Holbein', *ARTnews*, New York, November, 1995

Johnson, Ken, 'Roni Horn: Galerie Lelong', *Art in America*, New York, April 1989

Johnson, Ken, 'Material Metaphors', *Art in America*, New York, February, 1994

Johnson, Ken, 'Roni Horn', *New York Times*, 10 October, 1997

Jolles, Claudia, 'Roni Horn', *Kunst-Bulletin*, Zurich, Summer, 1992

Karmel, Pepe, 'The Corner as Trap, Symbol, Vanishing Point, History Lesson', *New York Times*, 21 July, 1995

Kazangian, Dodie, 'Poetry in Place', *Vogue*, New York, September, 1993

Kellein, Thomas, *Making Being Here Enough: Installations from 1980–1995*, Kunsthalle, Basel/ Kestner Gesellschaft, Hannover, 1995

Kersting, Hannelore, *Things That Happen Again*, Städtischen Museum Abteiberg Mönchengladbach/Westfälischer Kunstverein, Münster, 1991

Kertess, Klaus, *Lead*, Hirschl and Adler Modern, New York, 1987

Kertess, Klaus, *Roni Horn: Surface Matters*, Museum of Contemporary Art, Los Angeles, 1990

Kessler, Pamela, 'Roni Horn', *Washington Post*, Washington, DC, 5 February, 1988

Kimmelman, Michael, 'Uptown, Novices and Modern Masters', *New York Times*, 26 February, 1988

Kisters, Jürgen, 'Im Spinnennetz des Unbekannten', *Kölner Stadt-Anzeiger*, No. 295, Cologne, 19 December, 1996

Knight, Christopher, 'Drawings as Tangible as Sculpture', *Los Angles Times*, 23 November, 1990

Koepplin, Dieter, *Roni Horn: Zeichnungen*, Cantz Verlag, Ostildern, 1995

Koepplin, Dieter, *De Beuys a Trockel: Dessins contemporains du Kunstmuseum de Bâle*, Centre Georges Pompidou, Paris, 1996

Kuspit, Donald, *Awards in the Visual Arts*, Winston-Slaem, North Carolina, 1988

Langen, Andreas, 'Von fern, ganz nah', *Stuttgarter Zeitung*, Stuttgart, 1 January, 1997

Lee, Pamela, Mehring, et al., *Drawing is Another Kind of Language*, Harvard University Art Museum, Cambridge/Daco-Verlag Günter Bläse, Stuttgart, 1997

Leonelli, Laura, 'Roni Horn: Disponibile alla contemplazione del centro', *Il Sole 24 Ore*, No. 177, Milan, 29 June, 1997

Levin, Kim, 'Choices', *Village Voice*, New York, 23 February, 1988

Lewis, Diane, 'Notes from an Architiect', *Parkett*, No. 54, Zurich, 1998–99

MacAdam, Barbara, 'Roni Horn: Mary Boone Gallery', *ARTnews*, New York, December, 1993